The Ebsworth Collection

American Modernism, 1911–1947

Contributors

Charles E. Buckley

William C. Agee

John R. Lane

The Saint Louis Art Museum

Distributed by Northeastern University Press, Boston

Exhibition Itinerary

The Saint Louis Art Museum
November 20, 1987 – January 3, 1988

Honolulu Academy of Arts
February 3, 1988 – March 15, 1988

Museum of Fine Arts, Boston
April 6, 1988 – June 5, 1988

Copyright © 1987 by The St. Louis Art Museum
LCC 87-050815
ISBN 0-89178-031-9

Designed by Katy Homans with Mark LaRiviere
Composition in Monotype Walbaum by Michael & Winifred Bixler
Printed in Great Britain by Balding & Mansell International Limited

Contents

Foreword

The Ebsworth collection is an unusually wide-ranging collection, for it includes several acknowledged masterpieces, as well as works by artists whose names are unfamiliar except to specialists. Chronologically the collection ranges from just prior to World War I to shortly after the end of World War II. One of the earliest works is a fine painting by William Glackens dated 1914; the latest are three paintings from 1947 by Charles Sheeler, George Ault, and George Tooker. Most of the paintings, drawings, and sculptures in the collection date from between the two World Wars.

In the past decade, the names of Charles Sheeler, Georgia O'Keeffe, Charles Demuth, Arthur Dove, Joseph Stella, and Edward Hopper have achieved ever-increasing admiration. Many now have celebrity status, owing to fresh views of their pictorial achievements, often in the form of retrospective and group exhibitions, and rising prices in the market. In fact, this exhibition occurs simultaneously with retrospectives of Sheeler, O'Keeffe, and Demuth. As scholars continue to reevaluate their judgments, the public enthusiasm for these artists' work has steadily grown.

Rather than only a "safe" selection of famous names, the Ebsworth collection is also notable for its holdings of artists whose reputations are only now beginning to take hold. Byron Browne, Esphyr Slobodkina, and Jean Xceron are not well known today, but they are professional artists with substantial records of exhibition and critical approval in their day. We hope you will agree that their art is excellent and worthy of further examination.

Barney Ebsworth stands out as a collector not only for his ability to respond, pursue, and acquire major works of art, but also because he willingly considered artists who were not perceived in the top ranks in the 1970s. By now, the value judgments have shifted, and works by those artists are much sought after. For example, he acquired outstanding examples of the American abstract painters of the 1930s, much in advance of John R. Lane and Susan C. Larsen's important exhibition of 1983. Ebsworth was interested in the work of John Storrs, acquiring an important painting and two sculptures several years in advance of the present traveling exhibition organized by The Whitney Museum of American Art. Several other examples exist, and I encourage you to look at the catalogue section of this

book to discover for yourself how daring Ebsworth's visual associations have proven to be.

As a whole, the collection represents a scholarly, critical, and curatorial view of the 1911–1947 period as seen from the viewpoint of the last fifteen years. It is not only a selection of large-scale paintings and sculptures, but a broad view which includes drawings, watercolors, and small works as well. Almost every stylistic tendency is represented, not just one point of view. The omission of the Regionalist artists in a collection formed in Thomas Hart Benton's home state only points out the collection's progressive, modernist tilt. Like the collection of William H. Lane, recently exhibited by the Museum of Fine Arts, Boston, it is a museum-like selection which represents modernist art of the period.

What we see in this exhibition was chosen by one person. Ebsworth alone decided what to buy, sorting out the movements and "isms." He determined quality above price or celebrity; he had the judgment to acquire what others may have disdained or ignored. However many informed correspondents, helpful discussants, or zealous dealers approached him, only one person selected the works of art we see here.

Each author takes a different course. Charles E. Buckley, director of The Saint Louis Art Museum from 1964 to 1975, clearly was the catalyst who started Ebsworth on his present course, and remains a close friend. William C. Agee, a widely known scholar of the period and editor of the Stuart Davis catalogue raisonné, describes important movements and moments in American art that are exemplified in the Ebsworth collection. John R. Lane, director of the San Francisco Museum of Modern Art, writes to update scholarship in the wake of his pioneering exhibition and book organized by the Museum of Art, The Carnegie Institute on the abstract artists. The catalogue entries were assiduously prepared by Joni L. Kinsey, a doctoral candidate in American art at Washington University.

The exhibition reflects a mature collection. While there are certain lacunae, its overall strength and quality are clearly formed. With the reopening of our renovated Museum, it seems especially appropriate to present the collection of a dedicated Museum trustee whose art complements the Museum's holdings so closely. Most of all, the Ebsworth collection now stands on its own. Its statement about American art in this era is exceeded by only one or two museums.

We are grateful for the participation of several persons, without whose talents the exhibition might not have appeared. The exhibition and catalogue were coordinated in St. Louis by curator Michael E. Shapiro, with the assistance of Jack Sawyer. Curators in Honolulu, James Jensen, and Boston, Theodore E. Stebbins, Jr. and Carol Troyen, coordinated the exhibition at their institutions. Registrarial activities were the responsibility of Helene Rundell, Nick Ohlman, Amanda Slavin, and Joni Kinsey, St. Louis, with the help of Sanna Saks Deutsch in Honolulu and Linda Thomas and Francine Flynn in Boston. The book was edited and published under the direction of Mary Ann Steiner.

James D. Burke
Director The Saint Louis Art Museum

Charles E. Buckley

Barney A. Ebsworth, An American Collector

About collectors who devote themselves to the pursuit of art, much has been written. The best ones, as we know, focus on a special field and thereafter move steadily toward their goal. As one might imagine, there are many ways of building a collection. Once formed, it will, if it is truly distinguished, bear the stamp of the collector's personality and have that unmistakable "presence" that seldom fails to communicate itself to us. One soon learns to differentiate between those who buy art with a passion tempered by taste and knowledge – and there are now many such collectors – and those who think of it only as a means of further enhancing their personal environment.

When I first met Barney Ebsworth in April 1972, during my tenure as director of The Saint Louis Art Museum, it struck me that here was a collector in the making, one who already was instinctively moving in the right direction. His response to works of art of many different kinds was of such warmth and sensitivity, and his curiosity about them so persistent, that it seemed only a matter of time before he would attain "serious" collector status. Not long before, Barney had considered building a collection of seventeenth-century Dutch paintings and, in fact, he had made some initial purchases through a London dealer. But though he still owns these paintings, they have never motivated him to look further in the direction of buying other Dutch, or even other European, paintings. Perhaps Barney felt that no matter how often he might yield to the temptation of buying an occasional picture of merit there was really no particular reason for doing so. If he was to "collect," then he needed the focus that the best collectors soon learn to perfect. As yet "focus" was the missing element, but Barney was becoming ever more acutely aware of its importance.

Like many collectors, Barney might not find it easy to explain how it was that he so eagerly embraced his special field from the Armory Show to the emergence some thirty years later of the Abstract Expressionists; until he began to collect, his knowledge of that area was necessarily limited. But fine collectors have a way of emerging unexpectedly, and so it was with him. To pin down the precise moment when Barney was first made aware of American art is futile. Surely his first conversations in 1972 with those of us who

were then working at the Museum were important. At about the same time, some of the art dealers in New York that he was coming to know – Joan Washburn, Virginia Zabriskie, and Robert Schoelkopf especially – were helping him formulate the views he now holds of modern American art from the post-Armory Show era.

As for this period that had begun to attract him, that is from 1914 to 1945, Barney saw that it could offer him both the focus that he believed was necessary for any serious collector and the strong challenge to develop toward it a sustained scholarly interest. Unquestionably the period had produced some of this country's best artists, yet for many years our impression of it remained fragmented and its ramifications were far from being fully understood. From 1914 until well into the 1920s, awareness of what was then new in American art had been largely the concern of a small band of art dealers, critics, and collectors who were centered in New York and who strongly believed in the new art that was being produced. A few dealers, such as Alfred Stieglitz, Charles Daniel, and the Montross Gallery, had rallied even before the Armory Show in support of the ideals and work of the rising generation of painters and sculptors imbued with the spirit of modernism. Through their efforts these artists came to the attention of a small, forward-looking circle of collectors who became their initial patrons. The most dedicated of these was surely Ferdinand Howald, whose dazzling array of Americans now so distinguishes The Columbus Museum of Art. Howald showed strong preference for the work of Charles Demuth, Preston Dickinson, Marsden Hartley, John Marin, and Charles Sheeler. There were other collectors who, sustaining an equal or an even greater interest in modern European art, played similar supporting roles, among them John Quinn, Arthur Jerome Eddy, Walter Arensberg and, somewhat later, Duncan Phillips. But they formed a short list at best, and even after the 1920s there were still few well-rounded collections of this brilliant period until the appearance of William H. Lane whose superb collection, with its emphasis on Georgia O'Keeffe, Charles Sheeler, and Arthur G. Dove, was brought together in the 1950s and 1960s.

Barney Ebsworth's initial venture into the American field was in May 1972, when he acquired one of William Glackens' best pictures, *Cafe Lafayette* (cat. 27), painted in 1914. Our conversations about collecting earlier that year had included a remark from Barney that if I came across an American painting that I thought might interest him, it would do no harm to let him know. When I told him that the Glackens was about to come up for sale at Sotheby's, he reacted with characteristic decision by proposing that we fly to New York to see it. On our return, Barney began learning about Glackens as he had already made up his mind to buy *Cafe Lafayette*. For Barney, the habit of turning to research, as he did before buying this picture, is by now well defined and is an effective means of continually enlarging his reservoir of experience with paintings or sculpture that may be of potential interest to the collection.

The same sale that produced the Glackens also brought him Charles Burchfield's watercolor, *Black Houses* (cat. 9), dating from 1918, a time when the artist was finding some of his earliest subjects in the shabby buildings that were so much a part of the landscape of small-town Ohio. Later that year, and once again at auction, Barney bought the

painting that decisively steered him in the direction his collection now represents, a small watercolor study (cat. 60) by Charles Sheeler painted in 1928 for *Classic Landscape*. The latter, finished three years later, is a large oil painting of the Ford Motor Company where, in 1927, Sheeler had already carried out one of his most successful projects, a photographic documentation of Ford's great River Rouge plant. The Rouge, as it was known, was at that time one of the wonders of the industrial world. For Sheeler it turned out to be a major theme for both photography and painting. The image and concept underlying this precisely worked out study for *Classic Landscape* instantly appealed to Barney, even though he then knew very little about the artist. But now Sheeler emerged as a distinct and compelling figure, an artist who came to symbolize for Ebsworth a new world of aesthetic experience and stimulated him to think about American art of this period in ways that neither the Glackens, nor even the Burchfield, could do. Subsequently, this important watercolor study led Barney to purchase three other works by Sheeler, of which the most important is *Classic Landscape* (cat. 61) itself. This painting, together with its companion, *American Landscape*, 1930 (The Museum of Modern Art), ranks with Sheeler's finest work and is one of the most important industrial landscapes of our century. Each shape and form of this remarkable and exquisitely executed painting have been fitted into the carefully constructed image that Sheeler projects, an image of an almost surreal environment that lies before us, silent and devoid of human presence in this second year of the Great Depression. The second Sheeler acquired for the Ebsworth collection is the superb still-life dating from 1938 (cat. 62), a painting owned by Nelson Rockefeller until his death in 1979. Although very small – really no larger than Sheeler's own photographic image of the same still-life arrangement – and pared to the minimum without sacrificing the integrity of the subject, its strong visual presence belies its size. A third Sheeler, *Cat Walk* (cat. 59), from 1947, is a late work painted in the high key and flat style that he used at a time when he again sought to express more directly the basic abstract framework of a subject, just as he had done before 1920.

Barney's early move to this period compelled him to think more critically about the artists who had been at the forefront of modernism and whose work had been shown by Stieglitz and Daniel and at the Montross Gallery. The small Sheeler watercolor and the Stuart Davis *Still Life in the Street* (cat. 14), previously known as *French Landscape*, had provided the key for an appreciation not only of these artists but of O'Keeffe, Hartley, Marin, Hopper, and others now represented in his collection. When Barney first discovered them, he began educating himself about their work, understanding it in relation to the broader spectrum of twentieth-century art and finding examples of it in the art market. Although in the mid-1970s there still were opportunities to buy, it had been apparent for nearly a decade that the remaining important works by the leaders of this early generation were fast disappearing, moving from dealers' hands at steadily higher prices into private and museum collections. These artists, who first came to notice through the efforts of the dealers mentioned above and who were then largely taken up by Edith Halpert when she opened The Downtown Gallery in 1926, were now attracting wider attention. In further support of this growing interest was a growing body of schol-

arship from a new generation of art historians and dealers redefining the individual and collective contributions that these artists had made to modern art. This interest was not confined to the "Stieglitz" group alone but included the entire panorama of those artists who had been no less a part of this thirty-five year time span.

Buying American art of this period has been for Barney an act of strong personal commitment and discovery. Although the pleasure that he experiences from collecting is apparent to all who know him, it is what he learns from living with these paintings and sculpture that perhaps brings him the greatest satisfaction. By now, except for regionalists such as Grant Wood and John Steuart Curry who tended to dominate the 1930s, the Ebsworth collection takes into account many of the attitudes that prevailed in modern American art after 1914. Although it has its obvious "stars" in paintings by such masters as Sheeler, O'Keeffe, and Hopper, Barney finds merit in the work of artists of lesser renown who, he believes, must be reconsidered if we are to fully understand the period. Until recently these artists have been almost entirely overlooked, eclipsed by the pervasive changes that have affected American art since 1950. Among them are Morris Kantor, represented in the collection by *Orchestra* (cat. 35), from 1923, a painting that illustrates a very specific aspect of the American response to modern art a decade after the Armory Show, and Manierre Dawson, a still obscure but interesting figure who, in 1918, could paint so directly and so daringly a painting like *Blue Trees on Red Rocks* (cat. 15). There is also Luigi Lucioni, whose *Still Life with Peaches* (cat. 41) of 1927 established at that moment the artist's intense concern for calculated and precisely painted relationships between form and space. Another sharply focused painting from these years is a 1930 still life by George Ault (cat. 1) in which the immaculately brushed surfaces rival those of Charles Sheeler. An abruptly different painting is Ernest Fiene's brooding, snow-covered panorama of Pittsburgh in the dark days of 1935/1936 (cat. 23). As a powerful social comment this important painting stands somewhat apart from the main lines of Barney's collection. The collection also includes sculptures by lesser known artists. Two works by John Storrs, one of the best and, I believe, still most underappreciated sculptors of this period, stand out, an elegant marble shaft called *Study in Architectural Forms* (cat. 69), from 1923, and, from a somewhat later date, 1931/1935, *Abstraction #2* (*Industrial Forms*) (cat. 67). Although the names of these artists and others like them are not even now widely known or often to be found on every collector's "preferred" list, their presence in this collection is noteworthy. Not only do they enrich it in ways that masterworks alone do not, but they invite us to consider a neglected substratum that we are now beginning to explore in greater depth.

In 1973 Barney acquired his first abstract, or more accurately his first non-representational, paintings. From Edith Halpert's sale at Sotheby's in March of that year, he bought Georgia O'Keeffe's *Black, White and Blue* (cat. 51), a painting from 1930, that projects with the force of a billboard; soon after he purchased her *Music – Pink and Blue I* (cat. 53) of 1919. A more recent purchase is a vivid O'Keeffe watercolor called *Sunrise*, an early work from 1917 when she was painting almost unknown on the West Texas plains. These O'Keeffes trace her evolution from the quasi-mystical concerns of sunrise to full-strength in *Black, White and Blue*. Like Charles Sheeler, O'Keeffe made a deep impres-

sion on Barney. Of all the artists represented in his collection she is the only one that he came to know. In the last few years of her life O'Keeffe and Barney were good friends, and it was at her home in Abiquiu that he and his wife, Trish, were married in 1981.

Another painting that falls within a loose definition of "abstract" art is Marsden Hartley's *Painting No. 49, Berlin* (cat. 31), or, as it is also known, *Portrait of a German Officer,* one of a number of variations on this martial theme with which he was preoccupied during his German stay in 1914–1915, just as the First World War intensified. In its tight integration of planes, circles, and rectilinear shapes scattered across the plain background, the composition is purely "abstract;" yet the officer's feathered shako, military Iron Cross, and epaulets persuade us to accept its validity as a portrait. This dichotomy held Hartley's attention in other similar paintings as well during this significant phase of his career. The two O'Keeffe oils from 1919 and 1930, and Hartley's large military subject are joined by another major abstract painting, Patrick Henry Bruce's *Peinture/Nature Morte* (cat. 8), dating close to 1924. This particular still life theme dominated his creative output in these few years in the 1920s, as may be seen from closely parallel paintings in the Sheldon Memorial Art Gallery, the Addison Gallery of American Art, and the Corcoran Gallery of Art.

In terms of abstract representation, however, the Ebsworth collection reaches beyond 1930. As a logical progression from this earlier period, and as a result of conversations with Joan Washburn whose gallery featured their work, Barney in the mid-1970s began buying paintings by the next wave of abstract artists, those who fit into the framework established by John R. Lane and Susan C. Larsen in their catalogue for the 1983/1984 exhibition, *Abstract Painting and Sculpture in America, 1927/1944.* The paintings that Barney acquired over the next few years are from the late 1930s and early 1940s and by artists who only then had begun to attract collectors. In responding early to their work, Barney was fortunate in being able to buy Byron Browne's 1936 *Classical Still Life* (cat. 6); Suzy Frelinghuysen's 1943 *Composition* (cat. 25); and the superb, prism-like *Blue Diamond* (cat. 5) by Ilya Bolotowsky that, in itself, sums up many of the painterly concerns of this late abstract period when European influence remained strong. Barney also came to admire the work of Alice Trumbull Mason, surely one of the best artists of the period, and added to his collection with her *Forms Evoked* (cat. 44), which dates from 1940.

Among the Ebsworth paintings that stand at a distance from the more specifically formal work of these "late" abstract artists are Arthur G. Dove's *Moon* (cat. 21), painted in 1936 at the height of his career; Arshile Gorky's *Abstraction* (cat. 28), from the same year; and John Marin's oil *My Hell Raising Sea* (cat. 43), which, dating from 1941, is a late work for this artist whose watercolors are often better known than his oils. The paintings by Dove and Marin stem, in their distinctly different ways, directly from the level of personal sensory experience; so too does Gorky's, despite its European "abstract" heritage and direct debt to Picasso. Dove, who ranks as one of this country's pioneer modern painters, saw no need to move any distance from the world with which he was familiar and throughout his life remained in close touch with nature and all natural phenomena. Shapes abstracted from nature, light in its every degree of nuance, the texture of painted

and real surfaces, as one sees in his *Sea II* (cat. 22), and, not infrequently, even the experience of sound comprised a rich resource on which Dove could draw. *Moon*, one of his most important and most powerful paintings, exemplifies this adherence to nature in its expression of a fleeting and intensely felt moment. In Marin's seascape, the artist once again confronts the subject that fascinated him for so much of his life – the surge and contradiction of the sea's movement off the Maine coast.

Chop Suey (cat. 33), painted by Edward Hopper in 1929, is an early acquisition and with *Classic Landscape, Moon,* and a number of other major works, is one of the pillars of the collection. Among other works by Hopper, and also among other American paintings of this time, *Chop Suey* enjoys a certain celebrity from having been so often seen in exhibitions. As an artist to be reckoned with, Hopper began to come into his own in 1924 through a successful exhibition of his watercolors held by the Frank K. M. Rehn Gallery. By the end of that decade, his position as an artist was firmly established. *Chop Suey* was painted at the same time that Sheeler was concentrating on his River Rouge subjects and working on *Classic Landscape*. While the aesthetic of a painted surface was undoubtedly important to Hopper, his approach was more painterly and in complete contrast to Sheeler's well-brushed surfaces, whose origins begin with the Flemish masters of the fifteenth century. Hopper's concern was not so much with method; rather it was taken up with expressing the humanity of a commonplace scene, as in *Chop Suey*, a modest Chinese eatery of a sort that was once found in almost every American city and town. Hopper engages us with the life of his subject, yet there is an underlying abstract compositional grid that accounts for and disciplines its every aspect in a way no less strictly controlled than it is in *Classic Landscape*. Painted within two years of each other, these two paintings have in common the power to evoke, though in quite different ways, the mood of pervasive desolation that characterized the early years of the Depression.

Barney's most recent acquisition, *Tree of My Life* (cat. 66), 1919, by Joseph Stella, is one of the most impressive pictures in the collection. In its lyrical expression of Stella's early memories and its exotic vision of a new world, *Tree of My Life* represents a particularly significant moment in his still developing career when he was working on his now famous Brooklyn Bridge paintings. Like the Hopper, with its relentless realism, Stella's painting reminds us once again that Barney's interests extend well beyond the Stieglitz/Halpert group of artists, recognizing a variety of modes of expression, and not discounting surrealism as may be seen in the paintings by O. Louis Guglielmi (cat. 30, 31) and George Tooker (cat. 71).

In the intensely competitive climate of today's art market, the fifteen years in which Barney has been active is not long; this is especially true in the realm of important American pictures which have become much more difficult to find. In spite of this obstacle, Barney is nevertheless fast approaching his goal of building a collection that takes into account most of the principal creative currents in modern American art in the years after 1914. Though Barney has benefited from views other than his own, the collection, as we see it now, came into being and has since flourished solely because of his devotion to it on a scale he may not at first have anticipated, and his desire to explore in depth this period that has come to be seen as a vital one in the evolution of American art of this century.

William C. Agee

Cézanne, Color, and Cubism:

The Ebsworth Collection and American Art

The Ebsworth Collection engages us on first encounter because it represents many of our best-known modernists at the height of their powers – O'Keeffe, Hopper, Sheeler, Marin, Hartley, and Dove, for example, come immediately to mind. Such works show us American art at its highest level, and the rewards they provide are remarkable. It is not, however, solely a collection of familiar names. The collection is rich in works by artists of distinguished if still largely unrecognized achievement such as Patrick Henry Bruce and Jan Matulka. Further, the real depth of the collection, as opposed to its numerical size which is not exceptionally large, may be said to be measured, in part, in compelling pictures by artists who likely are unfamiliar to all but specialists – Andrew Dasburg, James Daugherty, and Morris Kantor among them. Such is the quality of these works that we are forced once again to question traditional notions of relative importance in American art; more importantly, we are forced to confront and recognize true accomplishment rather than labels or reputations.

Nor are the paintings, watercolors, drawings, and sculpture which comprise the collection a series of random or isolated works (although that would not be unwelcome in itself); the collection engages us for reasons historical as well as aesthetic. It suggests several themes, as well as historical moments and patterns, that touch at diverse and unsuspected points, all forming part of the complex mosaic of modern American art.

We might well begin with Andrew Dasburg (1887–1979) whose 1913 *Landscape* (cat. 12) is the earliest painting in the Ebsworth collection. Although not a major figure in the sense that Hartley or Dove were, Dasburg was a fine, sensitive artist whose accomplishment deserves our attention. The painting holds a special place in the collection, for it reveals the laborious study that went into the development of modernism in this country; in this sense, it is paradigmatic of earlier American modernism. This small but beautiful picture is densely painted, with a chromatic richness and solidity that give it a carrying power and internal scale far beyond its actual size. It was done on Monhegan Island, off the coast of Maine, a spot favored by American artists in the early years of this century. Yet Dasburg deliberately chose a site that would invoke not so much the Maine coast as it would Mont Sainte-Victoire (Figure 1), the favorite motif of Cézanne in his later

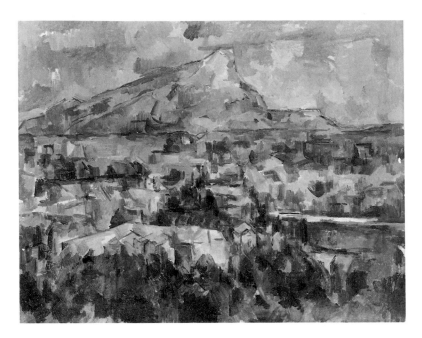

Figure 1
Paul Cézanne,
French, 1839–1906.
Mont Sainte-Victoire, 1902–1904.
Oil on canvas, 27½ x 35¼
inches. Courtesy Philadelphia
Museum of Art,
George W. Elkins Collection.

years. Dasburg and countless other artists, both American and European, looked to Cézanne as a model to emulate in rendering concrete their sensations of color and light. His course demonstrates that the independent study of Cézanne was clearly one of the most important factors in shaping American modernism.

Dasburg's assimilation of Cézanne resulted in large measure from his close working relationship with Morgan Russell (1886–1953), one of the pioneers of abstract art. They had met at the Art Students League in 1906, and the next year they worked together at the League's summer program in Woodstock. In 1908 Russell settled in Paris, and in August he wrote Dasburg recalling that "last summer we used to talk about edges, color edges, complementary values – just smear and play joyously the broken tones of light . . . "[1] Clearly, the two were under the sway of Monet and the "anatomy of light,"[2] as Russell termed it. This luminescence pervades Dasburg's 1913 picture, but it is made massive and solid through his immersion in Cézanne, whose art Dasburg studied diligently while working with Russell in Paris from the spring of 1909 through mid-1910. Russell borrowed a small Cézanne still life of apples from Leo Stein,[3] a close friend, and both Dasburg and Russell copied the painting, thus distilling Cézanne's techniques to meet their own ends. In a letter of October 27, 1910, Russell wrote to Dasburg from Paris that Cézanne's pictures are "wholes – solid and powerful, without holes, and rich and forceful in color and massive in form."[4] Dasburg in turn could proclaim that Cézanne was "sublime, each contact with his art fills me with new life . . . "[5] and that it "will rest in my mind as a standard of what I want to attain in my paintings."[6] In Dasburg's small land-

scape, each touch is constructed as if he were painting not so much light or color, but rather matter itself, something elemental and essential to the very structure of the world. For these two Americans, as for others, Cézanne extended the means to develop a modern idiom that would embody the weight and authority of the older art they deeply admired. By the fall of 1913, Dasburg had begun a series of abstractions in which the painting was carried solely by the myriad, non-associative color forms and harmonies that are clearly evident in the landscape of Monhegan Island. They are related to Russell's abstractions, and should be considered as an integral part of Orphism and Synchromism, and the art of color abstraction. After 1917, Dasburg abandoned abstraction and for a lifetime pursued an individual style based on the lessons of Cézanne. Dasburg's small picture makes it clear that for American artists, Cézanne held out entire pictorial worlds to explore. What Cézanne meant to American artists might have been best summarized by Rilke in a letter he wrote on the occasion of the Cézanne retrospective at the Salon d'Automne, in October 1907:

From the amount Cezanne gives me to do now, I notice how very different I have grown. I am on the road to becoming a worker, on a long road perhaps and probably just at the first milestone; but nevertheless I can already comprehend the old man who has gone on somewhat far ahead, alone. I went to see his pictures again today; it is remarkable what a company they form. Without looking at any single one, standing between the two rooms, one feels their presence joining in a colossal reality. As if those colors took away one's irresolution once and for all.[7]

In 1914, the year after Dasburg painted his Monhegan landscape, John Marin (1870–1953) also discovered Maine. Unlike Dasburg, who had only visited occasionally, Marin developed a lifelong attachment for the sea and shore of Maine. His work is virtually inseparable from the state's rugged topography, which provided Marin with seemingly inexhaustible motifs of innate structural and expressive potential. In a brilliant watercolor of 1922, *From Deer Isle, Maine,* (cat. 42) Marin fuses water and sky, tree and rocks. The color and light are dazzling, recalling Marin's early assimilation of Impressionism and Paul Signac during his prolonged stays in Europe, especially in Paris, from 1905–1910. No less than it had been for the paintings of Dasburg, the ultimate source for these works is Cézanne, not the dense, painterly fabric of Cézanne's later oils, but rather the open, airy translucence of his watercolors. Marin, like Cézanne, made bold use of the bare, untouched paper as a color itself, employing it as a complement and contrast to other colors. In addition, the open areas provided a kind of breathing space, a space of contraction and expansion, between the areas of intense Fauve-like hues. By not filling the paper, Marin intensified the focus of the picture, the edges of which are structured by the modified cubist grid that was a hallmark of Marin's art. This grid could sometimes become forced and mechanical, too much like a formula, with the reverse effect of deadening the surfaces. But when most successful it quickens with the surface, the blackness of the lines enriching the high-keyed hues and whiteness of the paper.

Marin had forged an independent, mature art by 1912, but the example of Cézanne's

monumental watercolors provided the impetus for Marin and others to continue to invigorate an American tradition that dates to the nineteenth century, most notably in the watercolors of Winslow Homer. But Cézanne demonstrated that the "thin" watercolor medium could produce a style of infinite possibilities suited for modern pictorial needs. In turn, the modern tradition was extended by Dove and O'Keeffe as well as by Marin, and later it affected artists as diverse as Helen Frankenthaler, Ad Reinhardt, and Morris Louis.

In still other ways, Cézanne – especially as he was seen through the eyes of Matisse – is at the heart of the *Seated Nude*, c. 1915 (cat. 13) by James Henry Daugherty (1889–1974). This apparently modest pastel by a little-known artist is seemingly unfinished; its subject is an age-old motif, and viewers may be tempted to pass it by. However, it is telling of the struggle to realize a new sensibility. The seated model is rendered almost exclusively through simple Cézanne-like patches of parallel strokes of color. The color of each area responds to the harmonies suggested by the adjacent area, which in turn leads to a new color response, the whole building itself as an ensemble of color orchestration. Through these techniques, the hues take on an existence of their own, reminding us of Cézanne's dicta that "one should not say model but, gradate," and "when color is at its richest, form is at its fullest."[8] Conveying mass and form through color alone was an essential ingredient of one aspect of modernist painting. In this pastel we see the process of color construction in its early stages as it was actually evolving through the artist's hand and feeling.

James Daugherty was an important conduit in America for these techniques. In early 1915, Daugherty met Arthur B. Frost, Jr. (1887–1917) who had just returned to New York after working with his close friend, Patrick Henry Bruce (1881–1936), in Paris. From Matisse, who declared that "Cézanne is the father of us all," Bruce and Frost learned to build a canvas systematically through color application, although pictorial intuition was their final guide.[9] By 1914, they both had done large abstractions that were important contributions to international modernism. After returning to New York, Frost began to disseminate the new color principles. Daugherty was immediately caught up in the excitement generated by his introduction to the new pictorial worlds of color. He first applied these lessons by working from the model, which is surely the moment, as well as the subject, captured in the Ebsworth pastel. We are witness here to the probing, searching process of the artistic discovery. Thereafter, Daugherty transformed these color touches into a substantial body of abstraction which added something genuine and significant to our art. In turn, he transmitted these ideas to other Americans such as his friend Jay Van Everen (1875–1947). Through exchanges of this type the corpus of modern American painting gradually was established.

Chromatic brilliance and richness were also hallmarks of the art of Marsden Hartley (1877–1943). They reached their peak of intensity in his great abstractions of 1913 to 1915, unquestionably the most powerful and accomplished paintings of American modernism of these years. Indeed, works such as the Ebsworth *Painting No. 49, Berlin* (cat. 31), of 1914–1915, force us to drop the qualifying "American," and place Hartley's achievement

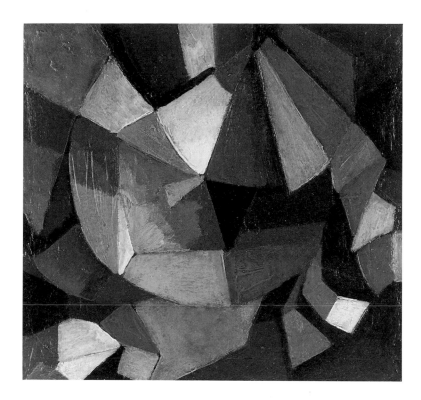

Figure 2
Morgan Russell,
American, 1886–1953.
Synchromy, 1914.
Oil on composition board,
13 x 24¾ inches. Courtesy
The Museum of Fine Arts,
Houston.

squarely in line with the best of international modernism of that decade. They are neither strictly Orphist nor Synchromist paintings, but they should be considered an integral part of the drive to realize a picture through the lucid construction of high-keyed spectral hues, an ambition uniting the otherwise disparate work of Robert and Sonia Delaunay, Morgan Russell, and Stanton Macdonald-Wright, as well as Bruce, Frost, Dasburg, and Daugherty (Figure 2). Specific formal and expressive devices common to color abstraction are the concentric circles emanating from the lower center of *Painting No. 49, Berlin.* Here they suggest the setting sun, but more importantly they both anchor and animate the entire composition, as part of a personal and highly inventive cubist syntax. They are sources of pulsating pictorial movement, recalling the roughly circular elements found in a nascent stage at the lower right of Dasburg's 1913 *Landscape.*

In contrast to the Dasburg, which is rooted in the natural world, Hartley's paintings of this period celebrate the visual rhythms, the sights, and sounds of the man-made world of the modern urban environment. Hartley was drawn first to New York and then to the capitals of European modernism, Paris and Berlin, where he spent much of his time between April of 1912 and December of 1915, when he returned to the United States. As part of the international artistic community in Europe, he quickly absorbed and then contributed to the development of abstract art. The cadence of the modern city is transmitted by the vivid color; Hartley relies principally on the primary hues of red, yellow, and blue, contrasted at certain points by a secondary hue, green, and more extensively by black and white. Various laws of color interaction are in force; we need not elaborate

them except to note that, in sum, they heighten the intensity and impact of the hues, and thus the forms. One color principle to note is the practice of gradation, whereby a given hue is modulated from a light to a darker value in adjoining or nearby areas, providing an inherent movement and unity; here, Hartley uses differing values of blue, ranging from the light center, to the dark of the triangle at top, and to the deep blue, approximating a black, at the center. In this way, Hartley, as well as other color abstractionists, constructed a painting as one might compose a musical score. It should also be noted that in using black and white in conjunction with spectral hues, Hartley was a pioneer in color application, since this practice was not widely employed until 1916.

To all appearances the painting invokes a festive mood, but the underlying theme is the record of a tragic event, one of the many that haunted the life of this restless, tormented man. The Ebsworth painting is the first of the series known as the German Military or German Officer portraits. They commemorate the death in battle on October 7, 1914 of a young German lieutenant, Karl Von Freyburg, to whom Hartley was deeply attached. His presence is invoked by the plumed helmet and the iron cross, as well as the number 24, signifying Freyburg's age at the time of his death. It is therefore a symbolic portrait, but the pronounced vertical axis supporting these elements suggests the rudiments of an anthropomorphic presence. The hues in subsequent pictures in the series became less spectral, more somber – though no less rich – with black assuming a proportionally larger role, in keeping with the tenor of the event memorialized. But because of the incongruity between the holiday mood of the vivid color and the sense of loss embodied in the painting, the Ebsworth picture captures the terrible irony of the incongruence and transience of life. In its special poetry, the painting movingly demonstrates the inseparability of intellect and intuition, form and content, in the best art that captures most tellingly the authenticity of experience.

Although worlds apart from Hartley, the work of Georgia O'Keeffe (1887–1986) from 1915 to 1919 suggests a similar grounding in the possibilities afforded by pure color. Her watercolors of 1916–1917 demonstrate a remarkable sensitivity to the carrying power and internal nuances of intense hues. The Ebsworth watercolor, Sunrise (cat. 54), 1917, emanates from the vast, open space of West Texas where she was then teaching, yet the references to the natural world dissolve in the waves of light and color expanding over and across the surface. Although the watercolor is more diffused (and O'Keeffe must be given a ranking position in modern watercolor painting) these patterns cannot help but call to mind, if only at a remove, the familiar discs of Orphist-Synchromist art. It may well be that O'Keeffe's absorption of color was assisted to some extent by her exposure to the work of the Synchromist Stanton Macdonald-Wright, who showed at the 1916 Forum Show (as had Russell and Dasburg) and who had a one-man show in 1917 at the gallery 291, run by Alfred Stieglitz, her champion and future husband. So distinctive is her personality in these works, however, that we are instantly caught up in the seemingly infinite variations of a single hue, red. This one color is made to seem as if it constituted an entire palette, modulated in degrees of light and by subtle distinctions in pressure and movement from the very touch of the brush; the red is relieved only by the yellow orb at the center,

and by the open areas of the white paper. The effect, although far from the strident tones of Hartley's paintings, is no less musical in its orchestration of soft, light-filled gradations.

The relationship of music and painting has a long and complex history in nineteenth and twentieth-century painting, and was invoked by, among others, Delacroix, Whistler, Gauguin, Matisse, and Kandinsky. O'Keeffe herself was exposed to the equation when she was studying in New York with Alon Bement and Arthur Wesley Dow at Teachers College, Columbia University in 1914. Bement had his students do drawings from various kinds of music, and the idea that "music could be translated into something for the eye"[10] later manifested itself in O'Keeffe's work. It is most obvious in the Ebsworth *Music – Pink and Blue I*, 1919 (cat. 53), a painting which unfolds in gentle ripples of color, a visual equivalent to the way musical chords might echo in our consciousness. Once more, the space is vast, even limitless, but it is now without suggestion of a landscape. Rather, it calls to mind a mental, or even otherworldly space, suggesting the infinite, unbound by natural or man-made constrictions. At the same time, however, the unfolding shapes do forecast the more precisely rendered flower images that form a sizeable portion of her work of the 1920s. The lilting harmonies of this picture are based on the multiple, close-valued gradation of just two colors – red and blue – with the merest suggestion of the third primary, yellow, at center.

In the Ebsworth collection there is also what is arguably O'Keeffe's best picture, *Black, White and Blue*, 1930 (cat. 51). In her later years, the mystique of her forceful, independent personality effectively obscured the nature and extent of her achievement, but with some reflection now possible, it is probable that the period 1917–1930 will be seen as her most consistently successful years, with the pinnacle of her achievement coming precisely around 1930. The mood of *Black, White and Blue* is in stark contrast to the earlier works – soft, diffused forms and colors have been replaced by sharp, assertive shapes; high-keyed colors by dark hues, severely limited in range, yet deep and resonant in their timbre. The painting once more invokes an infinite space, alluding to the Southwest that was so much a part of her. The three shapes of the painting – the vertical shaft, the sweeping arc, and the cutting triangle – suggest the collision and interaction of natural forces, a theme and format which appeared in modified versions in other paintings. Yet nowhere in her work do we see just this tautness of shape, depth of feeling, and luster of color, qualities which convincingly embody a sure sense of place.

Arthur Dove (1881–1946) is always considered a member of the pioneering generation of modernists whose first original work appeared just after 1910. Yet Dove's art only fully matured after 1920. As such, he is a pivotal artist of the twenties and thirties whose art refutes the still prevalent notion that modernism was in retreat after 1920. To be sure, the course of modernism changed (as it had in Europe), and it was challenged by the Social Realists and Regionalists who appeared in large numbers and seemed to overwhelm advanced artists. But our best art of the 1920s was still made by artists such as Dove and others of his generation, joined then most prominently by Stuart Davis (1892–1964), born a decade later. Among the most radical works of art produced by any artist during the decade of the twenties were the collages of Arthur Dove. They are astonishing in many

ways – for their audacious techniques, their combination of non-art materials, their formal inventiveness, and for the range of mood and feeling they embody. They can be humorous or satirical, gritty and unyielding, or, in the Ebsworth *Sea II*, 1925 (cat. 22), lyrical and gentle, as if we were enshrouded by water, fog, and gray light. It is a far different vision of the sea than Marin's turbulent watercolors and oils, but Dove's collage makes us feel no less close to the elements. The work is both a romantic view of the sea, but also a very real one; since he lived on the water, Dove knew full well the dangers of the sea, its sudden shifts in mood. Dove was also connected to the sea in another real sense because the fish and scallops he caught made up a goodly share of his diet.[11] Dove's ability to achieve these effects through a minimum of materials is astonishing. A hard, reflective aluminum panel, some sand glued to the surface, and a few wispy pieces of chiffon, leaving most of the surface open, are all that comprise the work. The bits of chiffon – placed seemingly at random – evoke simultaneous sensations, even images of clouds, gentle waves, spits of land, marine and plant life, fish and microscopic organic life darting in the water.

Could Dove have foreseen the effect that the aging of the panel would have, that with time and wear the panel would take on a patina of age that adds infinite nuances of light and movement as an intrinsic part of the atmosphere enveloping the work? We cannot say, but Dove drew out the innate qualities of the materials as consciously and effectively as his contemporary Brancusi used the reflections of brass and the veining of wood and marble. Indeed, he forecast the way Donald Judd has imbued aluminum, as well as steel and plexiglas, with a whole gamut of expressive means.

Contrary to inherited opinion, Dove carefully sought out and chose very specific materials for his collages. He did not simply use anything that was at hand, as we have been led to believe.[12] The diaries kept by Dove and his wife reveal, for example, frequent shopping trips to Huntington, New York especially to purchase special materials for the collages.[13] Although he used found objects and cast-off materials, his choices were not accidental. Nor were the collages undertaken out of desperation from lack of studio space or funds, as is often thought. They were undertaken consciously and deliberately, as part of a compelling artistic drive stemming from an intuitive understanding of certain pictorial demands he had to satisfy in his work. Why this is so is the subject of a study in itself, but the collages suggest that Dove realized his work required directness and openness, an assertion of the physical reality of the medium for it to succeed fully. He also understood apparently that these were needs best realized by collage at that point in the evolution of his art. Dove's pictorial intelligence, we may speculate, had told him by 1924, when the collages were begun, that his work was suffering, to some extent, from the constraints of a certain opacity and heaviness, a certain reserve that kept his art from reaching its full impact. Collage was the answer, for it is no coincidence that after completing the collages in 1928 Dove reached the height of his powers as a painter.

During the mid and late 1930s, Dove consistently painted some of his best pictures, among them *Moon*, 1935–1936 (cat. 21), now in the Ebsworth collection. Dove, like O'Keeffe, whom he had influenced early on, here invokes a scene of elemental, almost

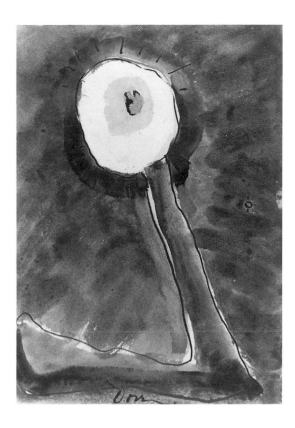

Figure 3
Arthur Dove,
American, 1880–1946.
Moon, 1935. Watercolor on
paper, 7 x 5 inches. Courtesy
Thomas R. Barrett and
Leni Mancuso.

primitive power. A tree, like some giant arm with a truncated hand, extends across and upward to enclose the radiant moon, painted as if it were the eye of a mythic creature suggesting the cyclops of Odilon Redon. From these concentric circles of the moon (once again, a distant echo of the discs of Synchromism and Orphism) emanates a pervasive, glowing light recalling the entire tradition of nineteenth-century moonlight scenes, particularly those of Blakelock and Ryder. But rather, the light is now embodied through the close-knit, parallel strokes and bleeding planes of Cézanne, the master who, as his diaries make clear, remained a guiding force even in Dove's later years.[14] The resonance of the picture, the light painted with an almost palpable substance, also brings to mind Rembrandt, another model, who with Cézanne set the highest standards for Dove.[15] The directness and immediacy of the painting account in large measure for its particular power, for there are no hints of the sometimes cloying reticence or fussiness that often hurt Dove's paintings.

Although neither as well known nor as esteemed as those of Marin or O'Keeffe, Dove's watercolors were an important part of his art and work processes (Figure 3). Often, his watercolors are remarkable works of art, as is *Holbrook's Bridge* (cat. 20). The bridge was located outside Geneva, in upstate New York, where Dove and his wife lived from 1933 to 1938, and was a site they frequently visited at this time. There are two painted versions, one of 1935 (private collection) and the other from 1937–1938 (Collection Roy Neuberger, New York) (Figure 4). The second was done at a time when Dove incor-

Figure 4
Arthur G. Dove,
American, 1880–1946.
Holbrook's Bridge to Northwest,
1937–1938. Oil on canvas, 25 x 35
inches. Courtesy
Roy R. Neuberger, New York.

porated industrial structures – a power house, tanks, a flour mill – as themes to provide
a built-in structure that would offer a firm pictorial underpinning as an alternative to the
ever-present softness and fluidity of nature that surrounded him and which had dominated
his work. Given a certain similarity in the density of the second version of the painting
and the Ebsworth watercolor, the watercolor may well date from between October–
December 1937 when, as the diaries reveal, Dove was again concentrating on the motif.[16]
The watercolor is certainly a study since it enabled Dove to center on the linear geometry
of the bridge; but the composition and format of the watercolor are substantially different
from the painting, and thus the watercolor is also an independent entity. The vertical
format, as opposed to the lateral disposition of the painting, gives the watercolor a com-
pression missing in either version of the painting. The watercolor is at once taut and
loose, dense and fluid, angular and open, realistic and abstract. The work represents Dove
at his best: intense, direct, filled with confidence, not holding back, not overworking the
painting, simply getting it down directly and spontaneously. His most successful art came
when he worked in this manner; otherwise his paintings often only partially succeeded
and thus his art can often frustrate us. This small watercolor is one of the most revealing –
and satisfying – works in the Ebsworth collection.

 Modernism in the United States received infusions of new blood during the 1920s
from many sources, including a new generation of artists, the most famous of whom was
Stuart Davis, whose art is discussed in more detail in John R. Lane's essay. It is a period
still not well known and little understood. We know almost nothing about many of the

Figure 5
Marcel Duchamp,
American, 1887–1968.
*Nude Descending a Staircase,
No. 2*, 1912. Oil on canvas,
58 x 35 inches. Courtesy
Philadelphia Museum of Art,
Louise and Walter Arensberg
Collection.

artists who emerged during the decade. Morris Kantor (1896–1974) is a foremost example. He is barely mentioned in our histories, yet the paintings such as *Orchestra*, 1923 (cat. 35) which he did in the early part of the decade hold a significant place in the history of Cubism in this country. Through a syntax of flattened and repeated planes, Kantor captures the strong musical rhythms as well as the internal energies of the orchestra itself. The musicians are in constant motion, reflecting the influence of Marcel Duchamp and his famous *Nude Descending a Staircase*, 1912 (Figure 5). Other echoes of Duchamp and his circle – the Puteaux cubists, who included his brothers Jacques Villon and Raymond Duchamp-Villon, as well as Fernand Léger and Albert Gleizes, are apparent in the appropriation and updating of a venerable theme, that of music as an urban entertainment. This can only hint at how deeply Duchamp, who really should be considered an American artist after 1915, made his presence felt at diverse points in American art. His use of non-art objects, for example, could inspire Stuart Davis to use an eggbeater as the motif for a series of paintings of 1927–1928 which were the most accomplished abstract paintings done in this country during the twenties. Kantor's picture at first appears to be a standard Cubist monochrome of somber colors, but closer examination shows a subtle and skillful use of color. He uses hues closely grouped on the color wheel, ranging from light yellow to deep red and brown, carefully alternating them across the surface. The quality of Kantor's pictures raises several insistent questions which still beg for answers. How did these paintings evolve? How many are there? Why were they not continued? Why do we know so little about him? The eloquence of the painting reminds us once more just how

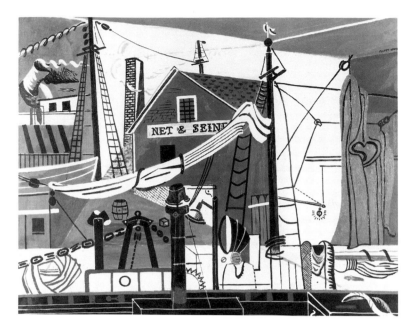

Figure 6
Stuart Davis,
American, 1892–1964.
Landscape with Drying Sails,
1931–1932. Oil on canvas, 32 x 40
inches. Courtesy Columbus
Museum of Art, Howald Fund II.

far we have yet to travel before we have compiled the full history of American art.

Jan Matulka (1890–1972) was another important and sophisticated Cubist of the 1920s about whose art we still need to know more. He provided a vital cultural link between New York and Paris, often traveling abroad after 1923 (it was his studio that Stuart Davis rented during his Paris stay in 1928–1929) and bringing back firsthand experience of what was still the center of world art. His work is clearly related to that of Davis (Figure 6); subsequently, David Smith acknowledged Matulka as a decisive influence in his development. Matulka's planar division in his watercolor *Cityscape* (cat. 47) offers intriguing similarities not only to Bruce's purist still lifes of the same period, but also to contemporary views of the city done by Stuart Davis. Matulka's *At Sea* (cat. 45), done in about 1932, is even more closely related to Davis. The work that each did during this year shows a severe angularity; for Davis, this linear cubism of 1932 decisively shaped the entirety of his subsequent work. Matulka's picture is rigorously conceived, its structure established by a complex series of angles that surely parallels the approach taken by Davis. Yet what precisely is the relationship between the work of these two artists? Can one be said to have been influenced by the other? Or are these concurrent developments worked out individually after years of reciprocal dialogue? We do not yet know. However, we are once more confronted with inescapable evidence that the twenties continue to elude easy characterizations.

Among the major monuments of American Cubism in the 1920s are the geometric still lifes of Patrick Henry Bruce. They should be seen as a logical, if painfully wrought

outgrowth of his earlier color abstractions of 1915–1916. Like many artists whose work had matured prior to World War I, however, Bruce had drawn back from pursuing fully abstract work and its implications. This was not a "retreat" from modernism, as it is often termed. Rather, it was a reshaping of advanced art, in keeping with a new world view that arose from the ashes of World War I. Instead of the simultaneous fusion of multiple elements that characterized the art of Bruce and others prior to 1918, many artists in the twenties sought a new clarity and stability that would be a metaphor for a new way of life to be constructed in the wake of the global disasters of the War. Although the elements of the Bruce still life are "objective," the painting functions by the non-objective interaction of color, space, surface, and pattern as surely as any work conventionally termed "abstract."

These paintings – they date from c. 1917 to c. 1930, with only twenty-five extant – frankly aspire to emulate the qualities inherent to the late, monumental still lifes of Cézanne, the artist who was the most formative influence in Bruce's early career, and who remained his standard of achievement.[17] Bruce, as he had done earlier in other painterly formats, laboriously and patiently built up these still lifes – which he entitled either *Peinture* or *Nature Morte* – part by part, often overpainting areas in order to orchestrate the color harmonies to their most resonant pitch (Figure 7). Bruce worked in series, and often only slight adjustments in format were made. The endless complexities of the patterns formed by the objects on the table offer one visual contradiction after another, preventing us from fully grasping the intricacies of the composition; yet, paradoxically the picture's strength ultimately derives from its extraordinary internal unity of design and color. Bruce also reconciles other apparently antithetical elements. For example, it is a "geometric" painting, but some surfaces are heavily textured, thus uniting the linear and the painterly; the heavy layering of paint is such that these areas become independent units of color, similar in conception and technique to Stuart Davis's methods of paint application in his Paris pictures of 1928–1929. (No evidence has been found, but one cannot help but wonder if the two had met or, at the least, if Davis knew Bruce's work.)

Bruce left some areas open and apparently "unfinished," but we know that he, like Cézanne, in fact did consider such works fully complete. These open areas, often further defined by beautiful flowing pencil drawing, act as contrasts to the alternating textured and matte surfaces. Bruce succeeds in encompassing virtually every kind of texture, surface, and finish within the supposedly mechanistic and dry facture of the purist type of picture. He takes relatively few hues – red, blue, green – and gradates them at close intervals (there are at least six variants of red) thus creating the illusion of a far more extensive palette; in addition, black, white, and gray are included as coeval colors.

These paintings were formerly viewed as consisting of totally invented shapes. On the contrary, Bruce painted what was around him, and each element was based on objects that were an intimate part of his daily life. Living in Paris, where he had moved by 1904 (he returned only in 1936, just prior to his suicide in New York), Bruce became increasingly withdrawn and isolated. He had once painted the sights and sounds of pre-War Paris as a recognizable member of the avant-garde, but after 1917 Bruce depicted only

Figure 7
Patrick Henry Bruce,
American, 1881–1936.
Peinture or *Nature Morte*
(*Forms on a Table*), c. 1924.
Oil on canvas, 28¾ x 36¼
inches. Courtesy Addison
Gallery of American Art,
Phillips Academy, Andover,
Massachusetts.

his immediate surroundings in the pristine studio apartment he occupied for many years at 6, rue Furstenberg. On a solitary and drastically tilted table (of which we have photographs) set against the summary forms of the room's architecture, Bruce placed forms that are distillations of the objects he handled constantly. The cylinders are vases and pitchers, the sphere an orange (fruit was a major portion of his diet), and a round of cheese with a wedge cut out, at center. Other shapes are pieces of woodworking and furniture, emblematic of the living he made as a buyer and seller of antiques. Thus, what may seem an "intellectual" picture is rather an intimate diary of an unhappy and tragic artist who, despite all, added significantly to the world's painting culture.

If Hartley's abstractions of 1913–1915 celebrated the dynamism of the modern city, then the painting of Edward Hopper (1882–1967) stands at another pole in the depiction of urban life. American art, dating to the nineteenth century, has often been characterized by a pervasive quietude and stillness. Hopper's paintings often continue this tradition and even more frequently they are filled with a pervasive sense of alienation, isolation, quiet despair, melancholy, and boredom induced by the condition of life in the modern urban city. In the Ebsworth *Chop Suey*, 1929, (cat. 33) we are witness to a scene of ostensible leisure, but in this sparsely peopled restaurant there is no hint of nor concession to comfort or pleasure, either in the stark furniture and decor, or in the total absence of food on the bare tables that would warm a cold winter's day, the season indicated by the heavy coat hanging on the wall. The diners sit passively, their eyes either downcast or averting their companion; by contrast, we might compare the more active scene of

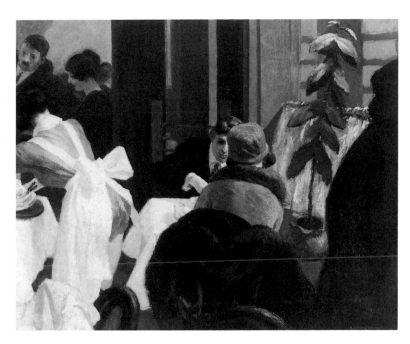

Figure 8
Edward Hopper,
American, 1882–1967.
New York Restaurant, 1922. Oil
on canvas, 24 x 30 inches.
Courtesy the Muskegon Museum
of Art, Muskegon, Michigan.

Hopper's 1922 *New York Restaurant* in the collection of the Muskegon Museum of Art
(Figure 8). The people are diminished, even trapped, by the looming neon sign and the
fire escape ladder. They are isolated by the unrelenting spotlight created by the harsh
rays of sun, which contrast with the artificial light sources of the sign and the lamps, now
off, rendered passive and inert, as are the patrons.

The mood of Hopper's pictures has been, of course, much discussed. But what can be
said of Hopper as a painter? How is this mood actually conveyed, if at all, by his painterly
means? For one thing, we may say, the pervasive feeling of stasis is captured and framed
in a state of acute tension by the strict geometry of the picture, a geometry as carefully
constructed in its way as the still lifes of Patrick Henry Bruce, Hopper's old friend and
classmate in the early years of the century. The crossing patterns of light seen through
the window at left, for example, become virtual architectural elements establishing the
rear plane, as do the tilted beams at the rear of the Bruce painting. In the Hopper, they
form the point of a long, piercing triangle of light that moves diagonally from right to left
and animates the surface. Hopper builds the interior space by an elaborate sequence of
rectangles formed by the windows and tables, a linear severity punctuated only by the
roundness of the women's heads and the few curves of the chairs and solitary dishes on
the tables. The geometry is disguised by the gently brushed, unobtrusive paint surfaces
that are in the tradition of the neutral, plain style of Eakins, even recalling Rembrandt,
two artists whom Hopper venerated. Hopper also parallels Bruce, because these paintings
were achieved only with long, painful, and laborious effort. But without these methods of

pictorial structure and paint handling, Hopper's art would not engage us with the intensity that it does.

Hopper's rural scenes portray another kind of isolation: not the sense of people trapped, but rather that transitory sense of a fleeting, elusive moment in an anonymous location, in which there is no contact with either people or place. An open road, as in the 1940 *Gas Station* (The Museum of Modern Art, New York), or a railroad track, as in *House by the Railroad*, 1925 (The Museum of Modern Art, New York) and in the Ebsworth watercolor *Cottages at North Truro, Massachusetts*, 1938 (cat. 34), were devices Hopper used. The track moves laterally across the picture, taking us almost aimlessly through a landscape apparently occupied only by deserted summer cottages, emblematic of the lack of rootedness and a feeling of spiritual emptiness in American life.

There is a similar stillness, through which we also move by means of a railroad track, in Charles Sheeler's famous painting of 1931 now in the Ebsworth collection, *Classic Landscape* (cat. 61). Yet the mood and feel of Sheeler's painting could not be a greater contrast. *Classic Landscape*, as well as his *American Landscape* from just a year earlier (Figure 9), places us squarely in a vision of utopian optimism. Indeed, there is no doubting the direction or purpose of the railroad track – it takes us directly into a future in which America's industrial might is seen as the promising embodiment of a new and better life. It is an innocent view, this pure landscape by Sheeler, as opposed to the grim reality we know actually to have existed then and now. Inspired by his photographs of the River Rouge Ford plant taken in 1927, the painting transforms the sharp black and white contrasts of photography into a scene bathed in a soft, golden light, invoking nothing less than a pastoral vision of a new America. We are, in fact, transported literally and metaphorically from the dark shadows at the left, symbolic of the past, along the track and into the clear light of the future. This future is marked by the attainment of a classical ideal of perfection, embodied here in the pristine clarity of the storage elevators and buildings. In the passage from old to new, from past to future, a journey celebrating the advent of modern technology, this seemingly most American of paintings in fact invokes ideas developed by the Puteaux cubists in Paris from 1910–1914, especially in the work of Raymond Duchamp-Villon. Sheeler was a friend and associate of Marcel Duchamp, whom he had met in New York at the salon of Walter and Louise Arensberg in 1917. There Sheeler would have heard at first hand of the ideas of the Puteaux group. These artists were deeply concerned with and celebrated the changes wrought by the new age.[18] In their work they often depicted the transformation of nineteenth-century motifs into images of twentieth-century technology. In Duchamp-Villon's *Horse*, 1914 (The Museum of Modern Art, New York), for example, the artist showed the horse (thus as an image of the old horse power) as it underwent a metamorphosis into a modern machine, embodying the change from the old to a new image and source of horsepower. Duchamp-Villon wrote of how the engineering miracle of the Eiffel Tower was the modern equivalent of the Cathedral of Notre Dame.[19] Sheeler also saw something religious in the industrial scene. Indeed, the towering smokestack of Sheeler's *Classic Landscape* similarly invokes the modern industrial equivalent of a church spire that would have dominated an older landscape of pastoral nineteenth-century America.

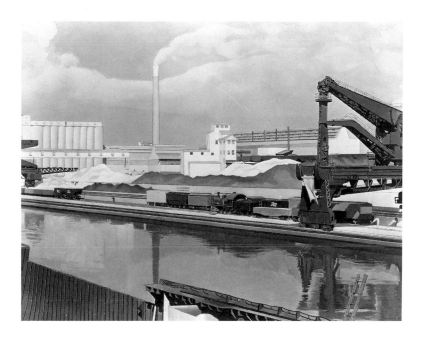

Figure 9
Charles Sheeler,
American, 1883–1965.
American Landscape, 1930.
Oil on canvas, 24 x 31 inches.
Courtesy The Museum of
Modern Art, New York,
Gift of Abby Aldrich Rockefeller.

The only stillness found in John Marin's late oil painting of 1941, *My Hell Raising Sea* (cat. 43) is at the distant horizon. Otherwise it is a picture in constant and turbulent motion, the sea dashing against the rocky shore of the Maine coast. Marin's handling of paint is nothing less than masterful. The richness and the expressiveness of this work are such that it yields seemingly endless pictorial surprises of color and touch. It is an infinitely rewarding picture, proving that Marin's staying powers in the 1940s were equalled only by Marsden Hartley and at points by Arthur Dove. That Marin's oils often surpass his watercolors and may well be his greatest accomplishment is by now not a novel opinion, but the weight and authority of this picture give the judgment renewed merit. It is the kind of painting that could prompt Clement Greenberg to write in 1948, "If it is not beyond doubt that Marin is the greatest living American painter, he certainly has to be taken into consideration when we ask who is."[20] In one sense, these oils culminate an earlier phase of American modernism, that phase of deeply-rooted love of nature that produced a moving and lyrical painterly art. They should not only be seen as the end of something, however, but as looking forward, paralleling the accomplishments of the then emerging New York School of painters; Marin's art is that strong, genuine, and original. Even today the lyricism of nature can inspire the best new art. It is but one more indication that American modernism of 1910 to 1945 is part of an ongoing tradition, one whose full dimensions have yet to be defined.

Notes

1. Letter, August, 1910 (day uncertain); copy in collection of the author.

2. *Ibid.*

3. The Cézanne is *Apples*, c. 1873–1877. Collection The Museum of Modern Art, New York.

4. Copy of the letter is in the author's possession.

5. Letter to Grace Mott Johnson, October, 1913 (day uncertain), quoted in Van Deren Coke, *Andrew Dasburg* (Albuquerque: University of New Mexico Press, 1979), p. 26.

6. Letter to Grace Mott Johnson, April 24, 1910, quoted *Ibid.*, p. 16.

7. Letter, Rainer Marie Rilke to Clara Rilke, October 13, 1907. Reprinted in Judith Wechsler, ed. *Cézanne in Perspective* (Englewood Cliffs, N.J.: Prentice-Hall, 1975), p. 67.

8. See William C. Agee, *Synchromism and Color Principles in American Painting, 1910–1930* (New York: M. Knoedler and Co., Inc., 1965), p. 16.

9. *Ibid.*

10. As quoted by O'Keeffe in *Georgia O'Keeffe* (New York: The Viking Press, 1976), no pagination.

11. Letter, Arthur Dove to Alfred Stieglitz, June 10, 1925, Collection of American Literature, The Beinecke Rare Book and Manuscript Library, Yale University.

12. See, for example, Roxana Barry, "Foreword," in Ann Lee Morgan, *Arthur Dove: Life and Work, with a Catalogue Raisonné* (Newark: University of Delaware Press, 1984), no pagination.

13. See the entries for October, 1924, for example. The diaries are in the Archives of American Art, Smithsonian Institution, Washington, and New York. Microfilm roll N70–52, frames 41–45.

14. Diary, August 13, 1929. Microfilm roll N70–52, frame 525.

15. *Ibid.*

16. Microfilm roll 39, frames 609 forward.

17. See William C. Agee, "The Recovery of a Forgotten Master," in William C. Agee and Barbara Rose, *Patrick Henry Bruce: American Modernist* (New York: The Museum of Modern Art and The Museum of Fine Arts, Houston, 1979), pp. 13–41.

18. See George Heard Hamilton and William C. Agee, *Raymond Duchamp-Villon* (New York: Walker and Company, 1967), pp. 89–103.

19. Raymond Duchamp-Villon, "L'architecture et le fer," *Poeme et Drame*, VIII (January-March, 1914), pp. 22–29. Reprinted and translated *Ibid.*, pp. 114–118.

20. Clement Greenberg, "John Marin," (1948), reprinted in *Art and Culture* (Boston: Beacon Press, 1961), p. 181.

John R. Lane

American Abstract Art of the Thirties

In the teens there emerged in the United States a pioneering generation of abstract artists whose work explored the possibilities of European modernism within an American context. Just how high the artistic achievement of this first generation of American abstractionists could be is vividly demonstrated by works in the Ebsworth Collection such as Georgia O'Keeffe's *Music – Pink and Blue I*, 1919 (cat. 53), and Marsden Hartley's *Painting No. 49, Berlin*, 1914–15 (cat. 31). However, following the First World War there was a wholesale retreat from these adventurous abstract enterprises and a return to more formally conventional presentations of recognizable imagery. For a period of nearly ten years virtually no abstract art was made in America. The painter Patrick Henry Bruce and the sculptor John Storrs, both particularly well represented by works of the 1920s in the Ebsworth collection – respectively, *Peinture/Nature Morte (Forms No. 5)*, c. 1924 (cat. 8), and *Study in Architectural Forms*, c. 1923 (cat. 69) – are conspicuous exceptions to this assertion, but it must be noted that these two American artists were living and working in Paris. In the late twenties a second generation of American abstractionists emerged to create a discernible movement, one whose beginning is marked in 1927 by the revitalizing forces of Stuart Davis's "Eggbeater" series (Figure 1) and the opening of A.E. Gallatin's Museum of Living Art at New York University. The period's end was heralded by the death in New York in 1944 of the great Dutch abstractionist Piet Mondrian, whose late style was strikingly influenced by his American experience, and, following the Second World War, the emergence of a third generation of American modernists, the Abstract Expressionists.

Judged by its own ambitions and by virtually every objective standard of its time, the second generation abstract movement of the thirties was a failure. The artists scarcely sold any work. Of the two major museum exhibitions of the decade, The Whitney Museum of American Art's *Abstract Painting in America* in 1935 really was not very abstract and, in any case, was largely populated by the works of the pioneering generation of American modernists. In 1936, The Museum of Modern Art was frank about saying it had excluded Americans from its landmark show, *Cubism and Abstract Art*, with the single exception of the Paris-based sculptor Alexander Calder, on grounds of insufficient artistic achievement.

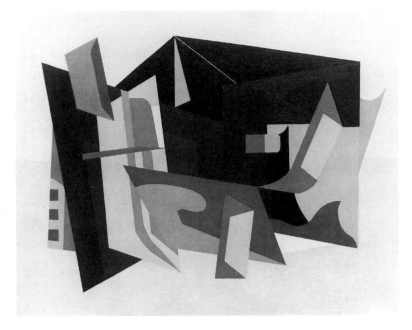

The work was largely dependent – some critics thought fatally so – on the artistic innovations of the European avant-garde for its forms, and there were often substantial lags between when European pictorial ideas were invented and the time they made their appearance in the work of American artists. During this period a great many members of the artistic community held leftist political convictions and were committed to the idea that art and artists could and should play a significant, vanguard role in the struggle for social change. But abstract art – whether as a reflection of progressive modern technology or as a model for harmonious social structures – was not popularly embraced; neither is there evidence that avant-garde art had any influence on the opinion leaders and decision makers who shaped the era. And, finally, the work of the abstractionists was largely ignored by critics and public of the time alike, and on those occasions when it received attention, it was, with a few exceptions, either dismissed or condemned.

Why then do we with interest look at and study the record of the abstract art of the thirties? One reason is that, in retrospect, the movement seems to have considerable historical relevance to the development of the much more significant chapter in American art that immediately follows. Abstract modernism was a dissenting voice very much at odds with the isolationist character of mainstream American culture in the thirties, and those abstract artists who remained committed to the international modernist movement kept a bridge open, providing continuous access to the most sophisticated art ideas of Europe, particularly in Paris – where leadership in the visual arts of Western civilization resided – and making a crucial link with the directions American culture would take in

the forties. A second reason is that much of the work is surprisingly ambitious, visually appealing, and, occasionally, resonant with poetic feelings and high ideals.

Styles of Abstraction

The American abstract artists of the thirties worked primarily within the cubist and geometric abstractionist traditions and looked to European art of the teens and twenties for inspiration, especially the late Cubism of Picasso and Léger, Mondrian's Neo-Plasticism, Russian and Bauhaus Constructivism, and the biomorphic Surrealism of Miró and Arp. The artists approached abstraction in two ways, abstracting from forms in nature, or making abstract compositions that were strictly their own inventions. The former was the practice of artists who were influenced by the cubists, particularly Picasso, while the latter – known as pure or non-objective artists – arose from Mondrian's Neo-Plasticism or the European Constructivism of Malevich, Moholy-Nagy, and Kandinsky. Those who practiced abstraction from nature were dominant in the early thirties; the non-objective artists began to prevail by the late thirties and were definitely in command by the early forties.

Subject Matter in Abstraction

In the late twenties and early thirties the most controversial issue in the American art world was the incorporation of the American scene as most artists, including a number of the abstractionists, endeavored to deal with nativist themes. But by the mid-1930s another issue had emerged, raising difficult questions about the role of art in a period of economic and social crisis. These questions presented especially acute problems for the abstractionists because the marriage of socialist humanism and the formalism inherent to modernist art was not an obvious one. The truth is that, while they were sincere, the elaborate arguments for the social utility of abstract art were tortuous. The art did not have a significant impact on social or political conditions because the ideas were not expressed in a way that either leaders in the political arena or the aristically unsophisticated masses could understand. (There is a precedent, but no solace, for the American abstractionists' dilemmas and disappointments: in post-revolutionary Russia, by the late twenties, the same official opinion that had initially embraced the most advanced abstract art turned against modernism, banning it and making Soviet Realism the official art of the Stalinist state.) By around 1940 most modernist artists' faith in the ideals of peace and social progress had been shattered by disillusioning events involving the political behavior of the Soviet Union. The American artistic avant-garde refocused itself on formal concerns, and the chief issue changed from the public quest for an art of social utility to the private search for a post-cubist visual vocabulary.

Abstractionist Art Theory

It seems a contradiction to say that abstract art is "realist," but this is exactly what many of the abstract artists of the thirties would have said about their work. Modernism, the broadly encompassing name for the era that begins in the second half of the nineteenth century, has as one of its chief characteristics the formalist aesthetic principle that art should seek to reduce itself to its essential elements. Abstract artists in particular did not feel a need to justify the existence of their art by making imitative reference to subjects in the natural world; instead, they took the position that their primary subject was the created object itself and the main reason to look at it was to appreciate its formal quality. This emphasis on the object itself and not what it represents is the logical extension of the materialistic implications of modernist art theory. One interesting characteristic of the abstract art made in the United States was the impact American culture had on much of that art, whether by incorporating images of the American scene, or more subtly by reinforcing the objective and materialistic sides of modernist art rather than its spiritual and utopian aspects. As eager as American abstract artists of the thirties were to accept the formal innovations of European art, they were inclined to discount the theory that frequently accompanied it. The rich holdings of the Ebsworth collection make it an excellent resource to reflect on how some of these ideas relate to actual works of art.

Artists Abstracting from Nature: the Cubists

Jan Matulka (1890–1972) immigrated as a young man to the United States from his native Bohemia in 1907, settled in New York, and took his formal art training at the conservative National Academy of Design from 1908 until 1917 and at the Art Students League in 1924–1925. He joined the modern movement in America before 1920 and his frequent trips abroad made him one of the best informed artists in New York about avant-garde European art. By virtue of his own artistic accomplishments and his inspirational efforts as a teacher at the League between 1929 and 1931, he was for a time a central and influential figure in the second generation of American abstractionists in the 1930s.

Just at the moment he was teaching so effectively at the Art Students League, his friendships with those other leading modernists on the New York scene – Stuart Davis, Arshile Gorky, and John Graham – were warmest and his own art most vital. *At Sea*, c. 1932 (cat. 45) in the Ebsworth collection belongs to this especially creative period in the artist's career and it reflects the cubist structural principles that were the foundation of Matulka's work. While Picasso's art from the late twenties most strongly influenced Matulka and the close circle of modernists to which he belonged, it is Davis's invention of a distinctly American brand of vernacular Cubism that informs the style and content of this nautical scene (Figure 2). The synthesis of European modernist style and American-scene subject matter attempted in the Matulka is emblematic of one of American art's most notable successes of the thirties, found most felicitously in the Davis paintings.

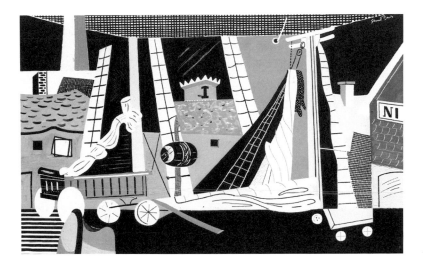

Figure 2
Stuart Davis,
American, 1892–1964.
The Red Cart, 1932. Oil on
canvas, 32 x 50 inches. Courtesy
Addison Gallery of American Art,
Phillips Academy, Andover,
Massachusetts.

Around 1930, Matulka's most successful paintings were still lifes and, despite a horizon line where sea meets sky, *At Sea* fits more readily within that genre than it does with traditions of marine painting. Its flattened, abstracted, and reproportioned nautical motifs, including a sailor, are recombined and laid out as a composition on a ship's deck that is tilted up towards the picture plane like a cubist table top. The artist summered at the New England shore and, no doubt in response to the popularity of the regionalist impulse in American art, Matulka's several paintings of nautical subjects of the early '30s, like Davis's Gloucester pictures, have a feeling for the locale's vigorous maritime life under bright blue northern Atlantic skies.

David Smith (1906–1965) was the most notable of the several younger artists of major consequence to study with Matulka. Smith's early development provides an excellent example of the important role the second generation of American abstractionists played in forming the careers of the third (or Abstract Expressionist) generation. In 1926 Smith enrolled at the Art Students League where eventually Matulka became his teacher. Here Smith also became friends with the sophisticated Russian emigré artist, John Graham, probably the best informed person in America on the subject of avant-garde European art. Through Graham, Smith and his wife, the artist Dorothy Dehner, met Stuart Davis, Arshile Gorky, and Willem de Kooning, and joined the small, informal group of American abstract artists familiar with the most recent developments in Paris.

Although David Smith is rightly considered one of the great sculptors of the twentieth century, he began his artistic career as a painter, and throughout his life continued to

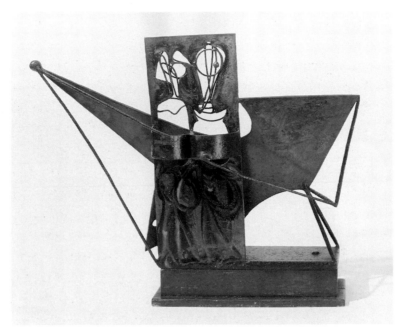

Figure 3
David Smith,
American, 1906–1965.
Billiard Player Construction,
1937. Iron and encaustic;
17¼ x 20½ x 6⅜ inches.
Courtesy Dr. and Mrs. Arthur E.
Kahn, New York.

paint and draw. *Untitled,* c. 1936 (cat. 64) is one of Smith's largest and most important paintings. It precedes the 1937 welded iron sculpture called *Billiard Player Construction* (Figure 3) and deals with the same subject, a personal enthusiasm of the artist. The painting contains the flattened, abstracted forms of two players – the one on the left standing and watching the one on the right prepare to make a shot – inhabiting an interior space of shallow perspective. The cubist vocabulary is taken unabashedly from paintings in Picasso's late twenties style, like *Painter and Model* (The Museum of Modern Art, New York). While there is a great deal to admire in Smith's painting, the artistic originality of the related sculpture transcends its two-dimensional counterpart, creatively contributing to the development of modern art and confirming the wisdom of the Paris-based American geometric abstractionist Jean Xceron's exhortation to Smith in 1935 that he dedicate himself to sculpture. Xceron himself is represented in the Ebsworth collection by a work of extraordinary quality, *Composition 239A,* 1937 (cat. 74).

While many American abstractionists were determinedly bohemian in their life styles and professionally self-conscious about their roles as artists, dedicated and gifted members of the elite made enduring contributions to American art as collectors, museum curators and directors, gallery owners, critics, art historians, and artists during the thirties. An instance of this is Suzy Frelinghuysen, born in 1912, a member of a prominent New Jersey family. She did not have formal art training, but from her youth pursued on her own an interest in drawing and painting. In 1935 she married the abstract painter, collector, and critic George L. K. Morris and, inspired by his own painting and his enthu-

siasm for Picasso, Braque, Gris, and Léger, she began to work for the first time in an abstract cubist style. However, unlike her husband, who was deeply involved in the New York and European art worlds, Frelinghuysen's interests were personal and intuitive, not public and theoretical, and she was the least visible of the group of wealthy and culturally sophisticated artist friends, called by some the "Park Avenue Cubists," that included Morris, A.E. Gallatin, and Charles Shaw.

Frelinghuysen's abstract manner was most informed by Juan Gris's lucid synthetic Cubism of the late teens and twenties and by the post-First World War work of Georges Braque. Her oil and collage paintings of the forties are her finest work, and the poetic *Composition*, 1943 (cat. 25) is arguably the most masterful of this group. It shares with the paintings of Gris a cool elegance of color and a strong sense of composition, but differs from his work in the richness of surface she achieved by contrasting feathery brush-strokes of blue, pink, and gray with the crispness of corregated paper collage elements. *Composition* is abstracted from the human shape. Frelinghuysen subscribed to the Parisian cubist idea that an artist should abstract from nature rather than invent new forms not ultimately based on objects inhabiting the natural world. Her work comes very late in the history of synthetic cubism, is a bit precious, and has little importance for the development of abstract art. Frelinghuysen's poetic command of the cubist visual vocabulary is noteworthy nevertheless, both aesthetically and as an indication of the level of cultivation that artists who sought to be part of the European tradition of modern art could achieve.

Non-objective Artists: The Constructivists

Ilya Bolotowsky (1907–1981) arrived in New York in 1923, having left his native St. Petersburg in the wake of the Russian Revolution. His artistic training was entirely American, taken at the National Academy of Design between 1924 and 1930. As Bolotowsky sought to find his individual voice in the 1930s, his work took its inspiration from a broad range of contemporary manners, including Constructivism, de Stijl, and biomorphic Surrealism. Kasimir Malevich, Piet Mondrian, and Joan Miró each provided the young artist with visual ideas he worked to develop, not infrequently all in the same painting.

By 1940 Bolotowsky had eliminated the anthropomorphic Surrealist elements from his paintings and, surely inspired by the example of that recent emigré to New York, Piet Mondrian, distilled his art into pure geometric abstraction. *Blue Diamond*, 1940–41 (cat. 5), is perhaps the finest of the artist's work from the early forties. The diagonal tilt to *Blue Diamond*'s geometry and its rich array of colors are personal characteristics typical of Bolotowsky's art, formal devices quite at odds with Mondrian's rigorous structures about right angles and primary colors. Torsion and illusionary space are created from the organization of various geometric shapes – triangles, a square, rectangles, parallelograms, trapezoids, and miscellaneous polygons – and planes of color – primaries, secondaries, and tertiaries – into a dynamic composition of potentially unstable elements that wants to rotate clockwise and to spiral backward into a vortex but is held in precarious balance by

Figure 4
Museum of Non-Objective
Painting as it was installed in
1945.

the one counterclockwise element, the blue polygon in the center of the painting. Never an artist to take too seriously the tendency in the thirties to become involved in politics, the polemics of art theory, or the use of art to convey narrative content or symbolic ideas, Bolotowsky was a committed formalist dedicated to an abstract art that was non-objective: his art did not derive its forms from nature but was instead the exclusive product of the artist's invention.

Rolph Scarlett's (b. Canada, 1889–1984) artistic career is intertwined with the early history of what is now The Solomon R. Guggenheim Museum. About 1934, without formal training, Scarlett made himself known as a Non-objective painter to the German-born aristocrat Hilla Rebay, curator of Solomon Guggenheim's collection and the founding director of "Art of Tomorrow, the Museum of Non-objective Painting," the original name of the Guggenheim when it opened in New York in 1939 (Figure 4). Based on her knowledge of Kandinsky's theories in *Concerning the Spiritual in Art* (1912) and her study of Theosophy and Eastern religions, Rebay held very strong and controversial views, believing, as her biographer Joan M. Lukach has written, that "art was the expression of man's spiritual nature, and a truly creative artist did not repeat forms already existing; however, with the guidance of a higher power (which she at times specifically named 'God'), one could create new forms united by a rhythm expressing cosmic forces."[1] She felt that Scarlett was her special discovery and in 1939 she introduced him to the man who would become his mentor, Rudolph Bauer, a German painter who, along with Kandinsky, Rebay believed to be foremost among Non-objective artists; she awarded Scarlett a Gug-

genheim Scholarship in 1938 and in 1939 hired him as the museum's weekend lecturer, a position that lasted eight years, and made him one of the chief spokesmen for Rebay's theories. Over the years she persuaded Guggenheim to buy nearly one hundred of Scarlett's paintings.

In Kandinsky's geometric style (as practiced by Bauer) Scarlett found the manner he wished to pursue. "Here," he told Harriet Tannin, "one deals with a few geometrical elements and the problem is to create an organization that is alive as to color, and form, with challenging and stimulating rhythms, making full use of one's emotional and intuitive creative programming and keeping it under cerebral control, so that when it is finished it is a visual experience that is alive with a mysticism, inner order, and intrigue, and has grown into a world of art governed by esthetic authority."[2]

Scarlett did not date his paintings and no chronology has been established for his work. While *Untitled* (cat. 57) looks like Kandinsky's and Bauer's geometric abstractions of the thirties, it was probably painted in the early forties, and it has a vitality and character of its very own. This distinct lyric personality may be found in geometric forms of poetic delicacy that, carefully balanced and, depending on their coloration – receding or advancing – float in a dreamy gray pictorial space of indeterminate dimension, creating a geometric abstractionist's vision of a constructivist rainbow in a cloudy, romantic sky. In works like *Untitled*, Scarlett achieved his personal artistic goals through priorities quite different from Rebay's and which, for the welfare of his relationship with her, he must have gone to considerable pains to keep from disclosing. He said only recently, "Rebay had a very emotional temperment and fancied herself a spiritualist. She would look into Bauer's work or Kandinsky's work and find something spiritualistic that could be read into it. Kandinsky did that too. It was a mistake. The main thing is not spiritualism or metaphysical phenomena. It's esthetics, order, form, color and rhythm."[3] Scarlett's revelation is a very interesting one since it reinforces the more general notion that American abstract artists of the thirties were eager to accept the formal innovations of European art but were inclined to discount the theoretical baggage, especially associated with the utopian and spiritualist art of Kandinsky's Bauhaus and Paris periods.

Assessing The Thirties Abstract Movement After Fifty Years

The exhibition, *Abstract Painting and Sculpture in America 1927–1944* (to which the Ebsworth collection was one of the most generous lenders, sending works by Bolotowsky, Browne, Frelinghuysen, Slobodkina, Storrs, and Xceron), was organized in 1983 by The Carnegie Museum of Art with the intention of presenting a specialized art history of the thirties, establishing a hierarchy of artists based on individual accomplishment, and developing a corpus of exceptional works of art that could be considered representative of the best achievements of their kind in the period (Figure 5). The documentation and interpretation were generally accepted by the critics, as were (with a few exceptions) the choices of artists and works. Considerable disagreement did emerge, however, on the key

Figure 5
Entrance view of the exhibition, *Abstract Painting and Sculpture in America 1927–1944*, installed at the Minneapolis Institute of Arts. A facsimile of the Ebsworth collection painting *Composition 239A* by Jean Xceron framed the entrance. Courtesy The Carnegie Museum of Art.

issue of what was, in the final analysis, the real level of achievement of the American abstractionists from the thirties.

On the one hand, a number of observers expressed varying degrees of approbation for the general accomplishment. John Ashbery commented, "Davis, Gorky, de Kooning and Graham are the undisputed stars of the event. Most of the rest is defiantly derivative, though it now has a quaint art-deco charm that would have horrified its stern-principled makers. . . . Yet they were pioneers who laid the groundwork for abstract expressionism and later American developments. For that, and for the freshness and loveliness of much of their work, they deserve this belated celebration."[4] Grace Glueck remarked that the "abstraction of the 30's was a lively, complex and important chapter in American art history that really set the stage for later events."[5] Peter Frank said that the work made a "distinctive, eloquent statement, not just period pieces. . . . there is barely a single picture or object in this show that looks dated or that seems devoid of intellectual or spiritual resonance," and he added that it was "honest and often beautiful work, unpreoccupied as it is by any frantic search for sheer originality. Originality, we see here, is not the sole, and perhaps not even the most, important justification for new art; true aesthetic profundity results from developing concepts, not just from generating them."[6]

On the other hand, several critics presented carefully considered disparaging views. In what was the most thoughtful piece engendered by the exhibition, the late Thomas Albright wrote, " . . . there is little about the abstract painting and sculpture exemplified by this show that is thrilling or inspiring – that does not, in fact, seem to have entered into the anonymous, gray alluvium that is the history of taste."[7] (He made exceptions for Gorky, de Kooning, Reinhardt, and Smith.) He continued, "Its modernism, to repeat a phrase that seems inescapable when discussing the 'advanced' art of this period, had grown quaint." He singled out Davis in particular, calling his work "Cubopicturesque;" David Carrier concurred, expressing the view that Davis was "always minor," and generally sharing Albright's serious reservations about the accomplishments of the period.[8] Albright complained that "virtually nothing about it was new," and "what one misses in most of this work is this sense of urgency, or 'inner necessity,' itself, the presence of some meaning which, however remote or impenetrable it may be to us, was compelling enough to the artist to make his work something more than trial-and-error experimentation, the solution of art problems." In naming his chief concerns he said, "Perhaps the most agonizing of these is how pursuits that were clearly of paramount importance to serious, intelligent artists only a couple of generations ago can so often seem devoid of purpose now."[9]

These critical assessments have helped me to refine my own conclusions about the period in the several years since Susan C. Larsen and I curated *Abstract Painting and Sculpture in America 1927–1944*. While I had very high esteem for a number of the artists whose work was going to be in the exhibition, I was unsure about just how well the show as a whole would cohere and concerned that problems might result from both the variety of abstract styles represented and the range in quality of the artists whose work was included. Recalling that I saw the exhibition practically every day for a period of two months, one of my principal impressions remains just how handsome the ensemble of

works seemed to be and how, through the combined strength of the individual objects, this ensemble exuded vitality and refused to be reduced to a "quaint" presentation of period design. What was really elevating about repeated visits to the exhibition, however, was how the paintings of Stuart Davis and Arshile Gorky, the paintings and reliefs of Burgoyne Diller, the reliefs of Charles Biederman and Gertrude Greene, and the sculptures of Alexander Calder, David Smith, and Theodore Roszak, all continued to reward repeated examination, as the work of a few of the artists definitely did not.

Perhaps the best way to sum up my feelings about the modernist enterprise of the thirties is to say that I sense a thinness to it; not only is it seldom that an American abstractionist plunged into the deepest currents of Western culture (or indeed, American culture), but even the number of fully resolved works by the very best artists is limited. Acknowledging that the accomplishments of the American abstractionists of the thirties are not generally characterized by a high sense of originality and that the abstract members of this second generation of American artists did not carry American art beyond its state of provincial dependence on the achievements of European modernism, it is nevertheless important to keep in mind what they did do. They maintained the tradition of twentieth-century modernist art in the United States during an era that was overwhelmingly anti-modernist in its bias; they gave rise to a complex and lively abstract movement that produced some of the finest American painters and sculptors of the time, nurturing many younger talents who would become leaders in the next generation of abstract artists; and they created in New York conditions that helped set the stage for the city to emerge in the post-War era as the world center for the new international modernist style of Abstract Expressionism. I would maintain that these are accomplishments of distinction by any measure but that they have, perhaps understandably, been neglected in the face of our enthusiasm for the romantically individualized American abstractionists of the first generation before them and by the heroic third generation of New York School Abstract Expressionists who came after them. Friends of American art like Barney Ebsworth – with a fresh vision for quality, independent ideas, and the courage of their convictions – are required to redress this imbalance in our attention to and appreciation of the contributions of the artists of the thirties to the American abstract tradition.

Notes

1. Joan M. Lukach, "Rolph Scarlett," in Museum of Art, Carnegie Institute, *Abstract Painting and Sculpture in America 1927–1944* (exh. cat.), John R. Lane and Susan C. Larsen, eds., p. 215.

2. "Memoirs of Rolph Scarlett as told to Harriet Tannin," unpublished typescript © 1982 by H. Tannin, Kingston, New York, p. 78.

3. Ibid., p. 56.

4. John Ashbery, "Our Forgotten Masters," *Newsweek*, July 30, 1984.

5. Grace Glueck, "At Whitney, Abstractionism's Lost Years," *The New York Times*, July 6, 1984.

6. Peter Frank, "American Abstract Artists Make A Concrete Impression," *Diversion Vacation Planner*, July/August 1984.

7. Thomas Albright, "Abstracts of the Depression," *San Francisco Chronicle*, March 4, 1984.

8. David Carrier, "American Apprentices: Thirties Abstraction," *Art in America*, February 1984.

9. Thomas Albright, op. cit.

Plates

1.

Ault, George

1891–1948

Fruit Bowl on Red Oilcloth, 1930

Oil on canvas

24¼ x 20 inches (62.2 x 50.8 cm.)

Signed and dated lower left corner:

G.C. Ault '30

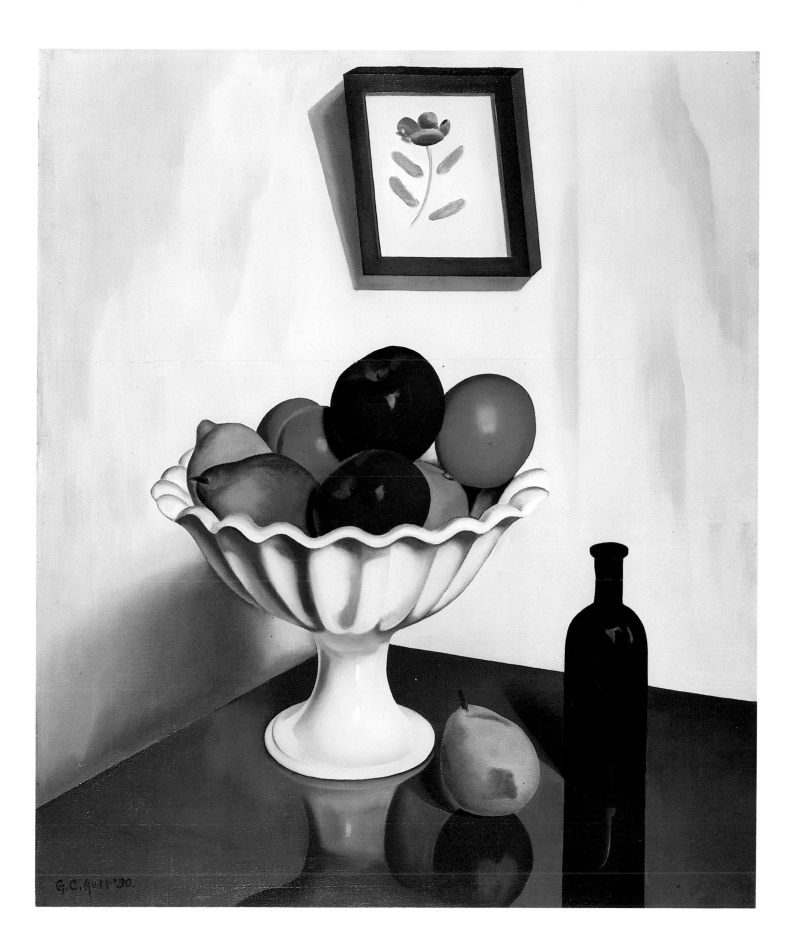

2.

Ault, George

1891–1948

Pile Driver, 1929

Oil on canvas

11 x 14 inches (27.9 x 35.5 cm.)

Signed lower right:

G.C. Ault '29

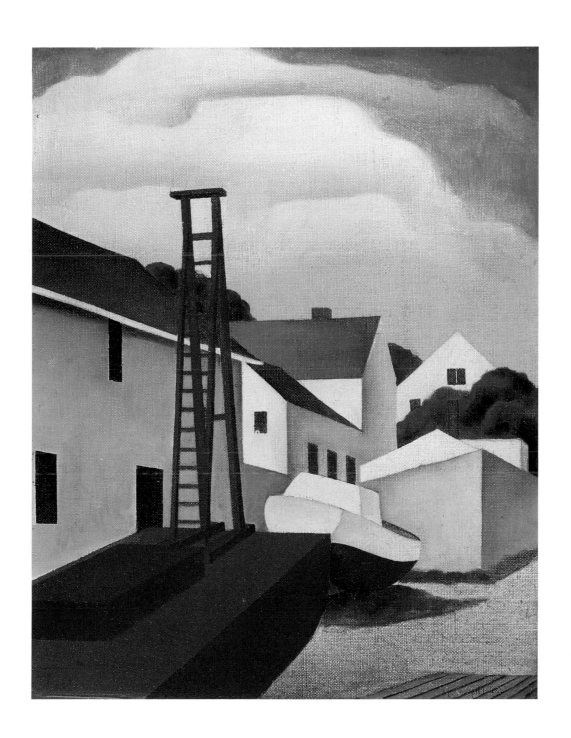

3.

Ault, George

1891–1948

Universal Symphony, 1947

Oil on canvas

30 x 24 inches (76.2 x 60.9 cm.)

Signed lower left:

G. C. Ault '47

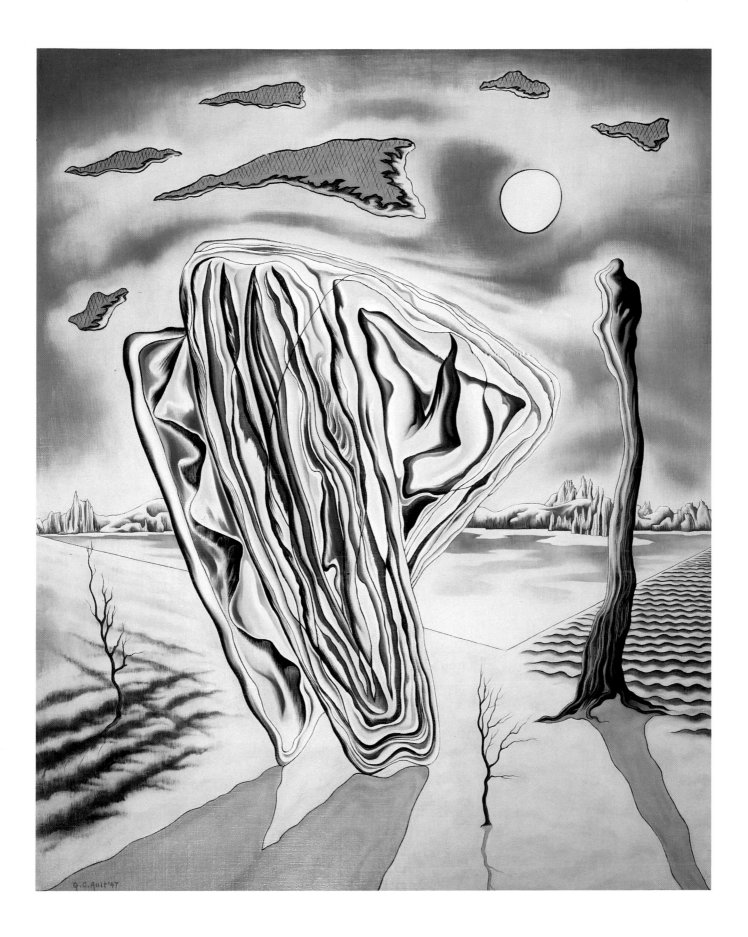

4.

Blume, Peter

born 1906

Flower and Torso, 1927

Oil on canvas

20¼ x 16⅜ inches (51.4 x 41.6 cm.)

Signed lower right:

Peter Blume

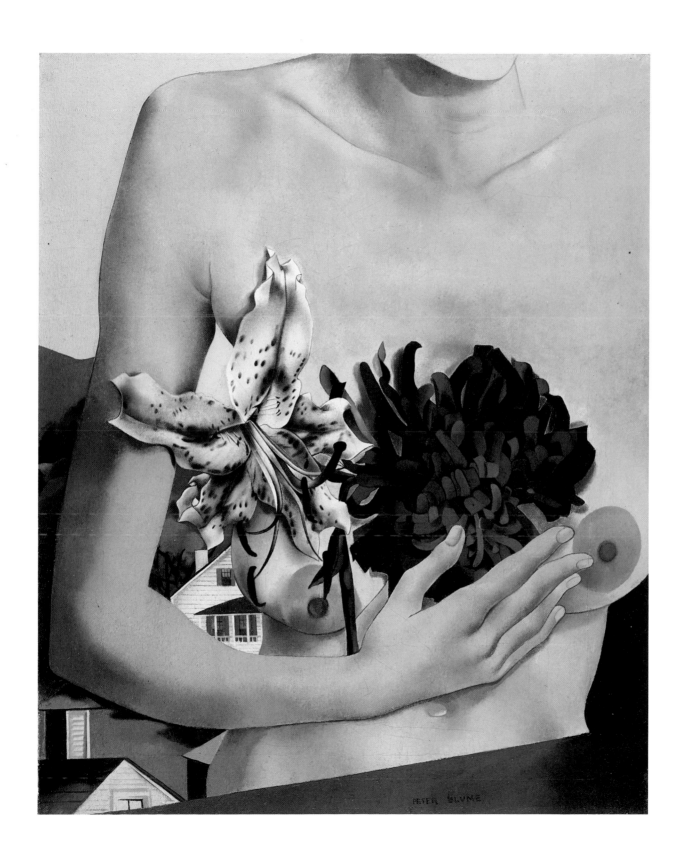

5.

Bolotowsky, Ilya

1907–1981

Blue Diamond, 1940–1941

Oil on canvas

21 x 21 inches (53.3 x 53.3 cm.)

Signed lower right:

Ilya Bolotowsky

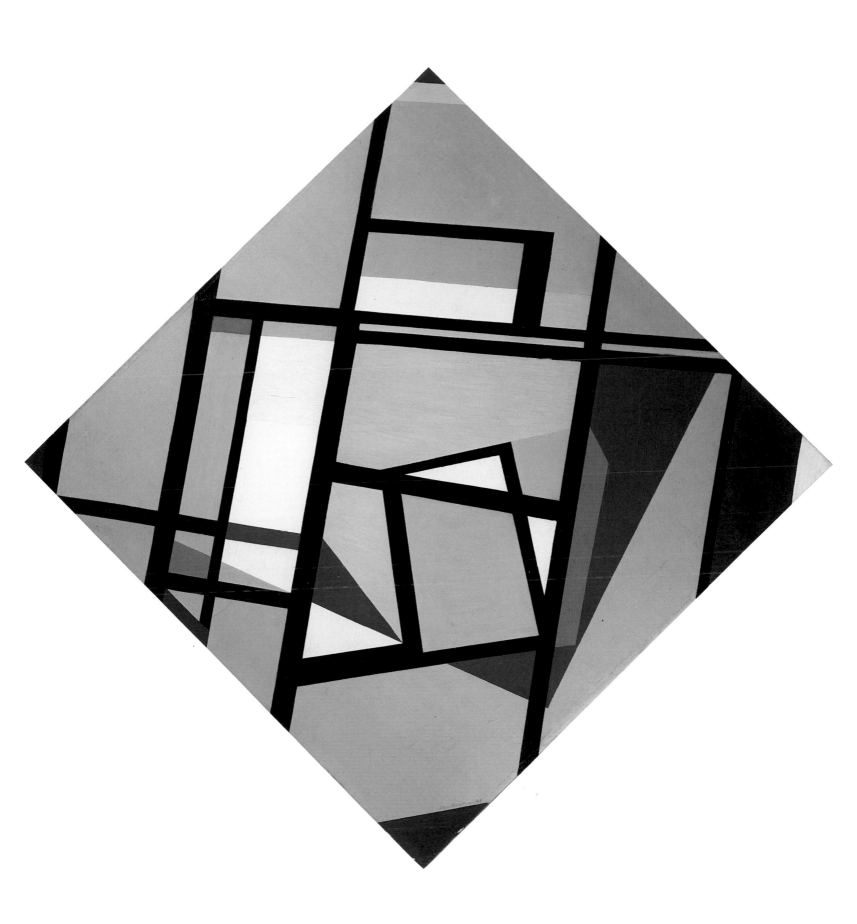

6.

Browne, Byron

1907–1961

Classical Still Life, 1936

Oil on canvas

47 x 36 inches (119.4 x 91.4 cm.)

Signed and dated lower right:

Byron Browne 1936

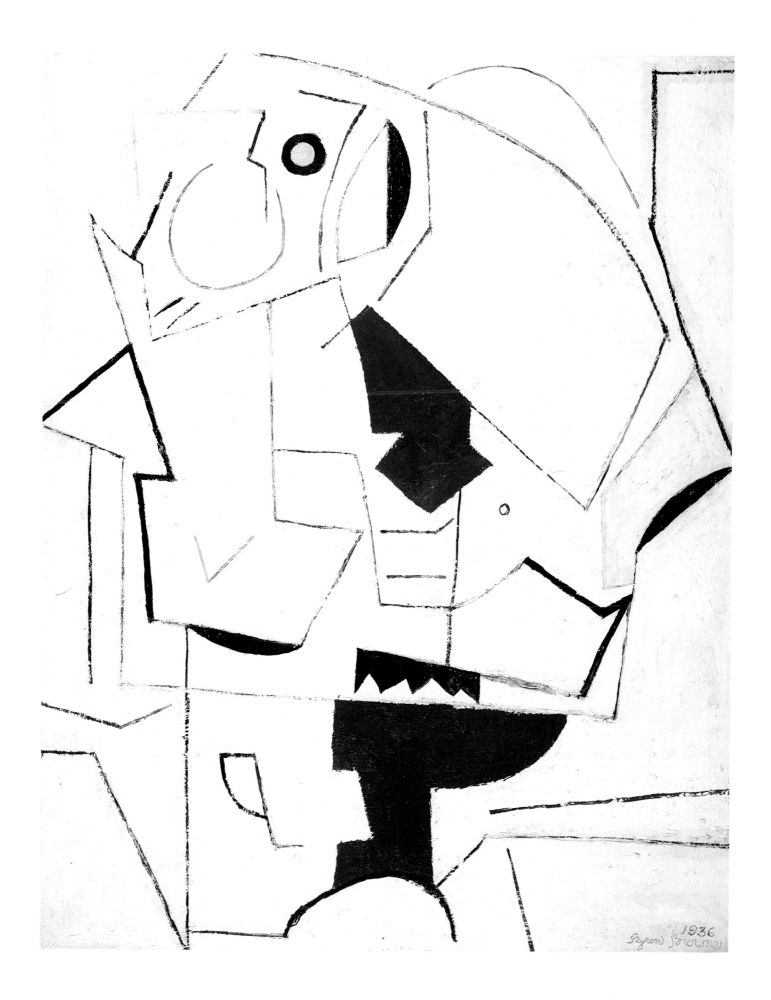

7.

Browne, Byron

1907–1961

Salute Each Time the Cock Crows, 1940

Oil on canvas

48 x 60 inches (121.9 x 152.4 cm.)

Signed lower right:

Byron Browne

and on verso:

Byron Browne, 1940, NYC

8.

Bruce, Patrick Henry

1881–1936

Peinture/Nature Morte, c. 1924

(*Forms No. 5*)

Oil and graphite on canvas

28¼ x 35¾ inches (71.7 x 90.8 cm.)

Inscribed on back: 92 x 73 30 F

Amas d'objects sans point d'appui #5 Rose Friend (sic)

Gallery, New York (pas à tout à fait fini)

9.

Burchfield, Charles

1893–1967

Black Houses, 1918

(*The Bleak Houses*)

Watercolor on paper

15⅞ x 24⅝ inches (40.3 x 62.5 cm.)

Signed lower right:

Chas Burchfield/ 1918

10.

Calder, Alexander

1898–1976

Le Coq, c. 1944

(*Hen with Red Knife*)

Four painted wood elements, steel wire

18½ x 8½ x 3¾ inches (47 x 21.6 x 9.5 cm.)

Signed at bottom:

CA

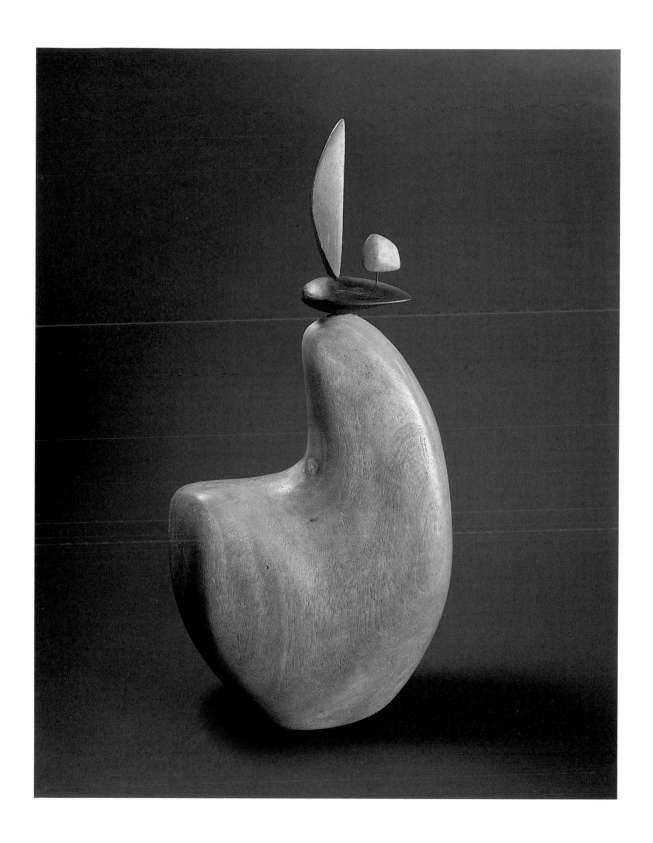

11.

Criss, Francis H.

1901–1973

Melancholy Interlude, 1939

(*Grain Elevator*)

Oil on canvas

25 x 30 inches (63.5 x 76.2 cm.)

Signed lower right:

Francis Criss '39

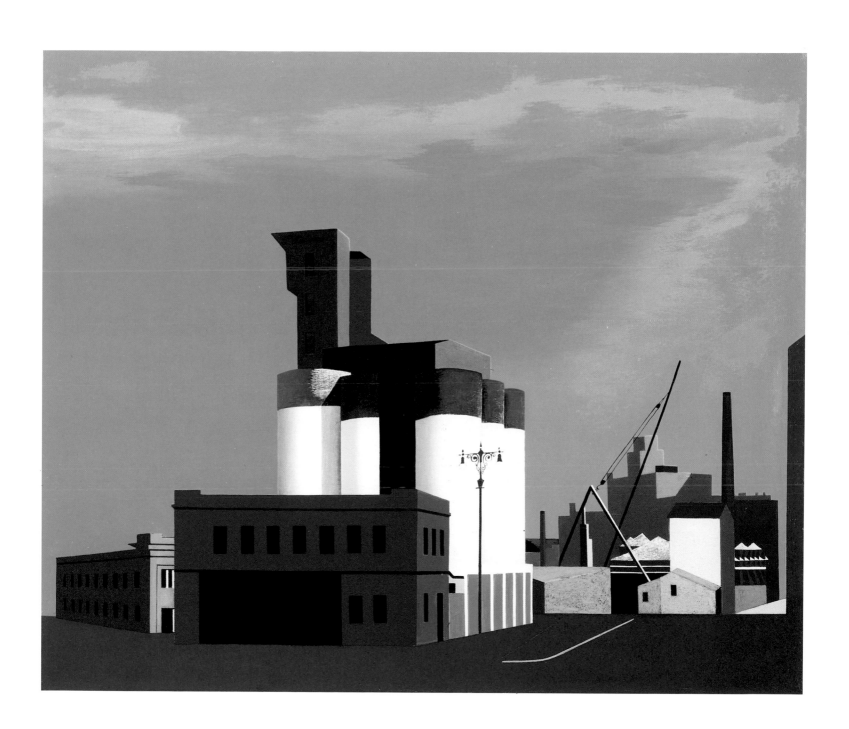

12.

Dasburg, Andrew

1887–1979

Landscape, 1913

Oil on panel

10⅛ x 12⅜ inches (25.7 x 31.4 cm.)

Dated: Monhegan 1913

and inscribed on verso:

To my dearest friend Grace Mott Johnson

13.

Daugherty, James Henry

1889–1974

Seated Nude, c. 1915

Pastel and graphite on paper

11 ⅞ x 8¹³⁄₁₆ inches (30.1 x 22.4 cm.)

Signed and dated lower left at a later date:

JD 1917

14.

Davis, Stuart

1892–1964

Still Life in the Street, c. 1941

(*French Landscape*)

Oil on canvas

10 x 12 inches (25.4 x 30.5 cm.)

Signed lower right:

Stuart Davis

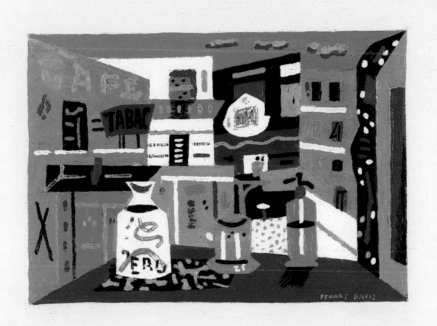

15.

Dawson, Manierre

1887–1969

Blue Trees on Red Rocks, 1918

Oil on panel

17¼ x 14⅛ inches (43.8 x 35.8 cm.)

Signed lower right:

Dawson 18

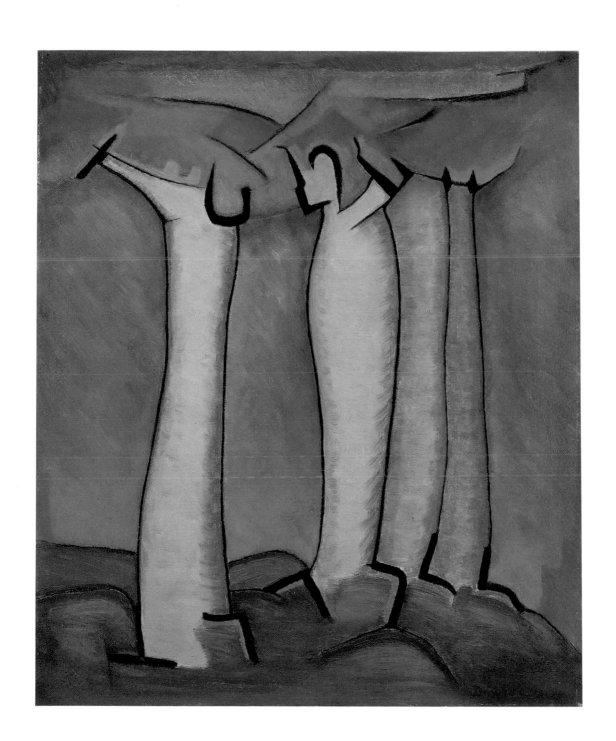

16.

Demuth, Charles

1883–1935

Fruit and Flower, c. 1928

Watercolor and graphite on paper

12 x 18 inches (30.5 x 45.7 cm.)

Unsigned

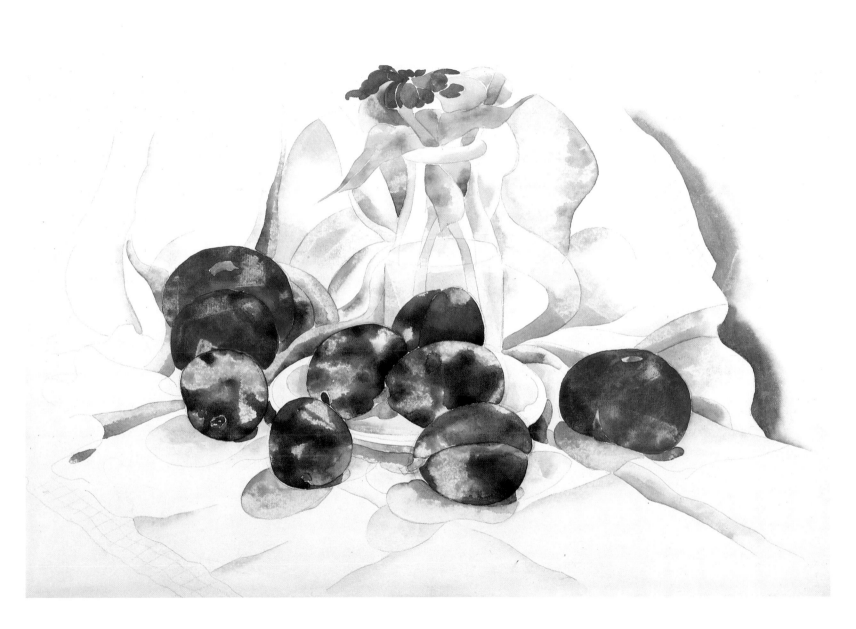

17.

Demuth, Charles

1883–1935

Three Lilies, 1926

(*Study of Three Flowers*)

Watercolor with graphite on paper

19¹⁵⁄₁₆ x 13¹⁵⁄₁₆ inches (25.2 x 35.4 cm.)

Unsigned

18.

Dickinson, Preston

1891–1930

The Artist's Table, n.d.

Oil on board

22½ x 14½ inches (57.2 x 36.7 cm.)

Signed lower right:

P. Dickinson

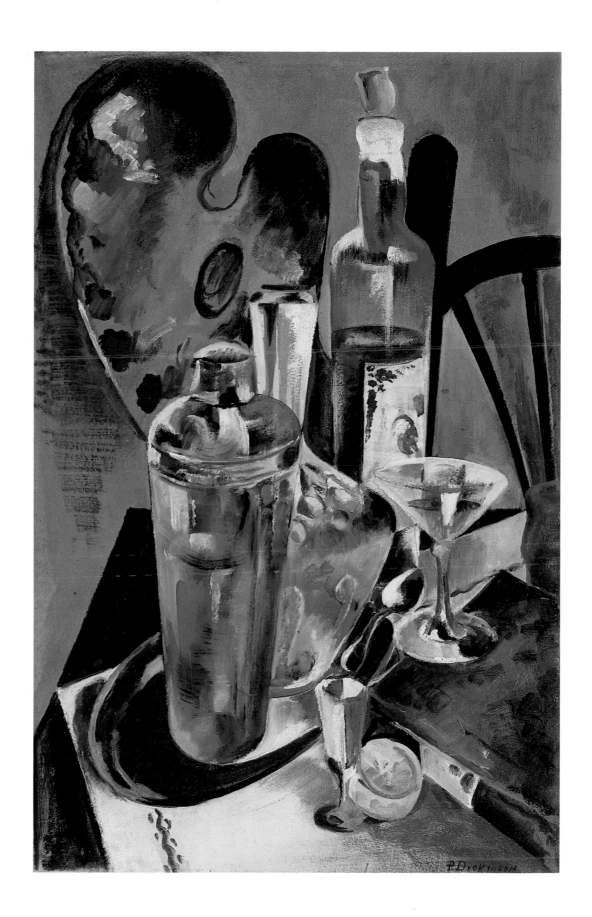

19.

Dickinson, Preston

1891–1930

Garden in Winter, c. 1922

Charcoal on paper, uneven sheet

14⅜ x 10½ inches (36.5 x 26.7 cm.)

Signed lower left:

Dickinson

20.

Dove, Arthur

1880–1946

Holbrook's Bridge, 1935

Watercolor and gouache on paper

7 x 5 inches (17.7 x 12.7 cm.)

Unsigned

21.

Dove, Arthur

1880–1946

Moon, 1935

Oil on canvas

35 x 25 inches (88.9 x 63.5 cm.)

Signed lower center:

Dove

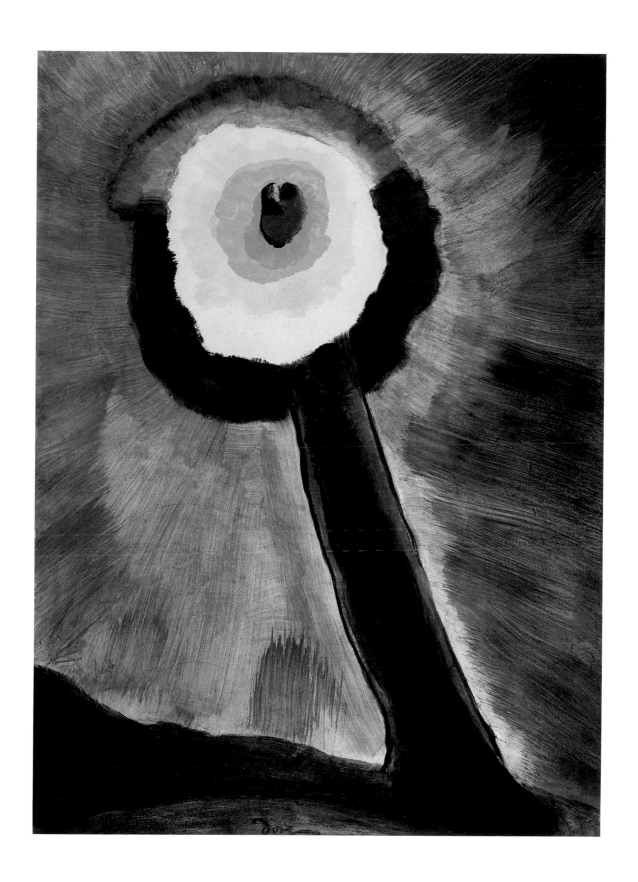

22.

Dove, Arthur

1880–1946

Sea II, 1925

Chiffon over metal with sand

12½ x 20½ inches (31.7 x 52.1 cm.)

Inscribed on panel affixed to verso:

Arthur Dove, Sea II, 1925.

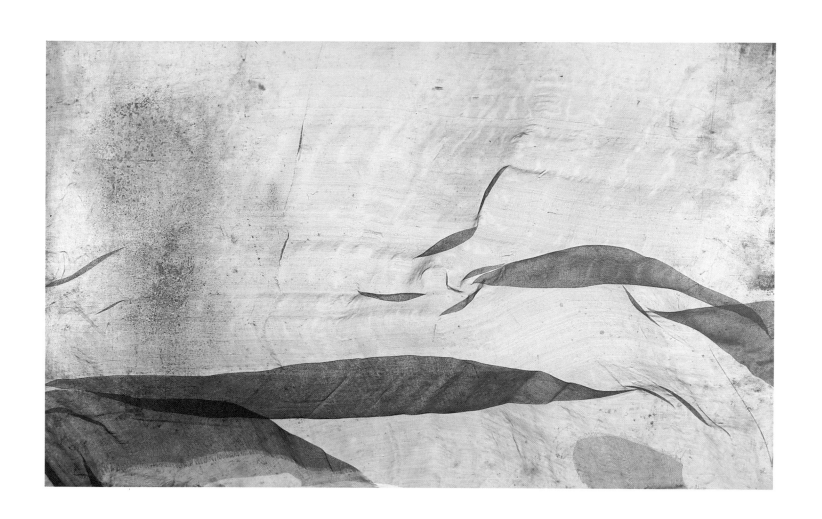

23.

Fiene, Ernest

1894–1965

Winter Day, Pittsburgh, 1935–1936

Oil on canvas

34 x 42 inches (86.3 x 106.7 cm.)

Signed lower right:

E. Fiene

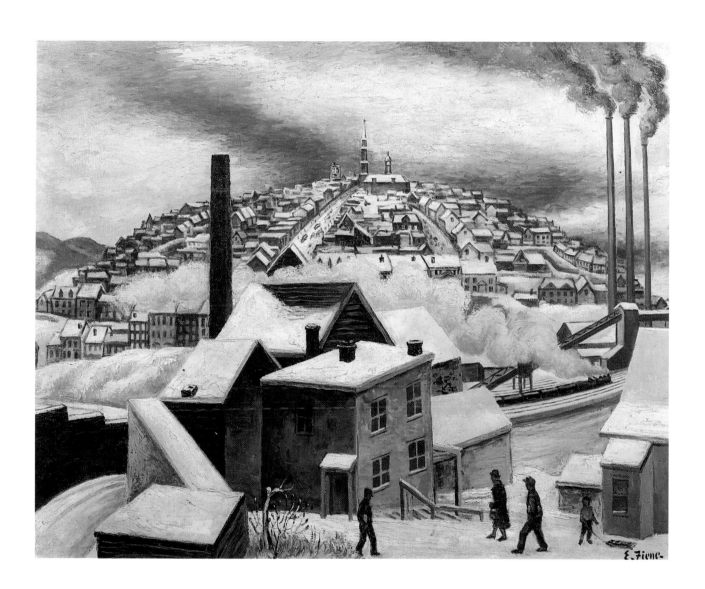

24.

Fiene, Paul

1899–1949

Grant Wood, 1941

Terracotta on alabaster base

18½ x 7½ x 8 inches (46.9 x 19.1 x 20.3 cm.)

Signed:

P. Fiene '41

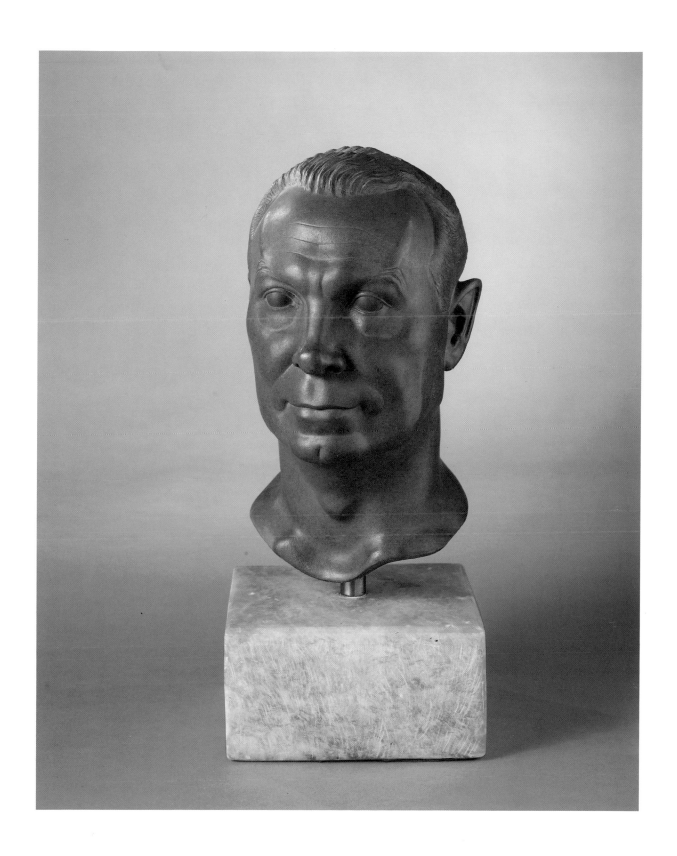

25.

Frelinghuysen, Suzy

born 1912

Composition, 1943

Mixed media (oil on panel with corrugated cardboard)

40 x 30 inches (101.6 x 76.2 cm.)

Unsigned

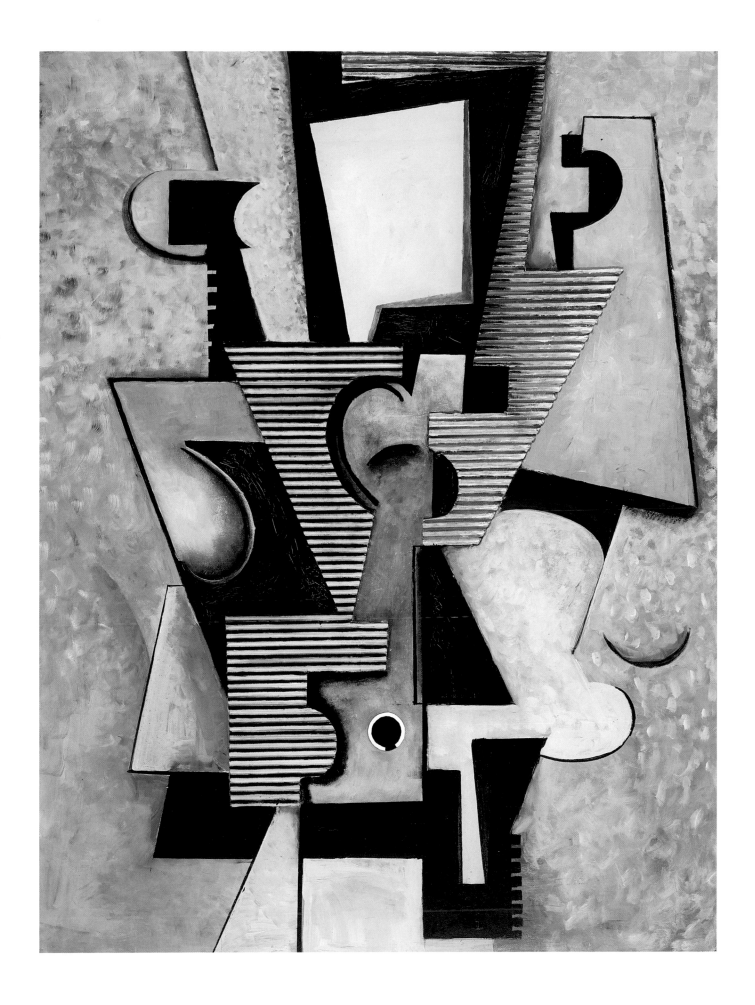

26.

Gallatin, Albert E.

1882–1952

Cubist Abstraction, 1943

Oil on canvas

16 x 20 inches (40.6 x 50.8 cm.)

Signed and dated on verso:

A. E. Gallatin Dec. 1943

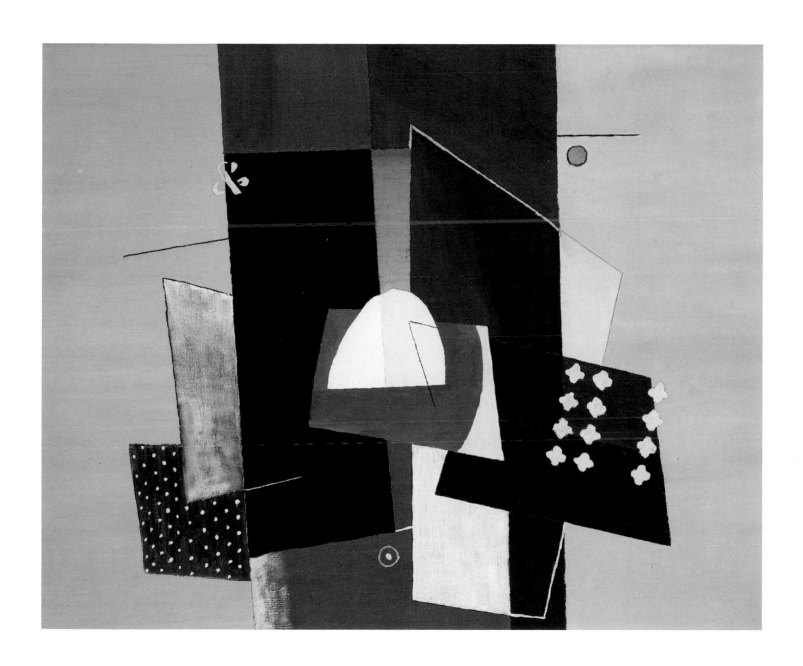

27.

Glackens, William

1870–1938

Cafe Lafayette, 1914

(*Portrait of Kay Laurell*)

Oil on canvas

31¾ x 26 inches (80.6 x 66 cm.)

Signed lower right:

Wm. Glackens

and inscribed "Kay Laurell" on verso

and titled on stretcher bar.

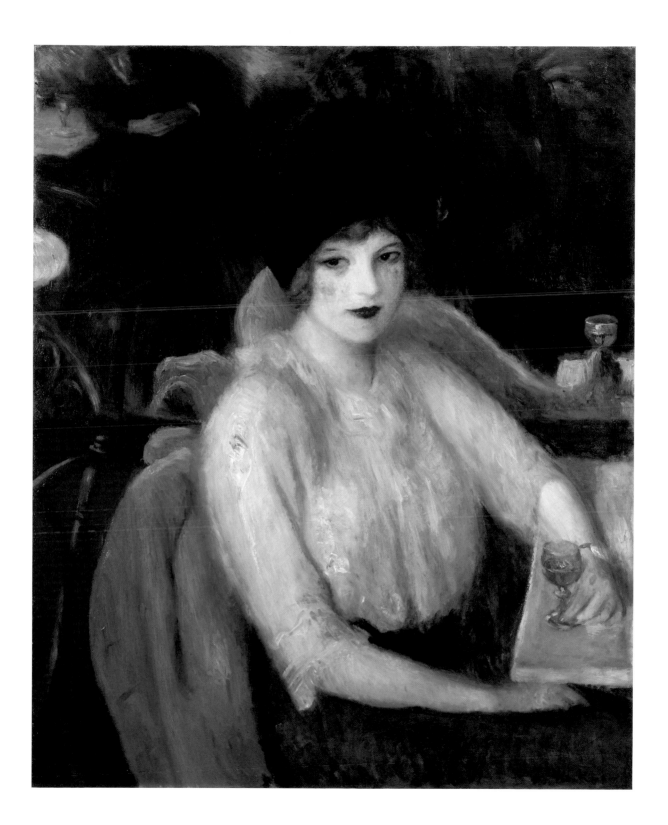

28.

Gorky, Arshile

1905–1948

Abstraction, 1936

Oil on canvas mounted on masonite

35⅛ x 43⅛ inches (89 x 109.5 cm.)

Unsigned

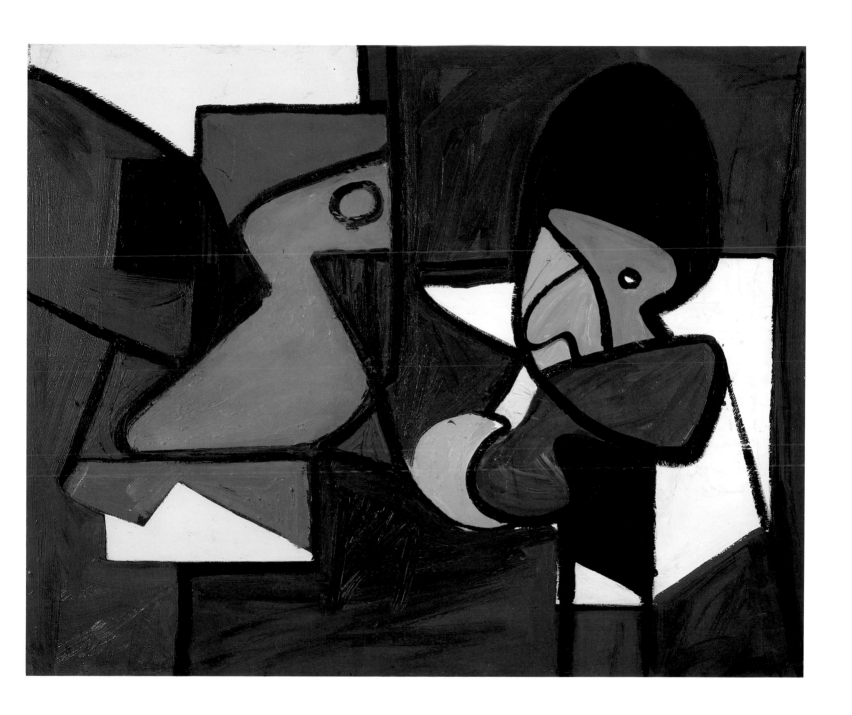

29.

Guglielmi, O. Louis

1906–1956

Land of Canaan, 1934

Oil on canvas

30¼ x 36½ inches (77.5 x 92.7 cm.)

Signed lower left:

Guglielmi

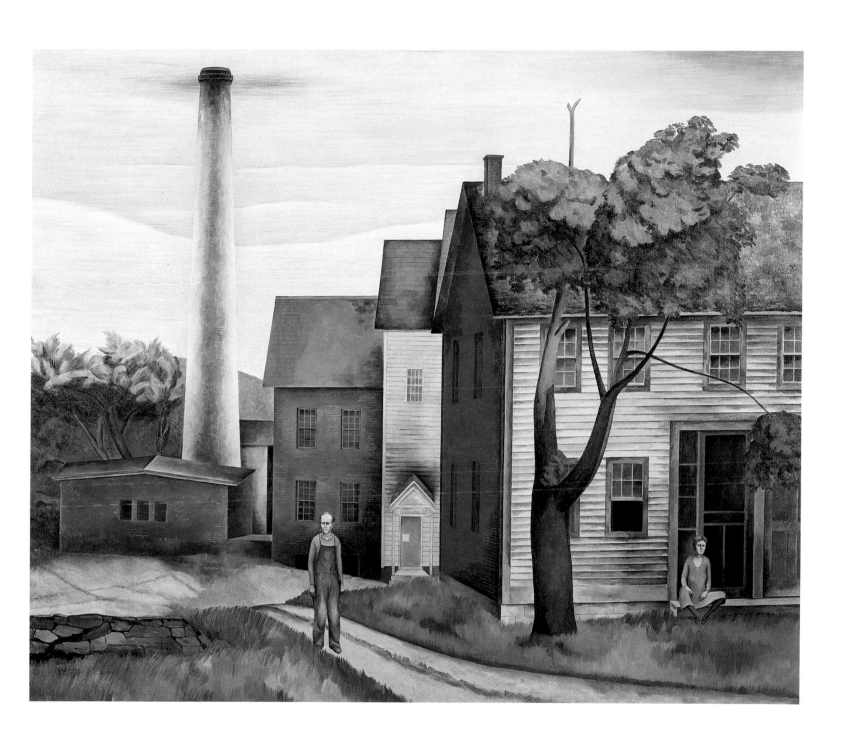

30.

Guglielmi, O. Louis

1906–1956

Mental Geography, 1938

Oil on masonite

35¾ x 24 inches (90.8 x 60.9 cm.)

Signed lower left:

Guglielmi 38

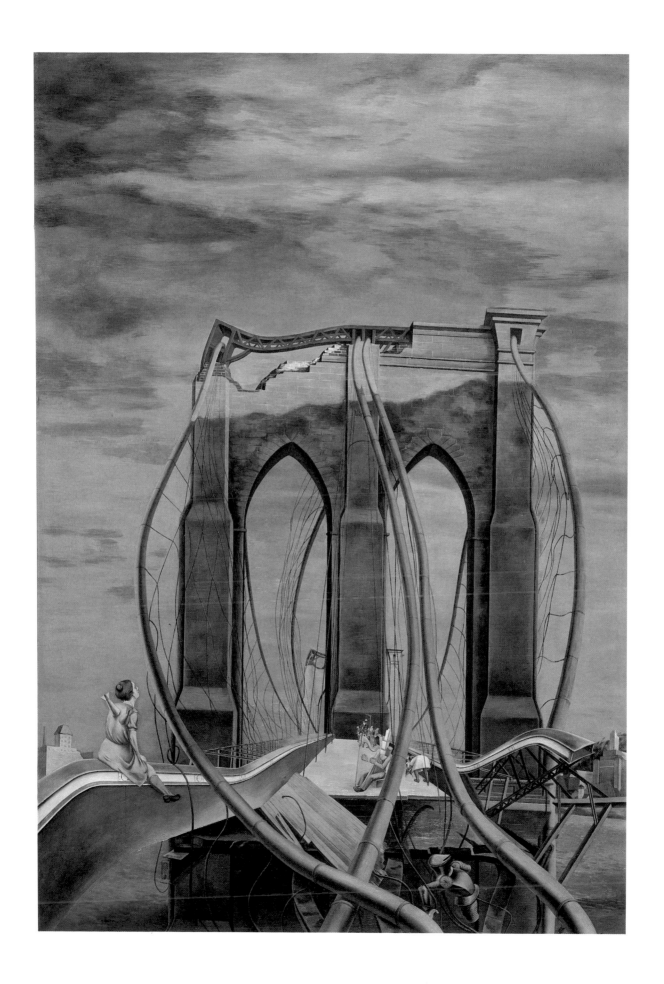

31.

Hartley, Marsden

1877–1943

Painting No. 49, Berlin, 1914–1915

(*Portrait of a German Officer* or *Berlin Abstraction*)

Oil on canvas

47 x 39¼ inches (119.3 x 99.7 cm.)

Unsigned

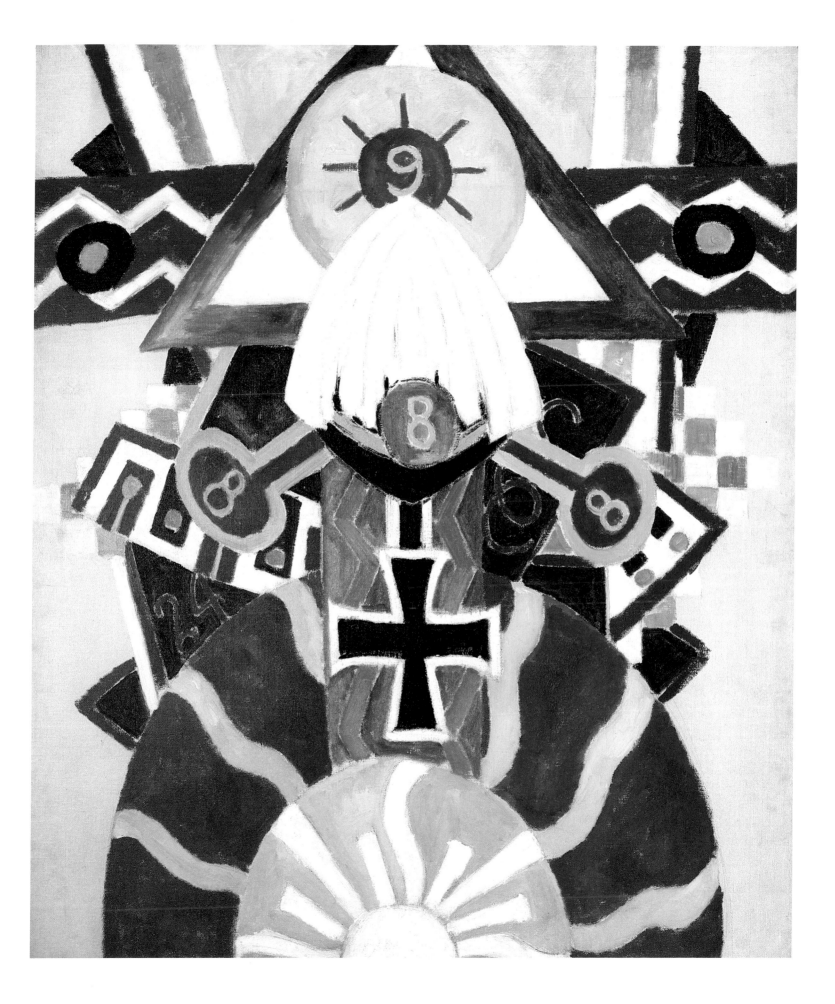

32.

Hirsch, Stefan

1889–1964

Excavation, 1926

Oil on canvas

35 x 45 inches (88.9 x 114.3 cm.)

Inscribed on license plate:

S H 1926

33.

Hopper, Edward

1882–1967

Chop Suey, 1929

Oil on canvas

32 x 38 inches (81.2 x 96.5 cm.)

Signed lower right:

EDWARD HOPPER

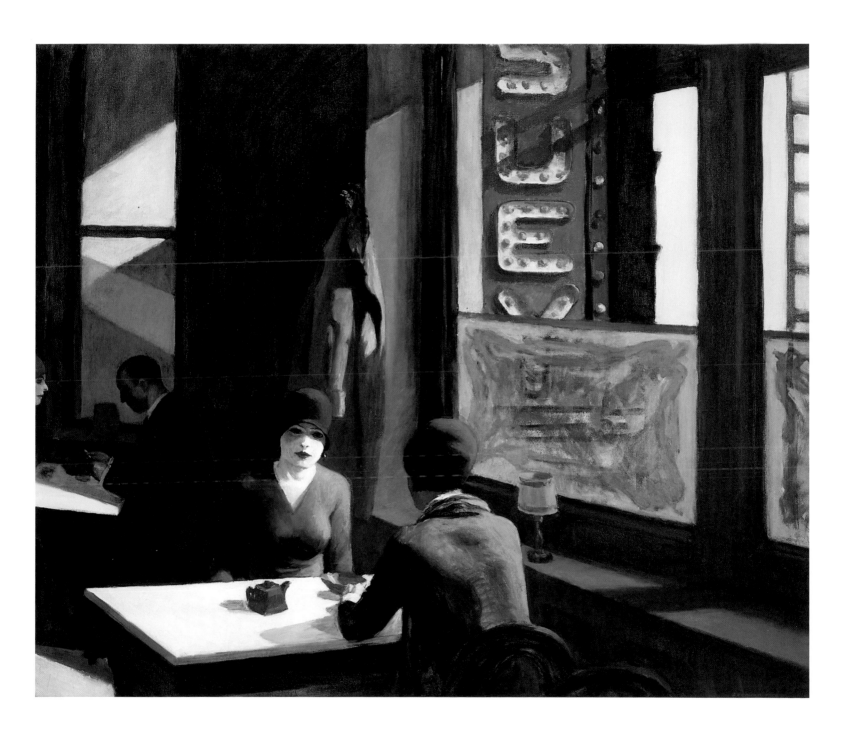

34.

Hopper, Edward

1882–1967

Cottages at North Truro, Massachusetts, 1938

Watercolor with underdrawing of graphite on paper

20³⁄₁₆ x 28⅛ inches (52.3 x 71.4 cm.)

Signed lower right:

EDWARD HOPPER

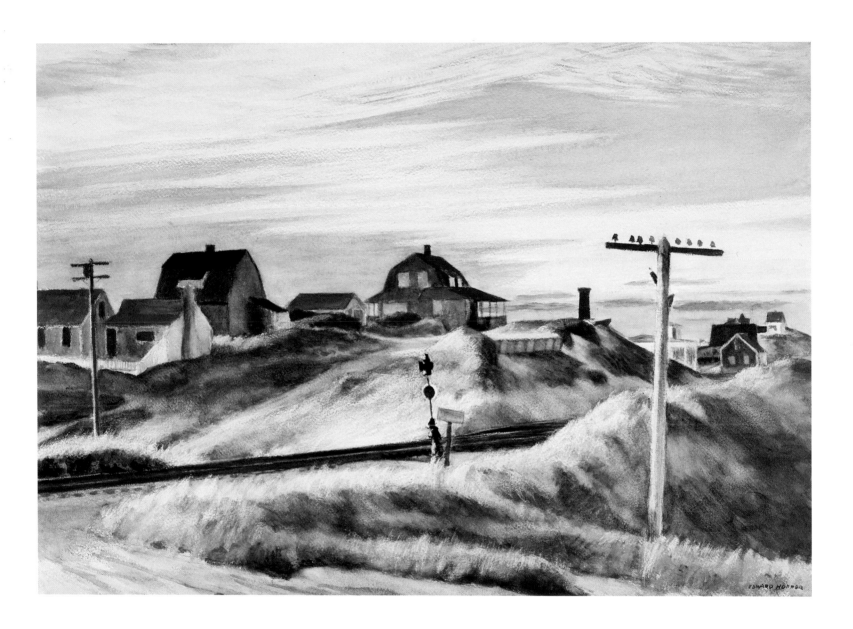

35.
Kantor, Morris
1896–1974
Orchestra, 1923
Oil on canvas
35 x 34 inches (88.9 x 86.4 cm.)
Unsigned

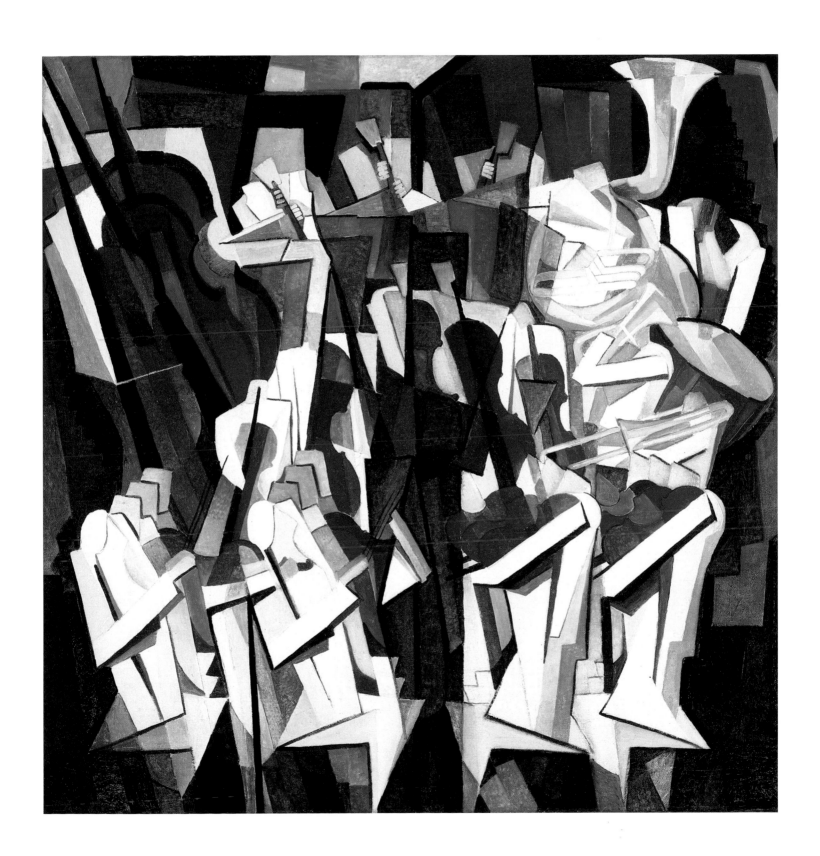

36.

Kelly, Leon

born 1901

The White Compotier, 1921

Pastel on board

21⅝ x 13¹⁵⁄₁₆ inches (55.1 x 35.3 cm.)

Signed and dated lower right:

Leon Kelly/1921

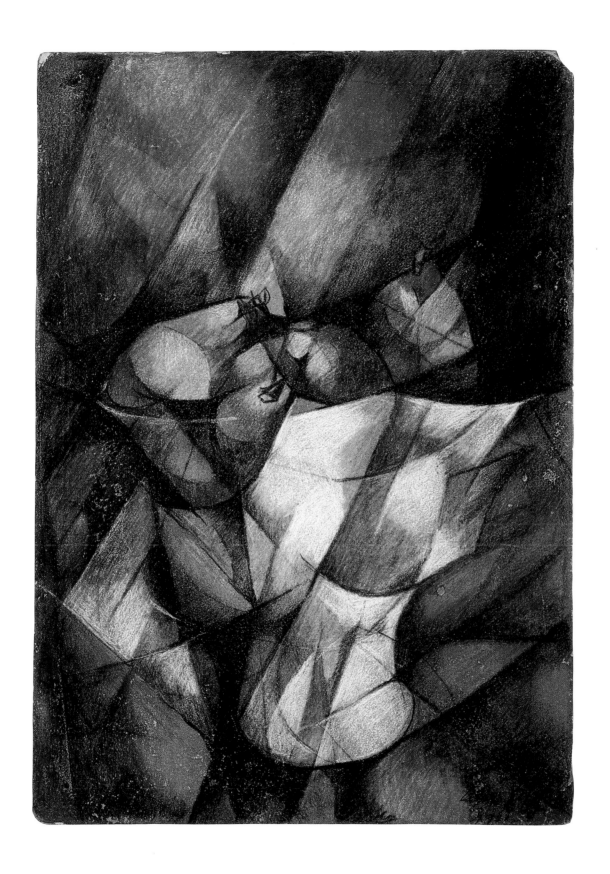

37.

Lachaise, Gaston

1882–1935

Back of a Walking Woman, c. 1922

Bronze, unique cast

16½ x 7 x 3 inches (41.9 x 17.8 x 7.6 cm.)

Unsigned

38.

Lachaise, Gaston

1882–1935

Mask, 1924

Bronze washed with nickel and brass on black marble

base, lifetime cast

6 x 5 x 4 inches (15.2 x 12.7 x 10.2 cm.)

Signed lower center:

G. Lachaise 1924

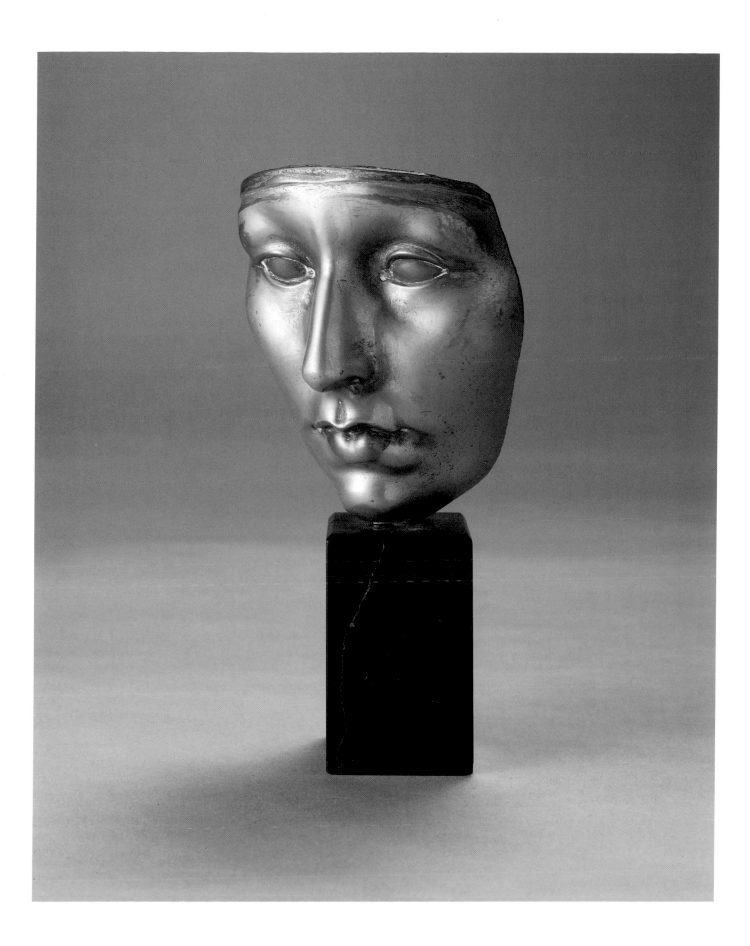

39.

Lachaise, Gaston

1882–1935

Mask, 1928

Bronze, lifetime cast

8¼ x 5½ x 3½ inches (20.9 x 13.9 x 8.9 cm.)

Unsigned

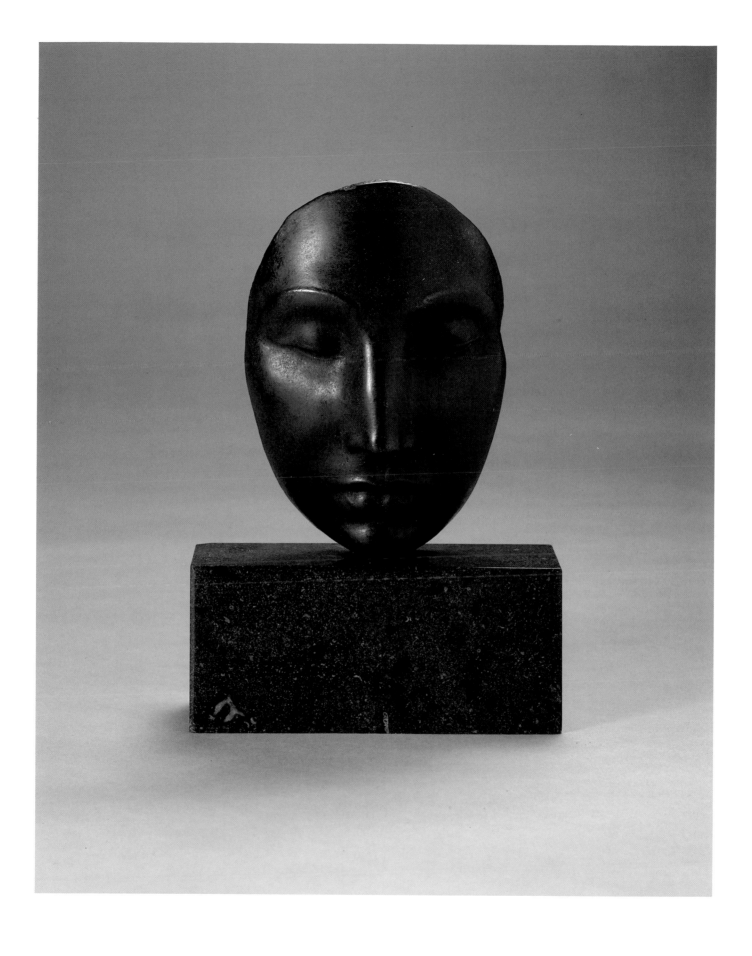

40.

Lachaise, Gaston

1882–1935

Standing Nude, n.d.

Graphite on paper

10⅞ x 8⁷⁄₁₆ inches (27.6 x 21.4 cm.)

Signed lower left:

G. Lachaise

41.

Lucioni, Luigi

born 1900

Still Life with Peaches, 1927

(*Red Checkered Tablecloth*)

Oil on canvas

24 x 30 inches (60.9 x 76.2 cm.)

Signed and dated lower left:

Lucioni 27

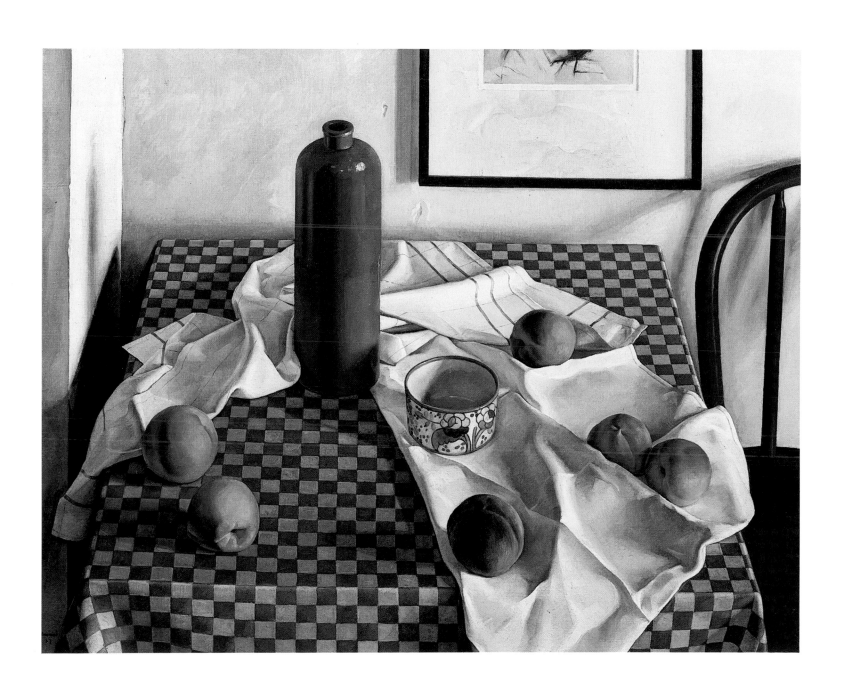

42.

Marin, John

1870–1953

From Deer Isle, Maine, 1922

Watercolor with black chalk underdrawing on paper

19⁹⁄₁₆ x 16³⁄₁₆ inches (49.7 x 41.1 cm.)

Signed lower left:

Marin 22

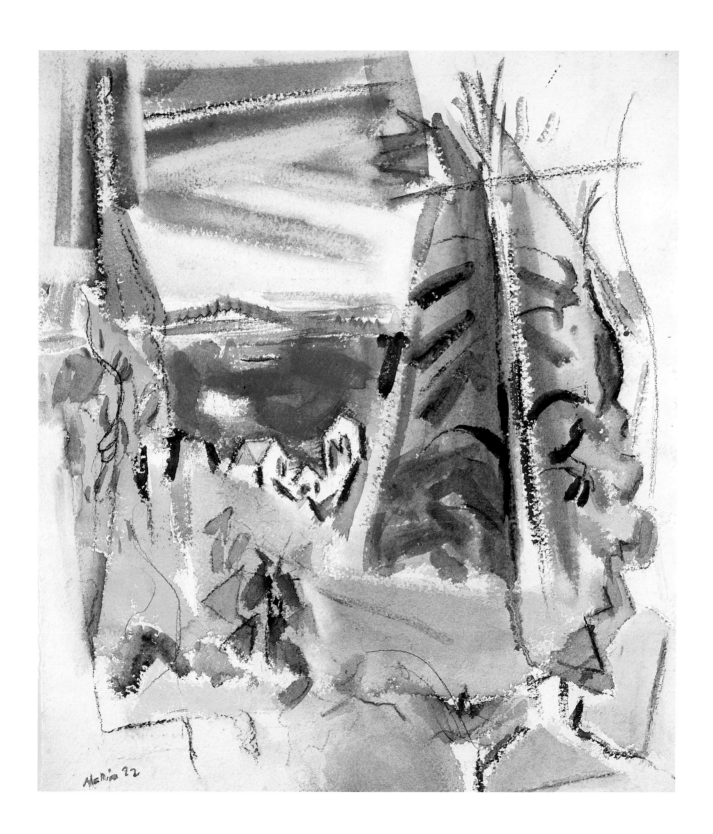

43.

Marin, John

1870–1953

My Hell Raising Sea, 1941

Oil on canvas

25 x 30 inches (63.5 x 76.2 cm.)

Signed and dated lower right:

Marin 41

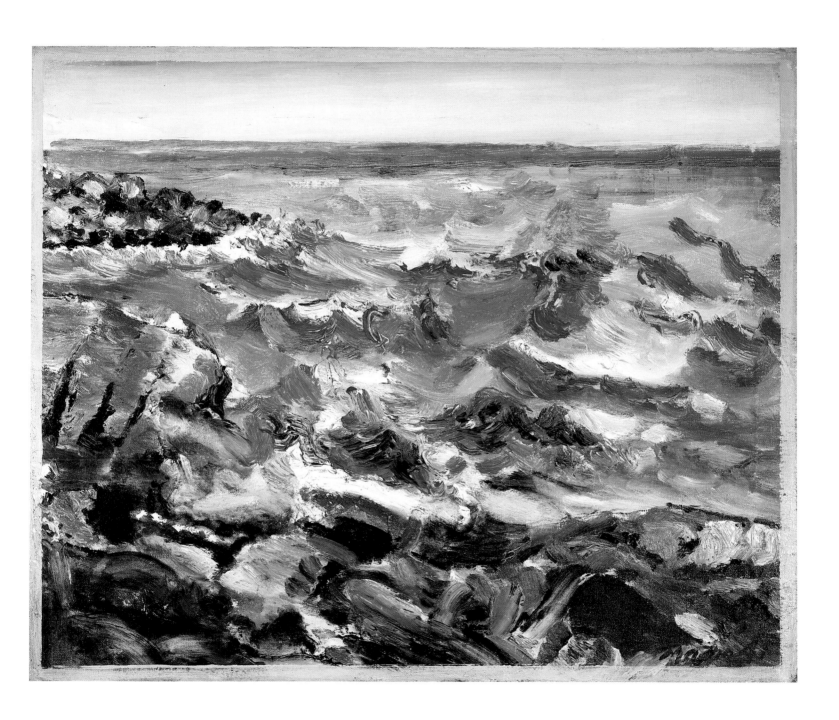

44.

Mason, Alice Trumbull

1904–1971

Forms Evoked, 1940

Oil on panel

17 x 22 inches (43.2 x 55.9 cm.)

Signed lower right:

Alice Mason

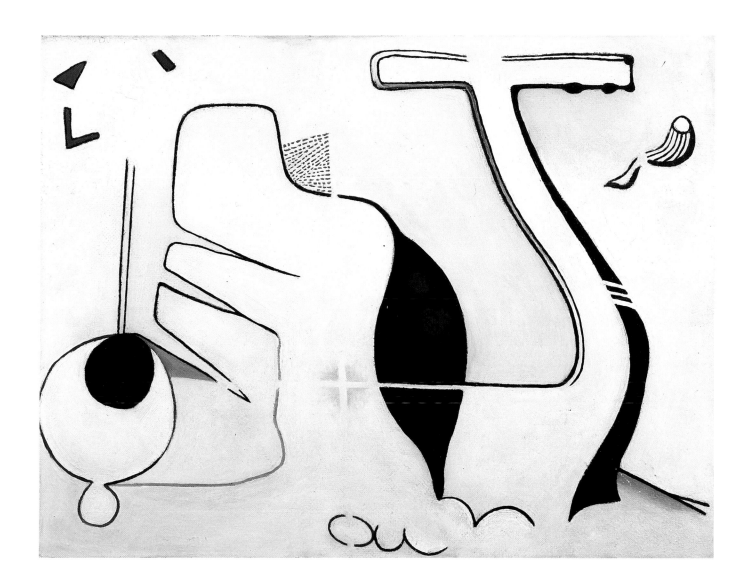

45.
Matulka, Jan
1890–1972
At Sea, c. 1932
Oil on canvas
36 x 30 inches (91.4 x 76.2 cm.)
Unsigned

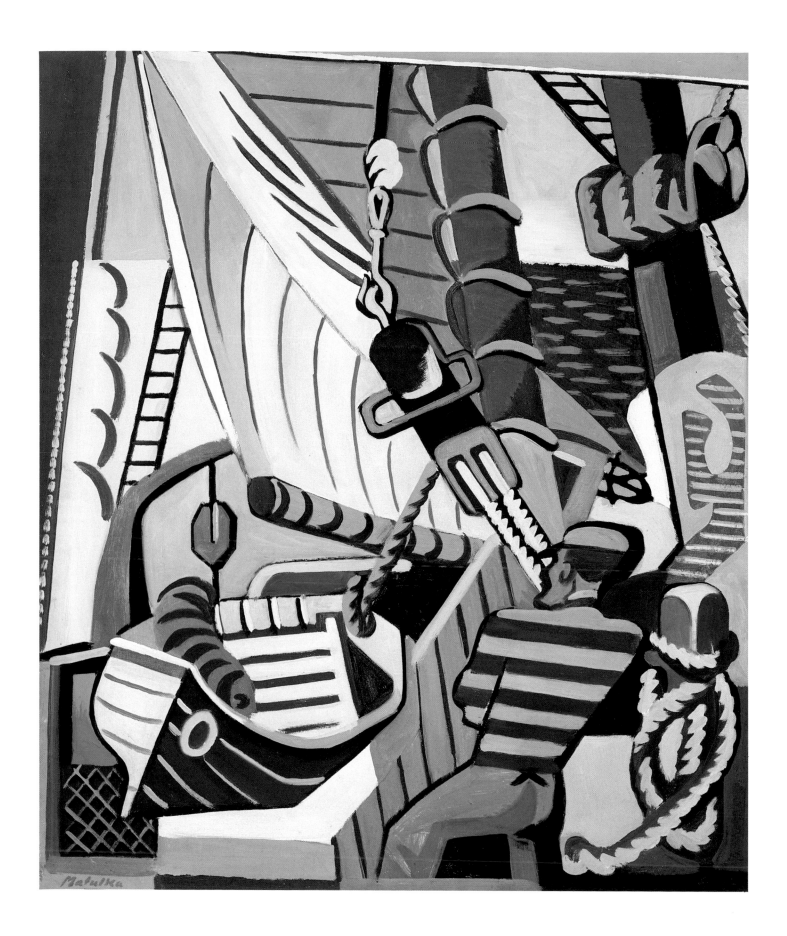

46.

Matulka, Jan

1890–1972

Bohemian Village, c. 1920

(*Slovak Village Turi Pole*)

Watercolor on paper

17¼ x 23⅝ inches (43.8 x 59.9 cm.)

Signed lower right:

J Matulka

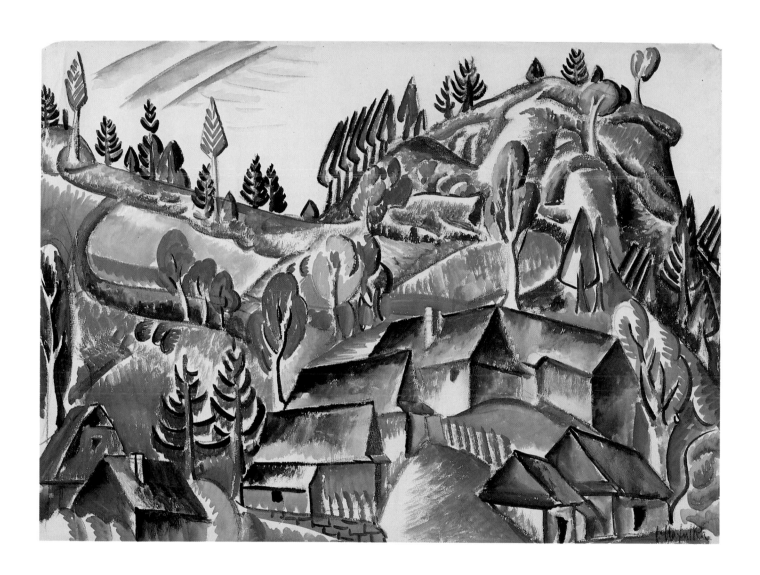

47.

Matulka, Jan

1890–1972

Cityscape, c. 1925

Gouache and graphite on paper

21¹⁵⁄₁₆ x 14 inches (54.7 x 35.6 cm.)

Signed lower left:

Matulka

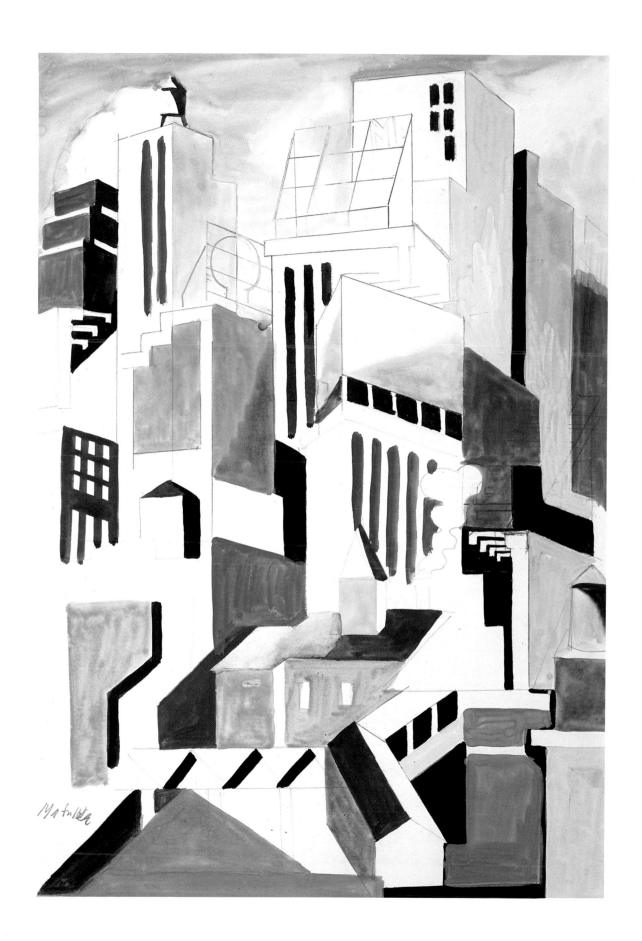

48.

Nadelman, Elie

1882–1946

Dancing Figure, c. 1916–1918

Bronze

30 x 12 x 12 inches (76.2 x 30.5 x 30.5 cm.)

Signed on back, under skirt:

Elie Nadelman

49.
Neel, Alice
1900–1984
Jose Asleep, 1938
Pastel on paper
12 x 9 inches (30.5 x 22.9 cm.)
Signed lower left:
Neel 38

50.
O'Keeffe, Georgia
1887–1986
Beauford Delaney, early 1940s
Charcoal on paper
24½ x 18⅝ inches (62.2 x 43.3 cm.)
Unsigned

51.

O'Keeffe, Georgia

1887–1986

Black, White and Blue, 1930

Oil on canvas

48 x 30 inches (121.9 x 76.2 cm.)

Signed with monogram and star on panel affixed to verso, also titled and dated in the artist's hand on a label affixed to verso.

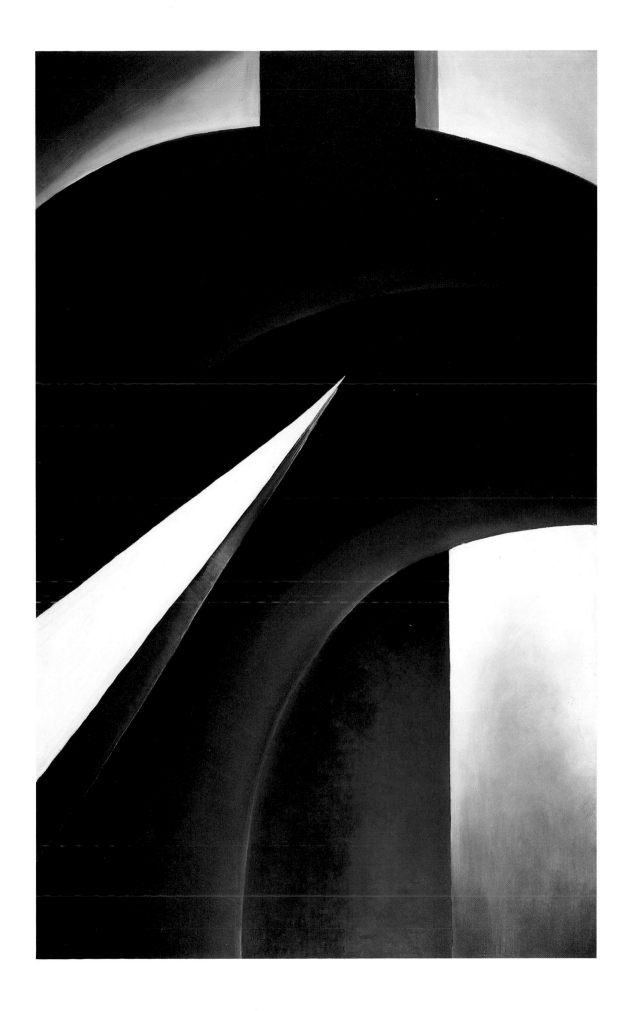

52.

O'Keeffe, Georgia

1887–1986

Horn and Feather, 1937

Oil on canvas

9 x 14 inches (22.8 x 35.5 cm.)

Unsigned

53.

O'Keeffe, Georgia

1887–1986

Music—Pink and Blue I, 1919

Oil on canvas

35 x 29 inches (88.9 x 73.6 cm.)

Signed on verso in graphite with O'Keeffe's monogram

and star

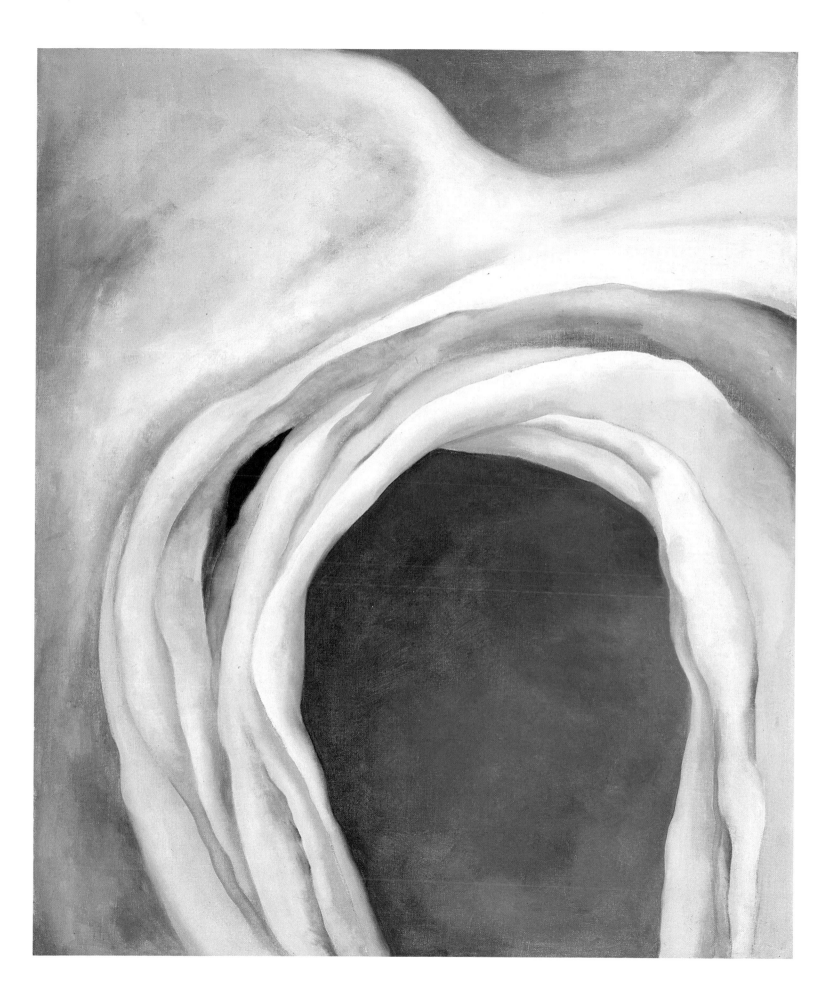

54.

O'Keeffe, Georgia

1887–1986

Sunrise, 1917

Watercolor on paper

8⅞ x 11⅞ inches (22.5 x 30.1 cm.)

Unsigned

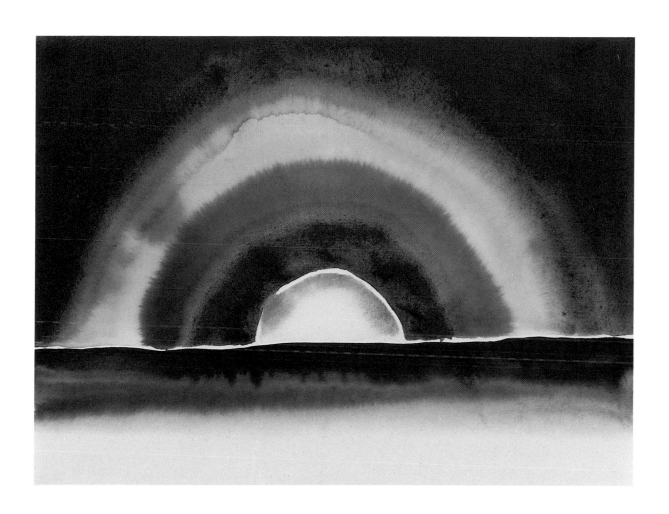

55.

Roszak, Theodore

1907–1981

Construction, 1937

Painted wood, wire, glass

12 x 17 inches (30.5 x 43.2 cm.)

Signed on front of box:

T.J. Roszak

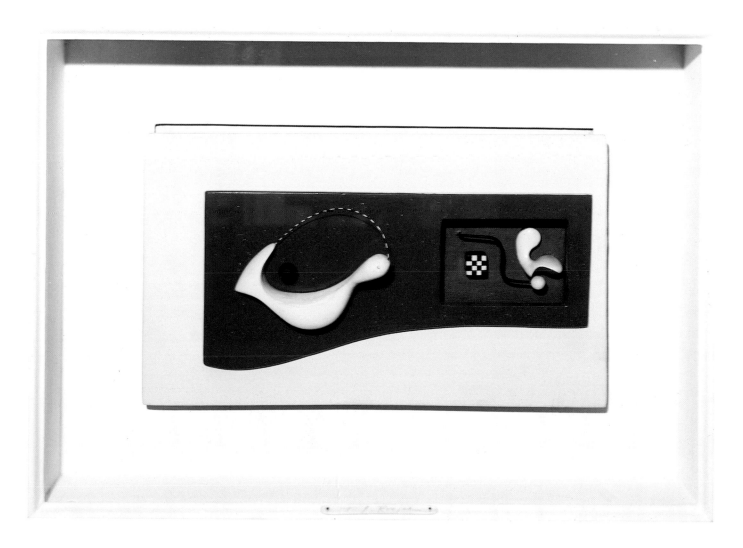

56.

Roszak, Theodore

1907–1981

Spatial Construction, c. 1942–1945

Painted steel, wire, and wood

23½ x 17 x 10 inches (59.7 x 43.2 x 25.4 cm.)

Unsigned

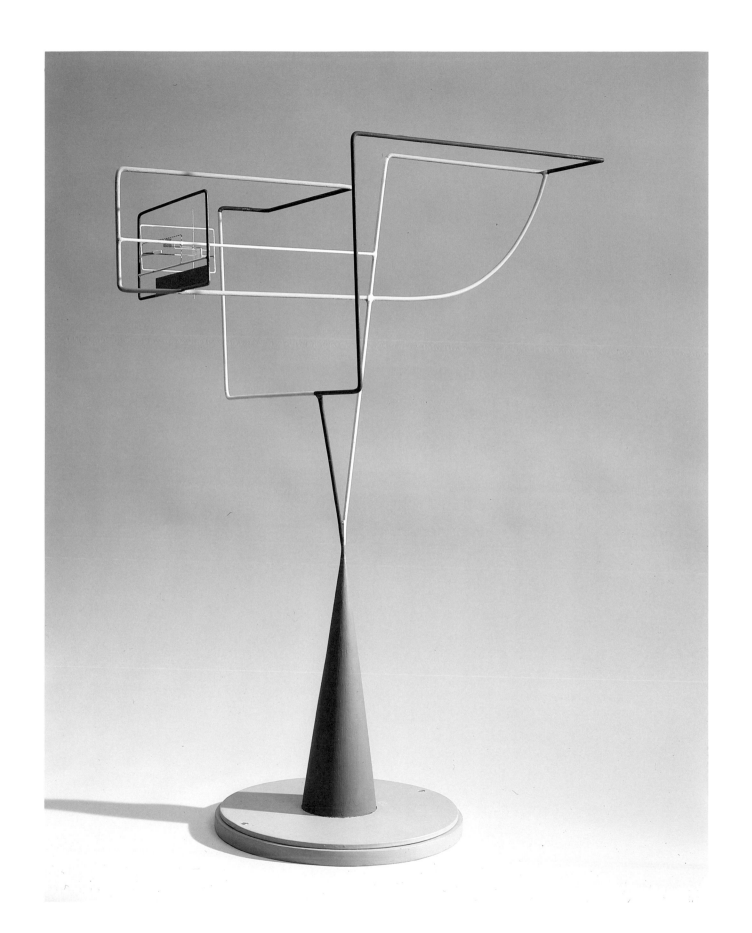

57.

Scarlett, Rolph

1889–1984

Untitled, 1940–1945

Oil on canvas

36¼ x 39¼ inches (92.1 x 99.7 cm.)

Signed on verso:

R.S.

Signed on stretcher bar:

Rolph Scarlett

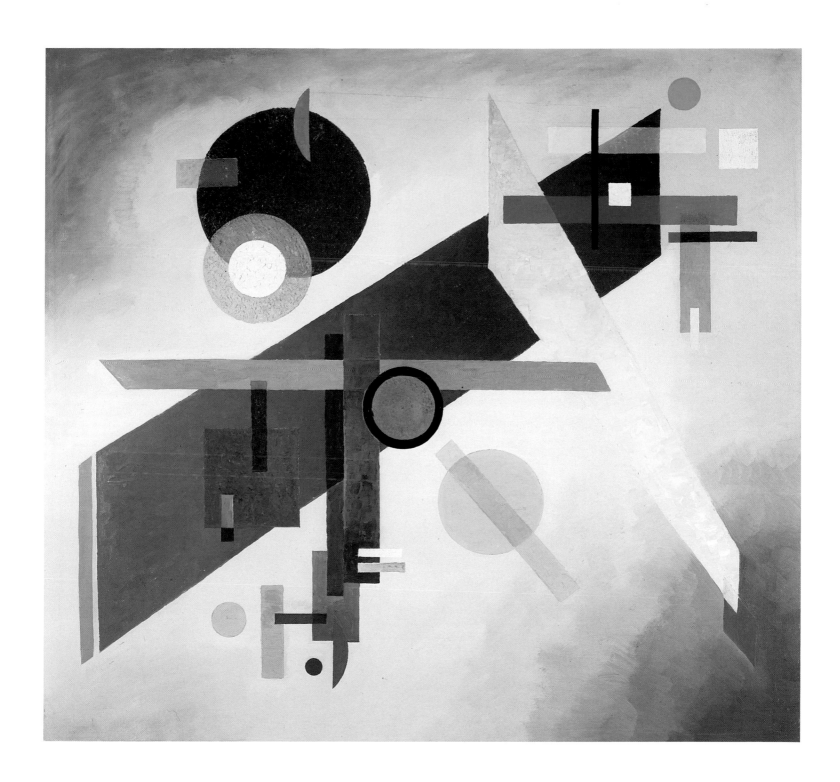

58.

Shaw, Charles

1892–1974

Untitled, 1940

Oil on composition board

30 x 22 inches (76.2 x 55.9 cm.)

Signed on verso:

Charles G. Shaw, 1940

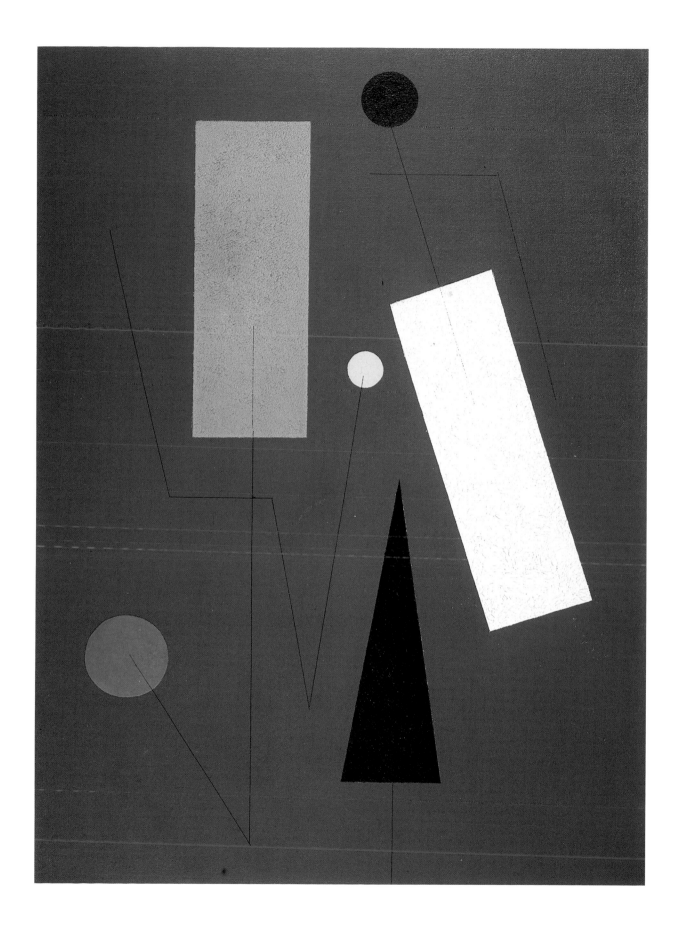

59.
Sheeler, Charles
1883–1965
Catwalk, 1947
Oil on canvas
24 x 20 inches (60.9 x 59.9 cm.)
Signed and dated lower right:
Sheeler—1947
Signed on stretcher:
Charles Sheeler 1947

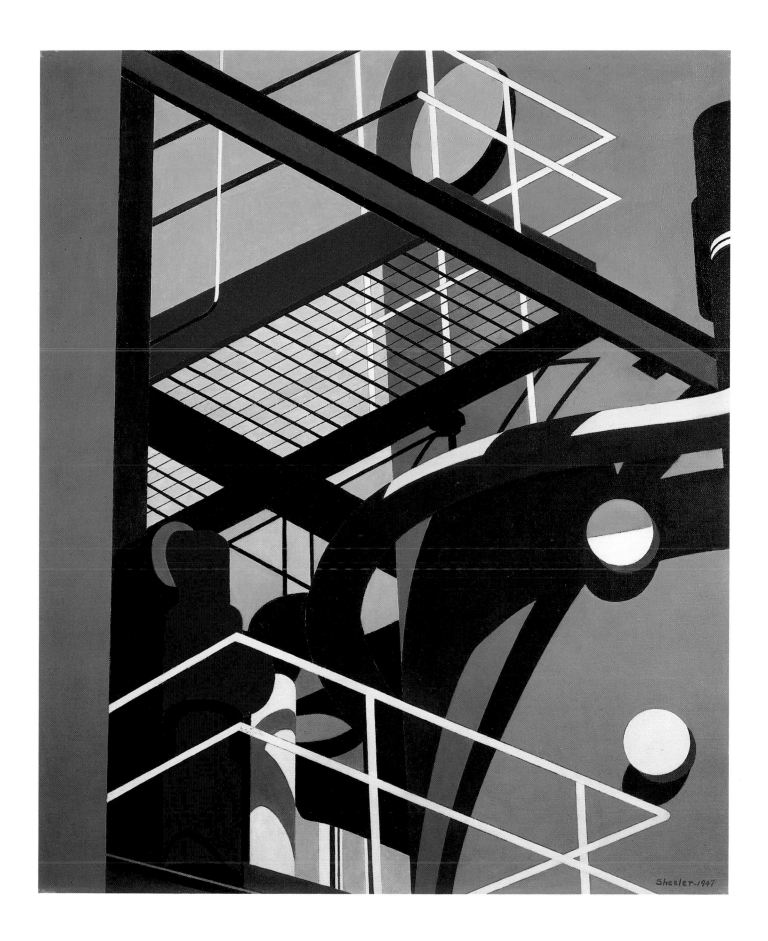

60.

Sheeler, Charles

1883–1965

Classic Landscape, 1928

Watercolor, gouache and graphite on paper

8¹³⁄₁₆ x 11¹⁵⁄₁₆ inches (22.4 x 30.3 cm.)

Signed lower right:

Sheeler 1928

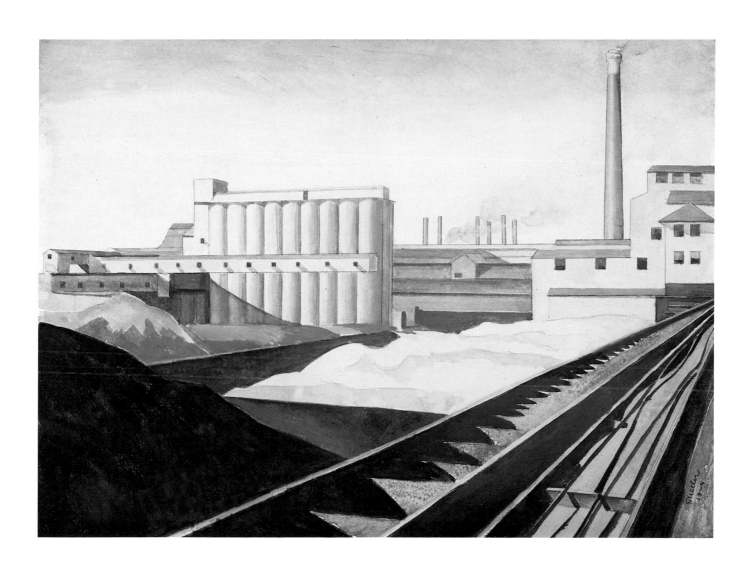

61.

Sheeler, Charles

1883–1965

Classic Landscape, 1931

Oil on canvas

25 x 32¼ inches (63.5 x 81.9 cm.)

Signed and dated lower right:

Sheeler—1931

Signed on canvas stretcher:

Charles Sheeler

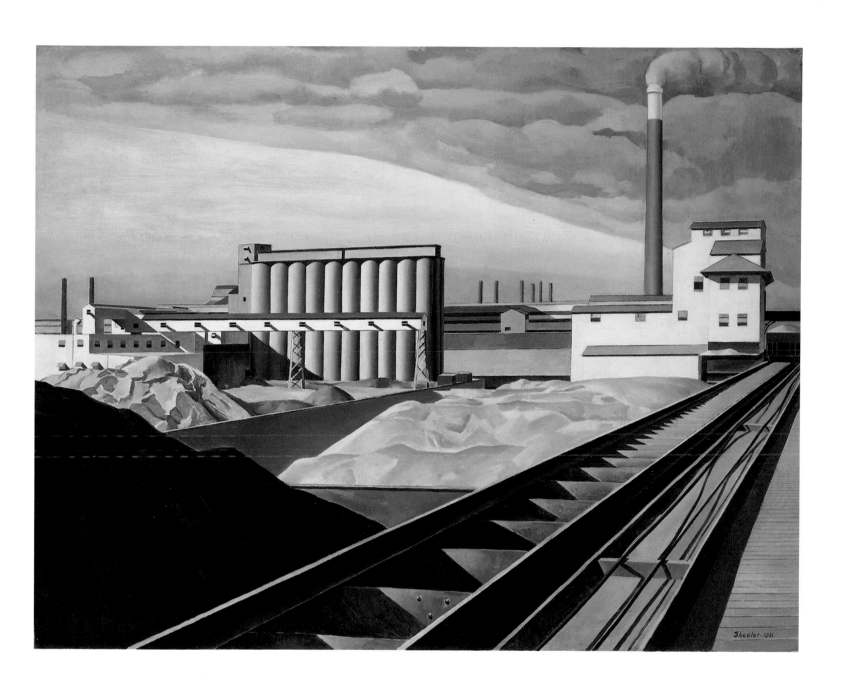

62.

Sheeler, Charles

1883–1965

Still Life, 1938

Oil on canvas

8 x 9 inches (20.3 x 22.8 cm.)

Signed and dated at bottom center:

Sheeler—1938

Signed on back of original stretcher:

Charles Sheeler, Still Life 1938, Charles Sheeler

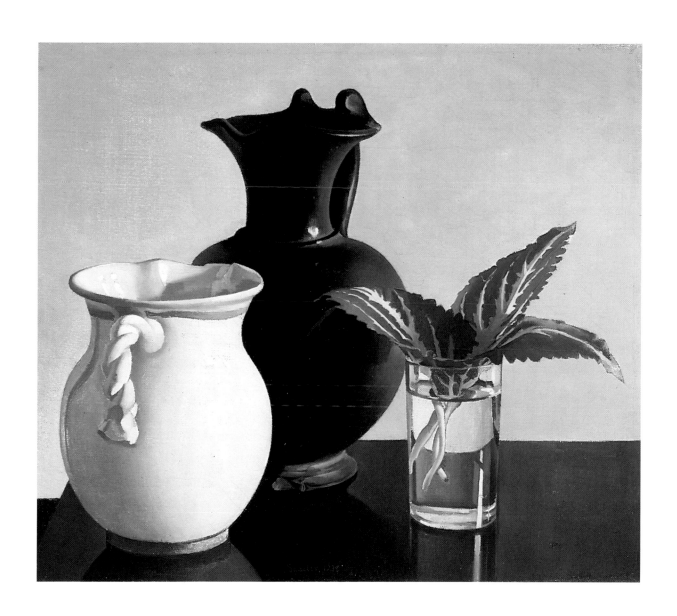

63.

Slobodkina, Esphyr

born 1908

Ancient Sea Song, 1943

(*Large Picture*)

Oil on board

35¼ x 43½ inches (89.5 x 110.5 cm.)

Unsigned

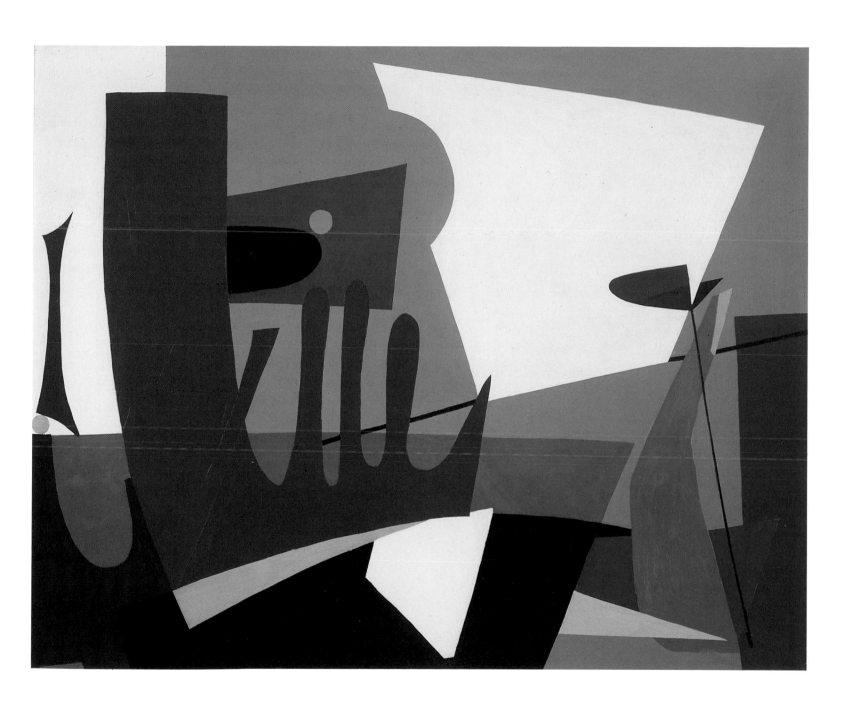

64.

Smith, David

1906–1965

Untitled, c. 1936

(*The Billiard Players*)

Oil on canvas

47 x 52 inches (119.4 x 132 cm.)

Unsigned

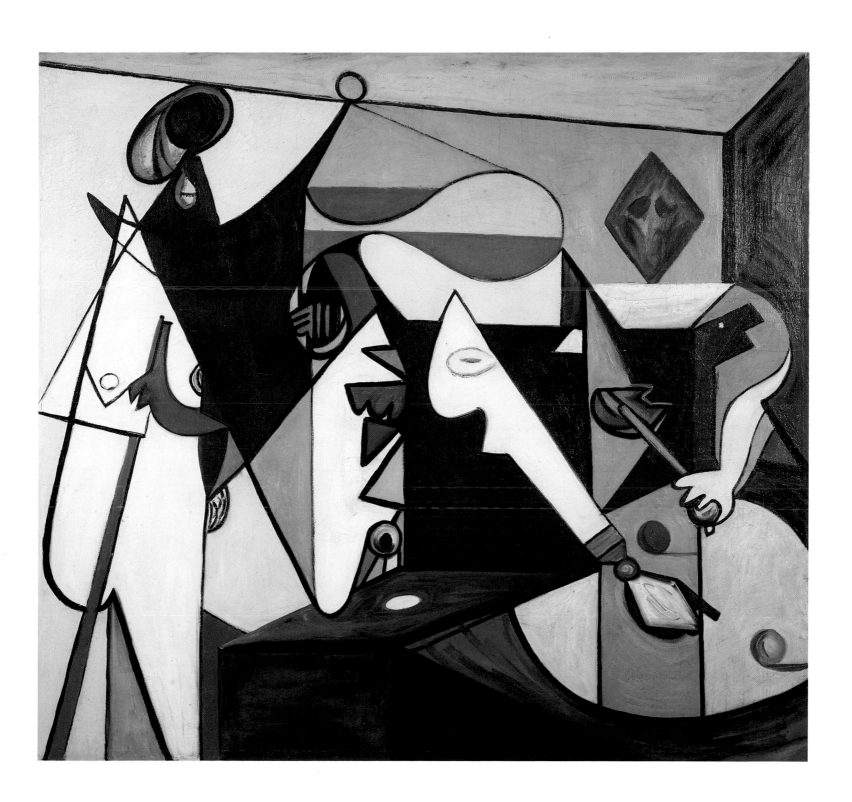

65.

Stella, Joseph

1877–1946

Gladiolus and Lilies, c. 1919

Crayon and silverpoint on prepared paper

sheet: 28½ x 22⅜ inches (72.4 x 56.8 cm.)

Signed lower right:

Joseph Stella

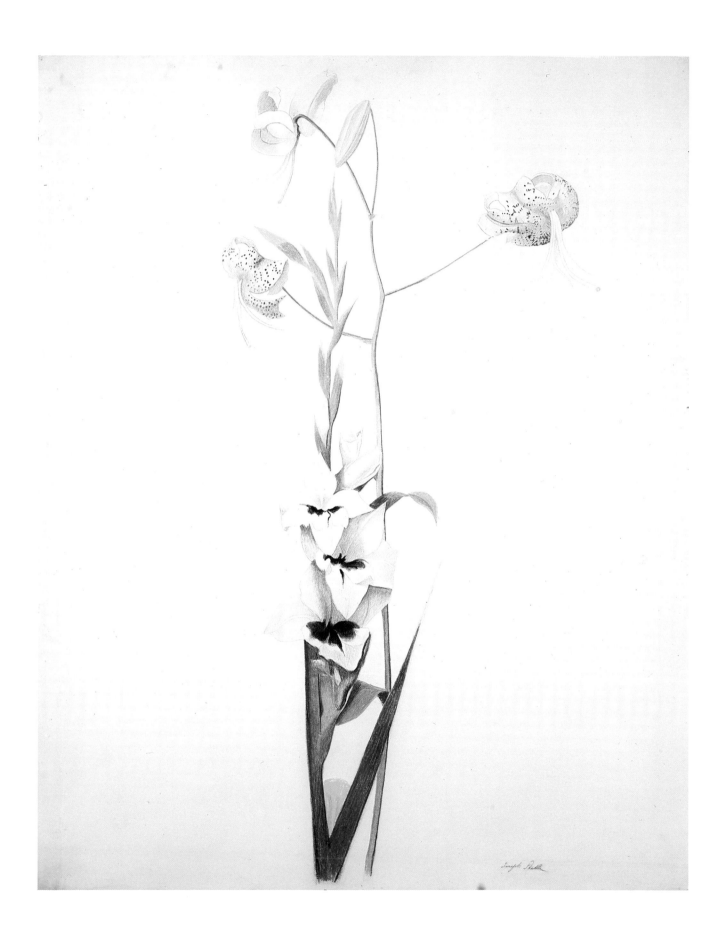

Joseph Stella

66.

Stella, Joseph

1877–1946

Tree of My Life, 1919

Oil on canvas

83½ x 75½ inches (212.1 x 191.8 cm.)

Signed lower right:

Joseph Stella

67.

Storrs, John

1885–1956

Abstraction #2, 1931/1935

(*Industrial Forms*)

Polychromed plaster

10 x 5 x 4 inches excl. base (25.4 x 12.7 x 10.2 cm.)

Signed underneath on one foot in orange paint:

John Storrs 21/5/35

on other foot without color:

11/12/31

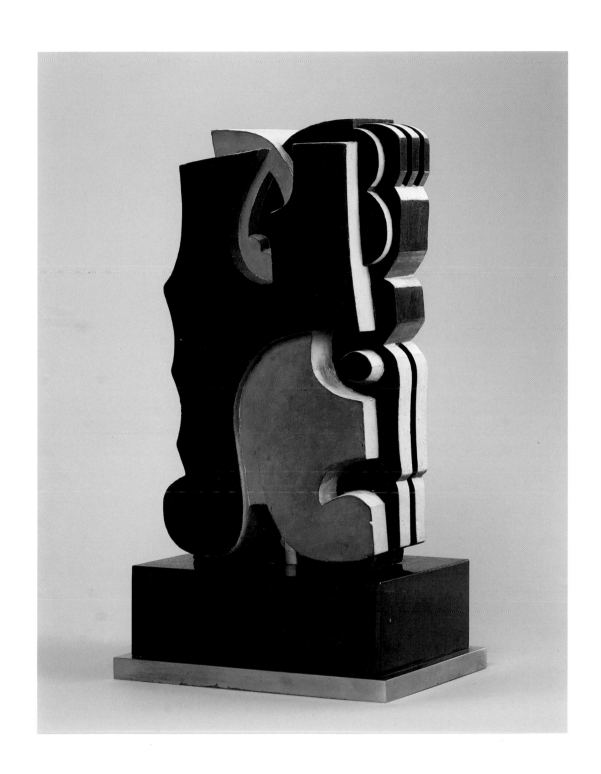

68.

Storrs, John

1885–1956

Double Entry, 1931

Oil on canvas

43¼ x 30¼ inches (109.8 x 76.8 cm.)

Signed lower left:

STORRS 5–3–31

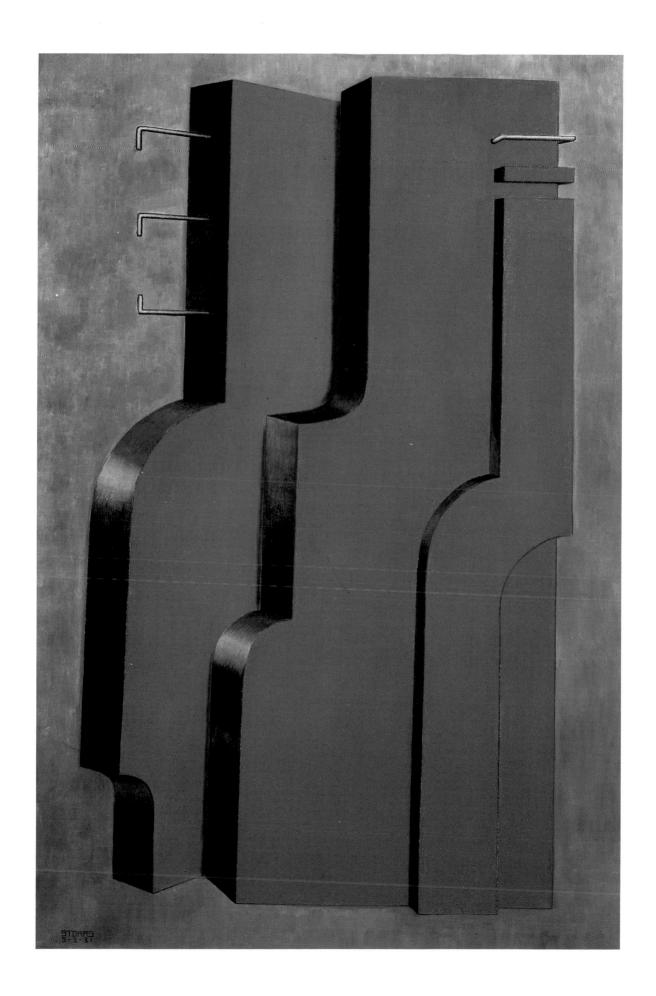

69.

Storrs, John

1885–1956

Study in Architectural Forms, c. 1923

Marble

66 x 10¾ x 3 inches (167.6 x 27.3 x 7.6 cm.)

Unsigned

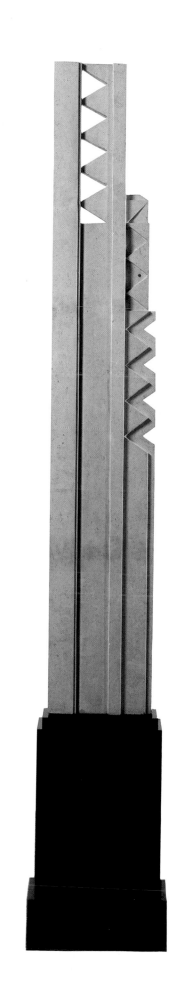

70.

Suba, Miklos

1880–1944

Storage, 1938

Oil on canvas

19⅞ x 24 inches (50.5 x 60.9 cm.)

Signed lower right:

MIKLOS SUBA.

Signed on verso: Brooklyn, N.Y.

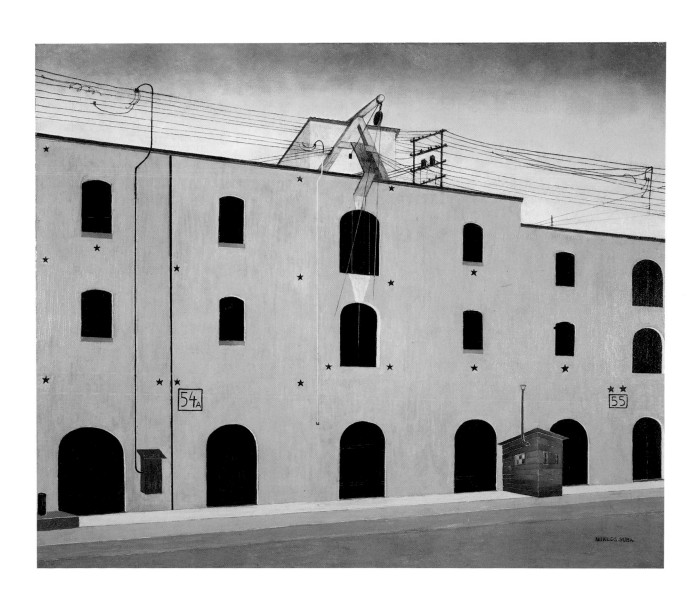

71.

Tooker, George

born 1920

The Chess Game, 1947

(*The Chessman*)

Egg tempera on masonite

30 x 14½ inches (76.2 x 36.8 cm.)

Signed lower left:

Tooker

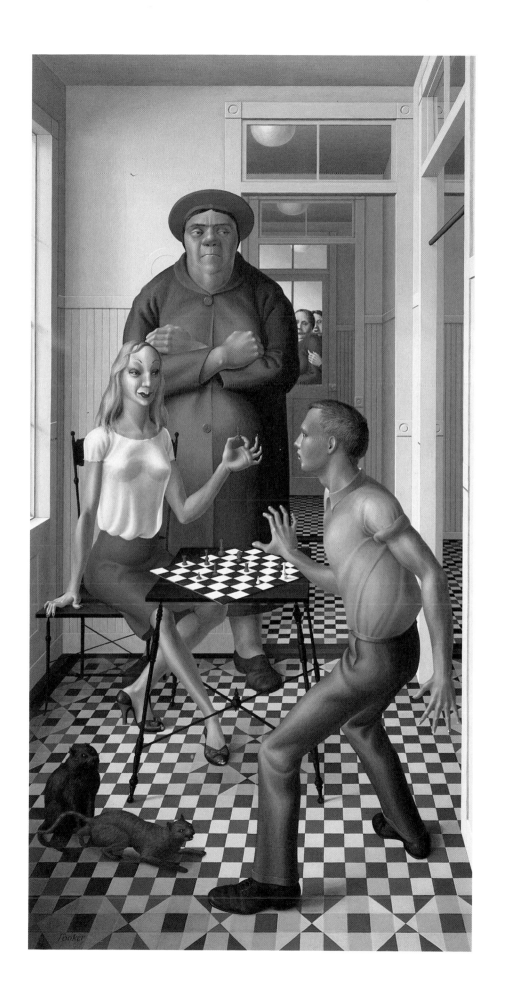

72.

Walkowitz, Abraham

1878–1965

The City, 1911

Graphite and black crayon on paper

sheet: 13¹⁄₁₆ x 8⅝ inches (33.2 x 21.9 cm.)

Signed lower right in ink:

A. Walkowitz/1911

73.

Wiltz, Arnold

1889–1937

American Landscape #3, 1931

Oil on canvas

16¼ x 20¼ inches (41.3 x 51.4 cm.)

Signed and dated lower left:

Arnold Wiltz Jan. 1931

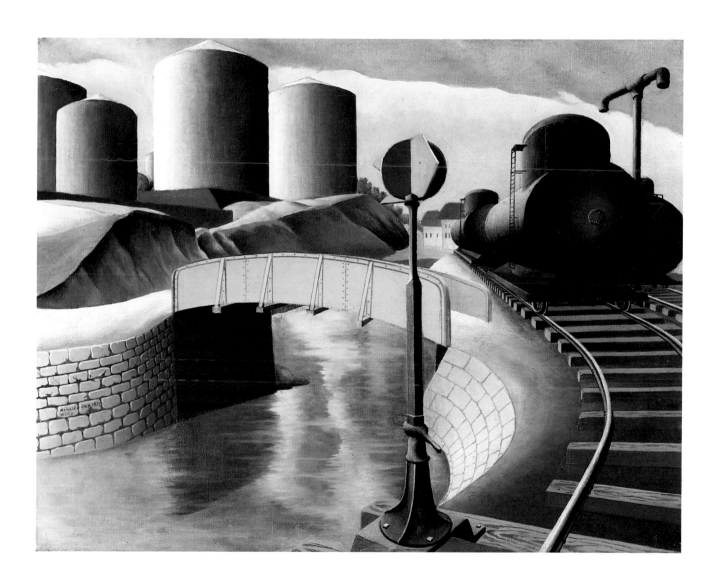

74.

Xceron, Jean

1890–1967

Composition 239A, 1937

Oil on canvas

51 x 34¾ inches (129 x 88.3 cm.)

Signed lower right:

J.X.

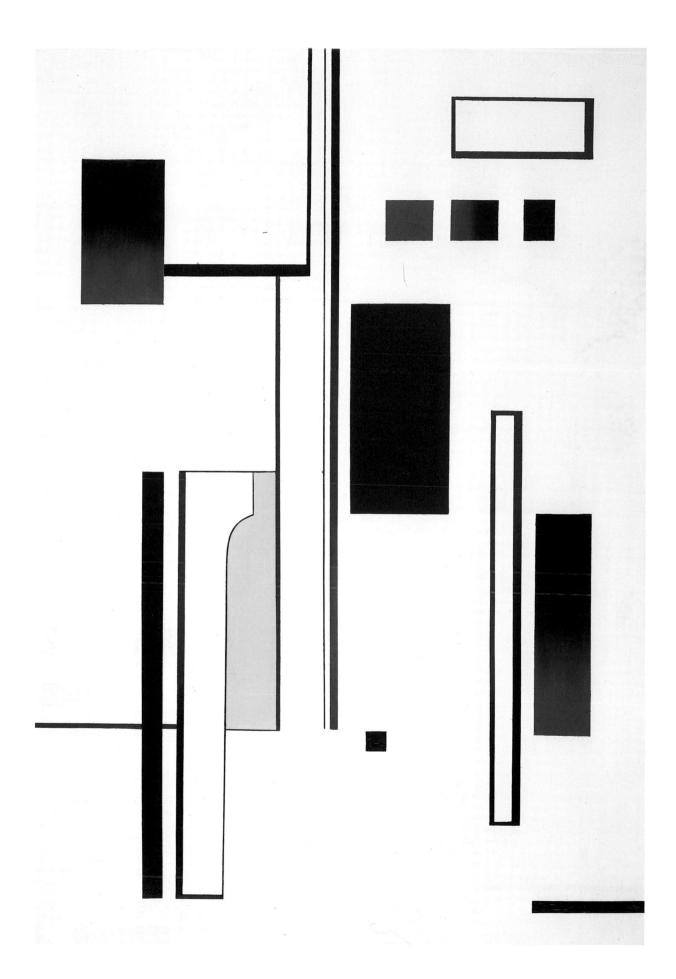

75.

Zorach, Marguerite Thompson

1887–1968

The Picnic, 1928

Oil on canvas

34 x 44 inches (86.4 x 111.8 cm.)

Unsigned

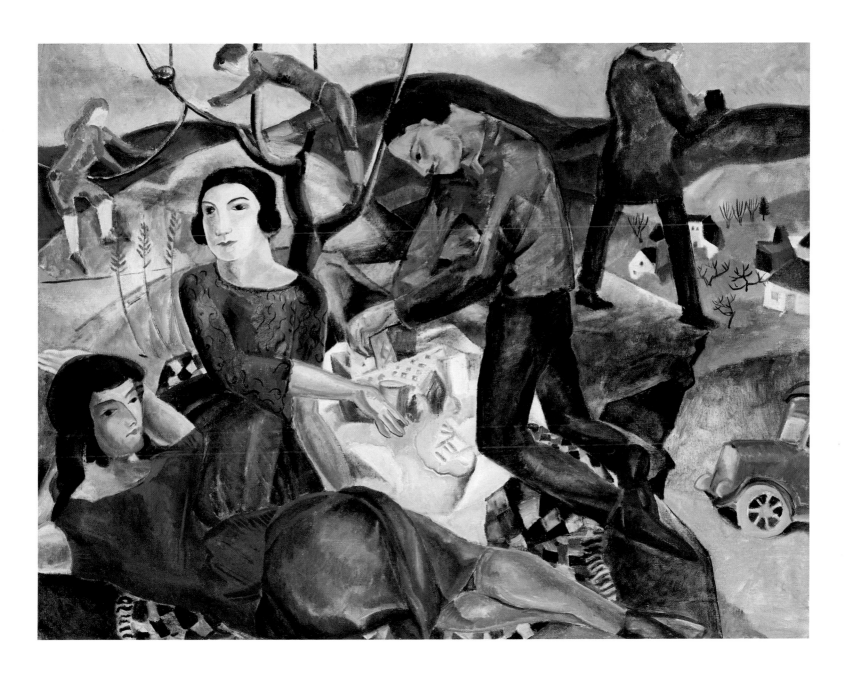

Catalogue

Ault, George
1891–1948

Fruit Bowl on Red Oilcloth, 1930

Oil on canvas, 24¼ x 20 inches
(62.2 x 50.8 cm)

Signed and dated lower left
corner: G. C. Ault '30

Provenance

Noah Goldowsky Gallery,
New York

Harry Spiro, New York

Zabriskie Gallery, New York

Acquired 1977

Exhibitions

1949
Woodstock, New York. Wood-
stock Art Gallery, *George Ault
Memorial Exhibition*, Septem-
ber 9–September 28, checklist
no. 17.

1957
New York. Zabriskie Gallery,
George Ault 1891–1948,
October 28–November 23, cat.
no. 4.

1977
New York. Zabriskie Gallery,
American Art: Fifty Years Ago,
May 24–June 18, no cat.

Bibliography

Archives of American Art,
George Ault Papers, Roll D247,
frame 297, reproduced.

Artnews, v. 76, Summer 1977,
p. 26, illus.

"In the Galleries," *Arts Maga-
zine*, v. 32, November 1957,
p. 52.

Stewart, Rick, "Charles Sheeler,
William Carlos Williams, and
Precisionism: A Redefinition,"
Arts Magazine, November,
1983, v. 58, no. 3, pp. 100–114,
illus. p. 108.

Ault, George
1891–1948

Pile Driver, 1929

Oil on canvas, 11 x 14 inches
(27.9 x 35.5 cm)

Signed lower right: G. C. Ault
'29

Provenance

Collection of the artist

Private collection, New York

Zabriskie Gallery, New York

Acquired 1982

Ault, George
1891–1948

Universal Symphony, 1947

Oil on canvas, 30 x 24 inches
(76.2 x 60.9 cm)

Signed lower left: G. C. Ault
'47

Provenance

Estate of the artist

Zabriskie Gallery

Acquired 1978

Exhibitions

1948
Pittsburgh. Museum of Fine
Arts, Carnegie Institute, *Paint-
ing in the United States, 1948*,
October 14–December 12, cat.
no. 260.

1949
Woodstock, New York. Wood-
stock Art Gallery, *George Ault
Memorial Exhibition*, Septem-
ber 9–September 23, checklist
no. 41.

1950
Woodstock, New York. Milch
Galleries, *George Ault Memo-
rial Exhibition*, January 30–
February 18, checklist no. 18.

1977
New Brunswick, New Jersey.
Rutgers University Art Gallery,
*Surrealism and American Art
1931–1947*, March 6–April 24,
cat. no. 1, illus., p. 67.

Bibliography

Adlow, Dorothy, "American
Art on Display," *Christian Sci-
ence Monitor*, February 11,
1950.

Archives of American Art,
George Ault Papers, Roll D 247,
frames 327, 444, 446–47, 455,
461, 491, 874.

Ault, Louise, *Artist in Wood-stock, George Ault: The Independent Years*, Philadelphia Dorrance and Co., 1978, pp. 171, 175.

Burrows, Carlyle, "Art Exhibits: Ault, Sepesky," *New York Herald Tribune*, Sunday, February 5, 1950.

"George Ault Memorial Exhibition," *Art News*, February 1950, v. 48, p. 50.

Lowengrund, Margaret, "George Ault 1891–1948," *Art Digest*, v. 23, September 15, 1949, p. 20.

————. "Death of Ault," *Art Digest*, v. 23, February 1, 1949, p. 25.

Tsujimoto, Karen, *Images of America: Precisionist Painting and Modern Photography*, exh. cat., San Francisco Museum of Modern Art, 1982, p. 180.

———

Blume, Peter
born 1906
Flower and Torso, 1927

Oil on canvas, 20¼ x 16⅜ inches (51.4 x 41.6 cm)

Signed lower right: Peter Blume

Provenance

The Daniel Gallery, New York

Mr. and Mrs. Robert Mack, New York

Katherine Henkl Balicki, New York

Acquired 1986

Exhibitions

1984
New York. James Maroney, Inc. *The Odd Picture—Distinctive and Yet Not Necessarily Predictable Efforts by Recognized Masters, All Modern in Their Several Ways*, November–December, cat. pp. 20–21, 62, cover illus., color and p. 63.

Bibliography

Art in America, v. 72, no. 10, November, 1984, p. 18, illus. in color.

The Museum of Modern Art, New York, Artists Files: Peter Blume.

———

Bolotowsky, Ilya
1907–1981
Blue Diamond, 1940–1941

Oil on canvas, 21 x 21 inches (53.3 x 53.3 cm)

Signed lower right: Ilya Bolotowsky

Provenance

Estate of the artist

Washburn Gallery, New York

Acquired 1984

Exhibitions

1976
New York. Washburn Gallery, *American Abstract Paintings from the 1930s and 1940s*, September 8–October 2, cat. unnumbered.

1979
New York. Washburn Gallery, *American Paintings, Drawings, Watercolors, and Sculpture, 1940–1950*, August 1–August 31, 1979, cat. unnumbered.

1979
New Haven. Yale University Art Gallery, *Mondrian and NeoPlasticism in America*, October 16–December 2, cat. no. 4, illus., text p. 9.

1983
Abstract Painting and Sculpture in America, 1927–1944, cat. no. 15, illus. color p. 87.

Pittsburgh. Museum of Art, Carnegie Institute, October 29–December 31.

San Francisco. San Francisco Museum of Modern Art, January 26–March 25, 1984.

Minneapolis. Minneapolis Institute of Arts, April 15–June 3, 1984.

New York. The Whitney Museum of American Art, June 28–September 9, 1984.

———

Browne, Byron
1907–1961
Classical Still Life, 1936

Oil on canvas, 47 x 36 inches (119.4 x 91.4 cm)

Signed and dated lower right: Byron Browne 1936

Provenance

Estate of the artist

Washburn Gallery, New York

Acquired 1977

Exhibitions

1939
New York. The Artists' Gallery, *Byron Browne, One Man Show*, February 28–March 13, no cat.

1962
New York. Art Students League, *Byron Browne, A Tribute*, January 29–February 15, cat. no. 5.

1975
New York. Washburn Gallery, *Byron Browne, Work from the 1930s*, January 7–February 1, illus. in cat. p. 4.

1983
Abstract Painting and Sculpture in America, 1927–1944, cat. no. 18, color illus. p. 88.

Pittsburgh. Museum of Art, Carnegie Institute, October 29–December 31.

San Francisco. San Francisco Museum of Modern Art, January 26–March 25, 1984.

Minneapolis. Minneapolis Institute of Arts, April 15–June 3, 1984.

New York. The Whitney Museum of American Art, June 28–September 9, 1984.

Bibliography

Archives of American Art, Byron Browne Papers, Roll NBB1, frame 701–702. Roll 97, frame 69, 117, 118, 304, 335.

"Byron Browne," *Art News*, v. 60, February 1962, pp. 44, 45.

———

Browne, Byron
1907–1961

Salute Each Time the Cock Crows, 1940

Oil on canvas, 48 x 60 inches (121.9 x 152.4 cm)

Signed lower right: Byron Browne and on verso: Byron Browne, 1940, NYC

Provenance

Collection of the artist

Raymond Ardsley, New York

Estate of the artist

Washburn Gallery, New York

Acquired 1980

Exhibitions

1944
New York. Pinacotheca Galleries, *Byron Browne*, December 12–January 1, 1945, checklist no. 3.

1979
New York. Washburn Gallery, *Abstract Art from 1930–1940: Influence and Development*, June 5–July 20, no cat.

Bibliography

Archives of American Art, Byron Browne Papers, Roll NBB1, frames 670–71, roll 97, frame 71, dated 1944, frame 217, 218.

Berman, Greta, "Byron Browne: Builder of American Art," *Arts Magazine*, December 1978, pp. 98–102.

"The Passing Shows/Byron Browne," *Art News*, v. 43, December 15, 1944, illus. p. 9.

————

Bruce, Patrick Henry
1881–1936

Peinture/Nature Morte, c. 1924 (*Forms No. 5*)

Oil and graphite on canvas, 28¼ x 35¾ inches (71.7 x 90.8 cm)

Inscribed on back: 92 x 73 30 F Amas d'objects sans point d'appui #5 Rose Friend (sic) Gallery, New York, (pas à tout à fait fini)

Provenance

Henri-Pierre Roche

Mme. Henri-Pierre Roche

M. Knoedler & Co., Inc., New York (on consignment)

Noah Goldowsky Gallery, New York

Mr. and Mrs. Henry M. Reed, Red Bank, New Jersey

Benjamin F. Garber, Marigot, St. Martin

Washburn Gallery, New York

Acquired 1982

Exhibitions

1950
New York, Rose Fried Gallery, *The Synchromists: Morgan Russell, Stanford MacDonald-Wright, Patrick Henry Bruce*, November 20–December 31, no cat.

1965
New York. Knoedler & Co. *Synchromism and Color Principles in American Painting, 1910–1930*, October 12–November 6, cat. no. 11.

1967
New York. Noah Goldowsky Gallery.

1969
Montclair, New Jersey. Montclair Art Museum, *Synchromism from the Henry M. Reed Collection*, April 6–April 27, cat. no. 6.

1979
Patrick Henry Bruce: American Modernist, no checklist, illus. in cat., plate p. 35.

Houston. Museum of Fine Arts, May 17–July 15.

New York. Museum of Modern Art. August 22–October 21.

Richmond. Virginia Museum, November 26–January 6, 1980.

Bibliography

Agee, William, "Patrick Henry Bruce: A Major American Artist of Early Modernism," *Arts in Virginia*, Spring 1977, v. 17, no. 3, pp. 12–32, illus.

Agee, William and Rose, Barbara, *Patrick Henry Bruce, American Modernist: A Catalogue Raisonné*, The Museum of Modern Art, New York, 1979, illus. pp. 27, 204, text pp. 30, 31, 36, 73, cat. no. D17.

Art in America, v. 68, March 1968, p. 20, illus. in color.

Kramer, Hilton, "Rediscovering the Art of Patrick Henry Bruce," *New York Times*, Sunday, July 17, 1979, D, p. 21.

Seuphor, Michel, "Peintures construites," *L'Oeil*, no. 58, October, 1959, illus. p. 39.

————. *L'Art Abstrait*, Paris, Maeght, 1971–1974, illus. v. 2, p. 102.

————

Burchfield, Charles
1893–1967

Black Houses, 1918 (*The Bleak Houses*)

Watercolor on paper, 15⅞ x 24⅝ inches (40.3 x 62.5 cm)

Signed lower right: Chas Burchfield/1918

Provenance

Kevorkian Galleries, New York

Frank K. M. Rehn Gallery, New York

Dr. and Mrs. Theodore Braasch, Cleveland, Ohio

Sotheby Parke-Bernet, New York, Sale #3373, May 24, 1972, Lot 175, illus. in color in cat.

Exhibitions

1920
New York. Kevorkian Galleries, *Drawings in Watercolor by Charles Burchfield*, February 16–February 28.

1956
Charles Burchfield, illus. cat. no. 14.

New York. The Whitney Museum of American Art, January 11–February 26.

Baltimore. The Baltimore Museum of Art, March 14–April 22.

Boston. Museum of Fine Arts, May 9–June 17.

San Francisco. San Francisco Museum of Modern Art, July 11–August 19.

Los Angeles. Los Angeles County Museum of Art, September 5–October 15.

Washington, D.C. The Phillips Gallery, November 4–December 11.

Cleveland. Cleveland Museum of Art, January 3–February 10, 1957.

1965
Tucson. University of Arizona Art Gallery, *Charles Burchfield, His Golden Year: A Retrospective Exhibition of Watercolors, Oils and Graphics*, November 14, 1965–January 9, 1966, cat. no. 15, illus. p. 64, text p. 23.

1967
Buffalo. Buffalo State University College, The Charles Burchfield Center, *The Burchfield Commemorative Program: Charles Burchfield Paintings Loaned by Two New York City Collectors, Theodore Braasch and David Rockefeller*, October 1, 1967–January 30, 1968, cat. no. 4.

1970
Utica, New York. Munson-Williams-Proctor Institute, *The Nature of Charles Burchfield: A Memorial Exhibition*, April 9–May 31, cat. no. 430, p. 77, illus. p. 81.

Bibliography

Archives of American Art, Roll 922, Letters from Charles Burchfield to Theodore Braasch, 1953–1965, frames 45–49, 54–55, 60, 75, 304–307.

Charles Burchfield: A Catalogue of Paintings in Public and Private Collections, Museum of Art, Munson-Williams-Proctor Institute, Utica, New York, 1970, no. 430, p. 77, illus. p. 81.

Reeves, Jean, "Art in the Buffalo Area/Early Burchfield Works in Buffalo State Show," *Buffalo Evening News*, October 11, 1967.

Straus, John, "Charles Burchfield," Honors thesis, Harvard College, 1942, no. 301.

Trovato, Joseph, ed. *Charles Burchfield*, Utica, New York, 1970, no. 430.

Calder, Alexander
1898–1976

Le Coq, c. 1944
(*Hen with Red Knife*)

Four painted wood elements, steel wire, 18½ x 8½ x 3¾ inches (47 x 21.6 x 9.5 cm)

Signed at bottom: CA

Provenance

Keith Warner, New York

Perls Galleries, New York

Leslie Waddington Galleries, London

Private collection, New York

Hirschl & Adler Galleries, New York

Acquired 1985

Exhibitions

1982
New York. Hirschl & Adler Galleries, *Carved and Modelled: American Sculpture 1810–1940*.

Bibliography

Art in America, July 1985, illus. inside front cover.

Bourdon, David, *Calder: Mobilist/Ringmaster/Innovator*, New York, 1980, illus. p. 85 as *Hen with Red Knife*.

Criss, Francis H.
1901–1973

Melancholy Interlude, 1939
(*Grain Elevator*)

Oil on canvas, 25 x 30 inches (63.5 x 76.2 cm)

Signed lower right: Francis Criss '39

Provenance

Encyclopaedia Britannica Corporation, Chicago

Senator William Benton, Connecticut

Charles and Marjorie Benton, Chicago

Hirschl & Adler Galleries, New York

Acquired 1985

Exhibitions

1945
Chicago. The Art Institute of Chicago, *The Encyclopaedia Britannica Collection*, April 12–May 12.

1947
St. Louis. City Art Museum, *Contemporary American Painting from the Encyclopaedia Britannica Collection*, cat. illus. p. 7. February 20–March 20.

1975
Storrs. University of Connecticut, Museum of Art, Indefinite Loan, Estate of William Benton.

1977
New York. Hirschl & Adler Galleries, *Lines of Power*, March 12–April 9, illus. cat. unnumbered.

1983
Evanston, Illinois. Terra Museum of American Art, *Two Hundred Years of American Painting from Private Chicago Collections*, June 25–September 2, cat. no. 53, illus., p. 30, text p. 39.

Bibliography

Archives of American Art, Francis Criss Papers, Roll N70–34, frame 19 as *Grain Elevator*: frame 492, illus., frame 703–705, illus.

Cessna, Ralph W. "Art via the Britannica," *Christian Science Monitor*, Weekly Magazine, March 3, 1945, pp. 10–11, illus.

"Esquire's Art Institute," *Esquire Magazine*, August 1945, vol. XXIV, no. 2, pp. 70–71.

Pagano, Grace, *The Encyclopaedia Britannica Collection of Contemporary American Painting*, 1946, cat. unnumbered, plate 26.

Dasburg, Andrew
1897–1979

Landscape, 1913

Oil on panel, 10⅛ x 12⅜ inches (25.7 x 31.4 cm)

Dated: Monhegan 1913 and inscribed on verso: To my dearest friend Grace Mott Johnson

Provenance

Grace Mott Johnson, New York

Christie's, New York, Sale #5580, June 1, 1984, Lot 226 A, illus. in color in cat.

Exhibitions

1925
New York. The Whitney Studio Club, *An Exhibition of Paintings by Andrew Dasburg and Katherine Schmidt*, January 29–February 14, cat. no. 10.

Daugherty, James Henry
1889–1974

Seated Nude, c. 1915

Pastel and graphite on paper, 11⅞ x 8¾ inches (30.1 x 22.4 cm)
Verso: Graphite on paper

Signed and dated lower left at a later date: JD 1917

Provenance

Estate of the artist

Robert Schoelkopf Gallery, New York

Acquired 1980

Davis, Stuart
1892–1964

Still Life in the Street, c. 1941 (*French Landscape*)

Oil on canvas, 10 x 12 inches (25.4 x 30.5 cm)

Signed lower right: Stuart Davis

Provenance

The Downtown Gallery, New York

Jemison Hammond, New York

Dr. and Mrs. Irving Burton, Huntington Woods, Michigan

Sotheby Parke-Bernet, New York, Sale #3417, October 18, 1972, Lot 54.

Exhibitions

1943
New York. The Downtown Gallery, *Stuart Davis*, February 2–February 27, no. 12 as *Still Life in the Street.*

1978
Stuart Davis, Art and Art Theory, cat. no. 109, illus. p. 190.

Brooklyn. Brooklyn Museum of Art, January 21–March 19.

Cambridge. Fogg Art Museum, Harvard University, April 15–May 28.

Dawson, Manierre
1887–1969

Blue Trees on Red Rocks, 1918

Oil on panel, 17¼ x 14⅛ inches (43.8 x 35.8 cm)

Signed lower right: Dawson 18

Provenance

Collection of the artist

Atrium Arts, Wilmette, Illinois

Robert Schoelkopf Gallery, New York

Acquired 1983

Exhibitions

1976
Chicago. Museum of Contemporary Art, *Manierre Dawson, 1887–1969: A Retrospective Exhibition of Painting*, November 13, 1976–January 2, 1977, listed in cat., unnumbered.

1982
New York. Richard York Gallery, *The Natural Image: Plant Forms in American Modernism*, November 6–December 4, cat. no. 6.

Demuth, Charles
1883–1935

Fruit and Flower, c. 1928

Watercolor and graphite on paper, 12 x 18 inches (30.5 x 45.7 cm)

Provenance

Mrs. Augusta W. B. Demuth, Lancaster, Pennsylvania

Robert E. Locher, New York and Lancaster, Pennsylvania

Richard C. Weyand, Lancaster, Pennsylvania

Sotheby Parke-Bernet, New York, Sale #1772, October 16, 1957, Lot 56, illus. p. 21 as *Fruit and Flower Group.*

The Downtown Gallery, New York

Mrs. Suydam Cutting, New York

Robert Miller Gallery, New York

James Maroney Inc., New York

Richard Manoogian, Grosse Pointe Shores, Michigan

James Maroney Inc., New York

Acquired 1986

Exhibitions

1937
New York. The Whitney Museum of American Art, *Charles Demuth Memorial Exhibition*, December 15, 1937–January 16, 1938, unpaged, no. 99, as *Fruit and Flowers.*

1948
Lancaster, Pennsylvania. Fackenthal Library of Franklin and Marshall College, *Twenty-Nine Watercolors by Demuth*, January 3–January 11, unpaged, no. 20, as *Fruit and Flowers.*

1958
New York. The Downtown Gallery, *Charles Demuth: 30 Paintings*, Gallery Collection, May 20–June 7, unpaged, no. 15, as *Fruit and Flower Group.*

1984
New York. James Maroney, Inc., *A Small Group of Especially Fine Works on Paper*, February, illus. in color.

1988
Detroit. The Detroit Institute of Arts, *Charles Demuth*, August 7–October 2.

Bibliography

Archives of American Art, Downtown Gallery Papers, Harris Steinberg Papers.

Art in America, vol. 72, February 1984, p. 18, illus. in color.

Eiseman, Alvord L., *Charles Demuth*, New York, 1982, pp. 74–75, pl. 35, illus. in color.

Farnham, Emily, "Charles Demuth: His Life, Psychology and Works," unpublished Ph.D. dissertation, Ohio State University, 1959, cat. no. 633.

Malone, Mrs. John E., "Charles Demuth: Watercolors by Charles Demuth," *Papers of the Lancaster County Historical Society*, vol. 52, no. 1, 1948, p. 15, as *Fruit and Flowers*.

Photographic Files, Frick Art Reference Library, New York.

————————

Demuth, Charles
1883–1935
Three Lilies, 1926
(*Study of Three Flowers*)
Watercolor with graphite on paper
19¹⁵⁄₁₆ x 13¹⁵⁄₁₆ inches (50.5 x 35.4 cm)
Unsigned

Provenance

Estate of the artist

Robert Locher, Lancaster, Pennsylvania

Richard C. Weyand, Lancaster, Pennsylvania

Edwin S. Weyand, Boise, Idaho

Roy Anderson, Brand Gallery, Ltd., San Francisco

Hirschl & Adler Galleries, New York

Acquired 1981

Bibliography

Farnham, Emily, "Charles Demuth: His Life, Psychology and Work," unpublished Ph.D. dissertation, Ohio State University, 1959, cat. no. 744.

————————

Dickinson, Preston
1891–1930
The Artist's Table, n.d.
Oil on board, 22½ x 14½ inches (57.2 x 36.7 cm)
Signed lower right: P. Dickinson

Provenance

Christie's, New York, Sale #5958, September 27, 1985, Lot 345.

Bibliography

Berman, Anne, "Christie's, 19th and 20th Century American Art," *Maine Antiques Digest*, December 1985, pp. 14–15D, illus.

————————

Dickinson, Preston
1889–1930
Garden in Winter, c. 1922
Charcoal on paper, uneven sheet, 14⅜ x 10½ inches (36.5 x 26.7 cm)
Signed lower left: Dickinson

Provenance

Wanamaker Gallery of Modern Decorative Art, Fifth Gallery, Belmaison, New York, 1922.

Christie's East, New York

Kraushaar Galleries, New York

Acquired 1984

Exhibitions

1922
New York. Wanamaker Gallery of Modern Decorative Art, Fifth Gallery, Belmaison, *Black and White Drawings by American Artists*, May 4–May 31, cat. no. 31.

Bibliography

Archives of American Art, Roll D176, Yasuo Kuniyoshi Papers, frame 107.

The Dial, v. 73, July 1922, f.p. 72.

"Preston Dickinson—Painter, 1891–1930," *Index of Twentieth Century Artists*, January 1936, vol. III, no. 4, p. 218.

————————

Provenance

Mr. and Mrs. Max Zurier, Los Angeles

John Berggruen Gallery, San Francisco

Acquired 1984

Exhibitions

1963
Pasadena. Pasadena Art Museum, *Mr. and Mrs. Max Zurier Collection*, April 30–May 21, cat. no. 21, date listed as c. 1924.

1976
La Jolla. La Jolla Museum of Contemporary Art, *Paintings from the Zurier Collection*, May 8–June 6, no cat.

1984
San Francisco. John Berggruen Gallery, *The Zurier Collection*, March 28–May 1, cat. no. 11, pp. 26–27.

Bibliography

Archives of American Art, Suzanne Mullet Smith Papers, Roll 1043, frame 350.

————————

Dove, Arthur
1880–1946
Moon, 1935
Oil on canvas, 35 x 25 inches (88.9 x 63.5 cm)
Signed lower center: Dove

Provenance

Alfred Steiglitz (An American Place), New York

The Downtown Gallery, New York

Mr. and Mrs. Max Zurier, Los Angeles

John Berggruen Gallery, San Francisco

Acquired 1985 by Mr. and Mrs. Barney A. Ebsworth Foundation

————————

Dove, Arthur
1880–1946
Holbrook's Bridge, 1935
Watercolor and gouache on paper, 7 x 5 inches (17.7 x 12.7 cm)

Exhibitions

1936
New York. The Whitney Museum of American Art, *Third Biennial Exhibition of Contemporary American Painting*, November 10–December 10, cat. no. 11.

1936
New York. An American Place, *New Paintings by Arthur Dove*, April 20–May 20, checklist no. 16.

1936
New York. An American Place, *Exhibition of Paintings: Charles Demuth, Arthur G. Dove, Marsden Hartley, John Marin, Georgia O'Keeffe, and Rebecca S. Strand*, November 27–December 31, no cat.

1941
New York. An American Place, *Exhibition of New Arthur Dove Paintings*, March 27–May 17, checklist no. 12.

1952
New York. The Downtown Gallery, *Arthur Dove, 1880–1946: Paintings*, April 22–May 10, cat. no. 9.

1952
Buffalo. Albright-Knox Art Gallery, *Expressionism in American Painting*, May 10–June 29, illus. in cat. p. 36, cat. no. 28, p. 58.

1954
Minneapolis. Walker Art Center, *Paintings and Watercolors by Arthur Dove*, January 10–February 20, cat. no. 11.

1956
Los Angeles. Los Angeles Municipal Gallery, *The American Scene*, April 17–May 6.

1956
Los Angeles. University of California at Los Angeles, *American Paintings in This Century*, November 4–December 14.

1957
New York. The Downtown Gallery, *Ten Paintings Selected From 'New Art in America,'* October 7–November 2, cat. unnumbered.

1958
Arthur Dove Retrospective Exhibition, cat. no. 52, p. 94.

New York, The Whitney Museum of American Art.

Washington, D.C. Phillips Memorial Gallery.

Boston. Museum of Fine Arts.

San Antonio. Marion Koogler McNay Art Institute.

Los Angeles. Art Galleries of the University of California at Los Angeles.

La Jolla. La Jolla Art Center.

San Francisco. San Francisco Museum of Modern Art.

1963
Pasadena. Pasadena Art Museum, *Mr. and Mrs. Max Zurier Collection*, April 30–May 21, cat. no. 23, illus. on cover.

1964
Pasadena. Pasadena Art Museum, *A View of the Century*, November 24–December 19, cat. no. 47.

1974
Arthur Dove, illus. in color, cat. p. 85.
San Francisco. San Francisco Museum of Modern Art, November 21, 1974–January 5, 1975.
Buffalo. Albright-Knox Gallery, January 27–March 2, 1975.
St. Louis. The Saint Louis Art Museum, April 3–May 25, 1975.
Chicago. The Art Institute of Chicago, July 12–August 31, 1975.
Des Moines. Des Moines Art Center, September 22–November 2, 1975.
New York. The Whitney Museum of American Art, November 24, 1975–January 18, 1976.

1976
La Jolla. La Jolla Museum of Contemporary Art, *Paintings from the Zurier Collection*, May 8–June 6, no cat.

1979
2 Jahrzehnte amerikanische Malerei 1920–1940, cat. no. 59, illus. p. 74.
Dusseldorf. Städtische Kunsthalle, June 8–August 5.
Zurich. Kunsthaus, August 23–October 21.
Brussels. Palais des Beaux Arts, November 15–December 31.

1980
A Mirror of Creation: 150 Years of American Nature Painting, cat. no. 43, illus. in color, cat. unpaged.
The Vatican. Collezione D'arte Religiosa, Braccio di Carlo Magno, September 24–November 23.
Evanston, Illinois. Terra Museum of Art, December 20, 1980–March 1981.

1982
Munich. Haus der Kunst, *Amerikanische Malerei, 1930–1980*, cat. no. 4, p. 24.

1984
San Francisco. John Berggruen Gallery, *The Zurier Collection: An Exhibition of 20th Century American and European Paintings and Works on Paper*, March 28–May 1, cat. no. 12, p. 27, illus. p. 11.

Bibliography

Archives of American Art, Downtown Gallery Papers, Roll ND 30, frame 335, Roll ND 31, frame 482, Roll 2425, frames 1092, 1093.

Baur, John, "Art in America: Four Centuries of Painting and Sculpture at Galaxon New York World's Fair," *Art in America*, v. 50, no. 3, Fall 1972, p. 59.

Baur, John, et al. *New Art in America: Fifty Painters of the Twentieth Century*, New York, New York Graphic Society, 1957, p. 80, illus.

Cohn, Sherrye, "The Image and the Imagination of Space in the Art of Arthur Dove, Part II: Dove and the Fourth Dimension," *Arts*, January 1984. pp. 121–25.

Metzger, Robert, "Biomorphism in American Painting," Ph.D. dissertation, University of California at Los Angeles, 1973, pp. 62–63.

Morgan, Ann Lee, *Arthur Dove: Life and Work with a Catalogue Raisonné*, Cranbury, New Jersey, Associated University Presses, 1984, no. 36.8, pp. 232–34, 257.

Rosenblum, Robert, *Modern Painting and the Northern Romantic Tradition: Friedrich to Rothko,* New York, 1975, pp. 207, 228, illus. #302.

Selz, Peter, *Art in Our Times: A Pictorial History 1890–1980,* New York, Abrams, 1981, illus. color, p. 325, no. 856.

Wight, Frederick, *Arthur G. Dove,* Berkeley and Los Angeles, University of California Press, 1958, pp. 66–67, illus.

Dove, Arthur
1880–1946

Sea II, 1925

Chiffon over metal with sand, 12½ x 20½ inches (31.7 x 52.1 cm)

Inscribed on panel affixed to verso: Arthur Dove, Sea II, 1925.

Provenance

Estate of the artist

Terry Dintenfass Gallery, New York

Edith Gregor Halpert, New York

Sotheby Parke-Bernet, New York, Sale #3484, March 15, 1973, Lot 105, illus. in color in cat.

Exhibitions

1955
New York. The Downtown Gallery, *Collages Dove,* November 1–November 26, cat. no. 8

1958
Houston. Contemporary Arts Museum, *Collage International: From Picasso to the Present,* February 27–April 6, listed in cat. (unpaged and unnumbered).

1961
Des Moines. Des Moines Art Center, *Six Decades of American Painting of the Twentieth Century,* February 10–March 12, cat. no. 20, listed as *The Sea.*

1967
College Park, Maryland. University of Maryland Art Gallery, *Arthur Dove: The Years of Collage,* March 13–April 19, cat. no. 15.

1971
New York. Terry Dintenfass Gallery, *Arthur G. Dove: Collages,* December 22–January 23, 1972, cat. no. 7.

1974
Arthur Dove, illus. in cat., p. 50.

San Francisco. San Francisco Museum of Modern Art, November 21, 1974–January 5, 1975.

Buffalo. Albright-Knox Gallery, January 27–March 2, 1975.

St. Louis. The Saint Louis Art Museum, April 3–May 25, 1975.

Chicago. The Art Institute of Chicago, July 12–August 31, 1975

Des Moines. Des Moines Art Center, September 22–November 2, 1975.

New York. The Whitney Museum of American Art, November 24, 1975–January 18, 1976.

Bibliography

Archives of American Art, Downtown Gallery Papers, Roll ND 31, frames 354, 355, 333, Roll 2425, frame 251.

Morgan, Ann Lee, *Arthur Dove: Life and Work with a Catalogue Raisonné,* Cranbury, New Jersey, Associated University Presses, 1984, p. 144, illus. p. 145, no. 25.16.

Fiene, Ernest
1894–1965

Winter Day, Pittsburgh, 1935–1936

Oil on canvas, 34 x 42 inches (86.3 x 106.7 cm)

Signed lower right: E. Fiene

Provenance

Estate of the artist

Jeanette Fiene, New York

Edward Levy, New York

D. Wigmore Fine Art, Inc., New York

Acquired 1983

Exhibitions

1937
Pittsburgh. The First National Bank, *The Industrial Scene,* October, cat. no. 17.

1983
New York. D. Wigmore Gallery, *The American Scene Movement in the Art of the 1930s and 1940s,* cat. illus. p. 15, color.

Fiene, Paul
1899–1949

Grant Wood, 1941

Terra-cotta on alabaster base, 18½ x 7½ x 8 inches (46.9 x 19.1 x 20.3 cm)

Signed: P. Fiene '41

Provenance

Family of the artist

Conner-Rosenkranz, New York

Acquired 1986

Frelinghuysen, Suzy
born 1912

Composition, 1943

Mixed media (oil on panel with corrugated cardboard), 40 x 30 inches (101.6 x 76.2 cm)

Unsigned

Provenance

Mrs. Charles H. Russel, New York

Washburn Gallery, New York

Acquired 1977

Exhibitions

1946
New York. Wildenstein & Co. *Sixth Annual Exhibition of Paintings and Sculpture by Members of the Federation of Modern Painters and Sculptors,* September 18–October 5, cat. no. 14.

1983
Abstract Painting and Sculpture in America, 1927–1944, cat. no. 48, illus. color p. 108.

Pittsburgh. Museum of Art, Carnegie Institute, October 29–December 31, 1983.

San Francisco. San Francisco Museum of Modern Art, January 26–March 25, 1984.

Minneapolis. Minneapolis Institute of Arts, April 15–June 3, 1984.

New York. The Whitney Museum of American Art, June 28–September 9, 1984.

Bibliography

Bazin, Germain, ed. *Histoire de la Peinture Classique et la Peinture Moderne*, Paris, 1950, 1960, p. 606.

Gallatin, Albert E.
1882–1952

Cubist Abstraction, 1943

Oil on canvas, 16 x 20 inches (40.6 x 50.8 cm)

Signed and dated on verso: A. E. Gallatin Dec. 1943

Provenance

Christie's, New York, Sale #5580, June 1, 1984, Lot 289, illus. color in cat.

Exhibitions

1945
New York. *Paintings by A. E. Gallatin*, Mortimer Brandt Gallery, February 3–February 17.

1952
New York. Rose Fried Gallery, *Retrospective Exhibition: A. E. Gallatin*, April 8–April 30, cat. no. 13.

Bibliography

Paintings by Gallatin, New York, Wittenborn, Schultz, 1948, plate 14, illus.

Glackens, William
1870–1938

Cafe Lafayette, 1914 (*Portrait of Kay Laurell*)

Oil on canvas, 31¾ x 26 inches (80.6 x 66 cm)

Signed lower right: Wm. Glackens. Inscribed "Kay Laurell" on verso and titled on stretcher bar.

Provenance

Kraushaar Galleries, New York

William Macbeth Galleries, New York

Mr. and Mrs. Lincoln Isham, Dorset, Vermont

Sotheby Parke-Bernet, New York, Sale #3373, May 24, 1972, Lot 186.

Exhibitions

1933
Cleveland. Cleveland Museum of Art, *Thirteenth Annual Exhibition of Contemporary American Oils*, June 16–July 16, no cat.

1933
Springfield, Massachusetts. Springfield Art Museum, October.

1933
Kansas City. William Rockhill Nelson Gallery of Art, *Opening Exhibition: A Loan Exhibition of American Paintings Since 1900*, December 10, 1933–January 4, 1934, listed in cat., unnumbered.

1938
New York. The Whitney Museum of American Art, *William Glackens Memorial Exhibition*, December 14, 1938–January 15, 1939, cat. no. 82, illus.

1939
Philadelphia. Carnegie Institute, Department of Fine Arts, *Memorial Exhibition of Works by William Glackens*, February 1–March 15, cat. no. 78.

1982
St. Louis. The Saint Louis Art Museum, *Impressionism Reflected: American Art, 1890–1920*, May 8–June 27, listed in cat., unnumbered.

Bibliography

Art News, v. 37, December 17, 1938, p. 9.

Bennett, Ira, *A History of American Painting*, London, The Hamlyn Group Ltd., 1973, illus., color, p. 161, fig. 162.

DuBois, Guy, *William J. Glackens*, The Whitney Museum of American Art, New York, 1931, illus. facing p. 32.

Glackens, Ira, *William Glackens and the Ashcan Group: The Emergence of Realism in American Art*, New York, Crown Publ., 1957, illus. in plates between pp. 174–175.

New York Evening Post Wednesday Gravure, February 15, 1933.

St. Louis Post-Dispatch, Sunday Supplement, May 9, 1982, illus.

"'The Thirteenth Exhibition of Contemporary American Oils," *The Bulletin of the Cleveland Art Museum*, Summer 1933, p. 101.

"William Glackens, Painter," *Index of Twentieth Century Artists*, vol. II, no. 4, January 1935.

Gorky, Arshile
1905–1948

Abstraction, 1936

Oil on canvas mounted on masonite, 35⅛ x 43⅛ inches (89 x 109.5 cm)

Unsigned

Provenance

Mr. and Mrs. Hans Burkhardt, Los Angeles

Sotheby Parke-Bernet, New York, Sale #4064, December 16, 1977, Lot 97, illus. in color.

Dr. Henry Ostberg, New York

Acquired 1978

Exhibitions

1958
Pasadena. The Pasadena Museum of Art, *Paintings by Arshile Gorky*, January 3–February 2, no. cat.

1963
Arshile Gorky: Paintings and Drawings 1927–1937, cat. no. 10.

La Jolla, California. La Jolla Museum of Art, February 21–March 21, 1963.

San Francisco. San Francisco State College, September 14–October 10, 1964.

Calgary. Alberta College of Art.

Bibliography

Bordeaux, Jean-Luc, "Arshile Gorky: His Formative Period (1925–1930)," *American Art Review*, v. 1, no. 4, May–June 1974, p. 143.

Jordan, Jim M., and Goldwater, Robert, *The Paintings of Arshile Gorky: A Critical Catalogue*, New York and London, New York University Press, 1982, no. 172, pp. 316–17.

Guglielmi, O. Louis
1906–1956

Land of Canaan, 1934

Oil on canvas, 30¼ x 36½ inches (77.5 x 92.7 cm)

Signed lower left: Guglielmi

Provenance

George S. Kaufman, New York

Edith Gregor Halpert, New York

Sotheby Parke-Bernet, New York, Sale #3484, March 15, 1973, Lot 81.

Exhibitions

1936
New York. The Downtown Gallery, *American Art 1800–1936: Tenth Anniversary Exhibition*, October 28–November 26, no cat.

1958
Lynchburg, Virginia. Randolph Macon Women's College, The Maier Museum of Art, *47th Annual Exhibition: The Painter as Social Commentator*, March 2–March 30, checklist no. 3.

1965
New York. The Downtown Gallery, *A Gallery Survey of American Art*, September 8–October 2, no. cat.

1967
Fort Worth. Amon Carter Museum, *American Art, 20th Century: Image to Abstraction*, September 14–November 19.

1972
Washington, D.C. The National Collection of Fine Arts, *Edith Gregor Halpert Collection*, April, cat. no. 7.

1980
O. Louis Guglielmi: A Retrospective Exhibition, cat. no. 17, illus. color, plate 1.

New Brunswick. Rutgers University Art Gallery, November 2–December 21.

Providence, Rhode Island. Bell Gallery, Brown University, January 10–February 1, 1981.

Albany. University Art Gallery, State University of New York, March 1–April 25, 1981.

New York. The Whitney Museum of American Art, May 6–July 5, 1981.

Bibliography

Archives of American Art, Downtown Gallery Papers, Roll ND 44, frames 58–59.

Guglielmi, O. Louis
1906–1956

Mental Geography, 1938

Oil on masonite, 35¾ x 24 inches (90.8 x 60.9 cm)

Signed lower left: Guglielmi 38

Provenance

Edith Gregor Halpert, New York

Sotheby Parke-Bernet, New York, Sale #3484, March 15, 1973, Lot 137.

Exhibitions

1938
St. Louis. City Art Museum, *Thirty-third Annual Exhibition of Paintings by American Artists*, December 31, 1938–February 12, 1939, cat. no. 29, p. 9.

1938
New York. Downtown Gallery, *Guglielmi: Oils and Gouaches*, November 15–December 3, checklist no. 13.

1939
New York. The Museum of Modern Art, *Art in Our Time: An Exhibition to Celebrate the Tenth Anniversary of the Museum of Modern Art and the Opening of the New Building*, April 1939, cat. no. 201, illus.

1939
San Francisco. The California Palace of the Legion of Honor and the M. H. DeYoung Memorial Museum, *Seven Centuries of Painting: An Exhibition of Old and Modern Masters*, December 29, 1939–January 28, 1940, cat. no. Y–169, p. 52.

1940
Chicago. The Art Institute of Chicago, *The Fifty-first Annual Exhibition of American Paintings and Sculpture*, November 14, 1940–January 4, 1941, cat. no. 90.

1941
Washington, D. C. Corcoran Gallery of Art, *The Seventeenth Biennial Exhibition of Contemporary American Oil Paintings*, March 23–May 4, cat. no. 254, p. 9.

1942
Washington, D. C., Phillips Memorial Gallery, April.

1943
New York. The Museum of Modern Art, *American Realists and Magic Realists*, February, cat. no. 106, p. 65.

1952
Baton Rouge. Foster Hall Art Gallery, Louisiana State University, March 11–March 30, checklist no. 1.

1958
New York. Nordness Gallery, *O. Louis Guglielmi Memorial Exhibition*, October 14–November 1, cat. no. 8.

1960
Washington, D. C. Corcoran Gallery of Art, *Edith Gregor Halpert Collection*, January 16–February 28, cat. no. 28.

1960
Clinton, New York. Hamilton College, Edward Root Art Center, *Selections from the Edith Gregor Halpert Collection*, November 13–December 17, cat. no. 12, illus.

1964
New York. The Downtown Gallery, *New York City: Paintings 1913–1965 by American Artists*, May 12–June 5, checklist no. 6.

1966
New York. Association of Contemporary Artists, *Protest Painting USA, 1930–1945*, April 4–April 23, cat. no. 10.

1973
New York. Robert Schoelkopf Gallery, *Brooklyn Bridge: Paintings, Prints, Photographs, Memorabilia, and Historical Documents Celebrating the 90th Anniversary of One of Man's Noblest Works*, May 19–June 15, cat., no checklist.

1977
New Brunswick. Rutgers University Art Gallery, *Surrealism and American Art 1931–1947*, March 6–April 24, cat. no. 45, illus. p. 80, color cover.

1980
O. Louis Guglielmi: A Retrospective Exhibition, cat. no. 33, fig. 39, text pp. 19–23.

New Brunswick. Rutgers University Art Gallery, November 2–December 21.

Providence, Rhode Island. Bell Gallery, Brown University, January 10–February 1, 1981.

Albany. University Art Gallery State University of New York, March 1–April 25.

New York. The Whitney Museum of American Art, May 6–July 5.

1983
Brooklyn. The Brooklyn Museum, *The Great East River Bridge*, March 19–June 19, cat. no. 69, illus. p. 166.

1985
The Surreal City 1930–1950, listed in checklist, unnumbered.

New York. The Whitney Museum of American Art at Phillip Morris, May 3–June 11.

Evanston, Illinois. Terra Museum of American Art, July 18–October 13.

Youngstown, Ohio. Butler Institute of American Art, October 22–December 20.

Clinton, New York. Fred L. Emerson Gallery, Hamilton College, January 4–February 10, 1986.

Atlanta, Georgia. High Museum of Art at Georgia Pacific Center, February 24–April 25, 1986.

Bibliography

Archives of American Art, Downtown Gallery Papers, Roll ND 58, frames 293–94, Roll ND 60 frames 238–39. O. Louis Guglielmi Papers, Roll 69/119, frames 233–34, 241, 321–23, 356.

Baker, John, "O. Louis Guglielmi: A Reconsideration," *Archives of American Art Journal*, v. 15, no. 2, 1975, pp. 15–20.

Dearce, Howard, "Brief Comment on Newly Opened Exhibition: A Reviewer's Opinion," *New York Times*, November 20, 1938.

Fort, Ilene Susan, "American Social Surrealism," *Archives of American Art Journal*, v. 22, no. 3, 1982, pp. 8–20.

Filler, Martin, "The Brooklyn Bridge at 100," *Art in America*, Summer 1983, pp. 140–152, illus. p. 150.

"First New York Show of Guglielmi, Satirist of the American Scene," *Art News*, November 1938.

Frankenstein, Alfred Victor, "American Art and American Moods," *Art in America*, March–April 1966, v. 54, p. 97, illus. p. 85.

Glueck, Grace, "Art: A Nostalgic Visit to 'The Surreal City,'" *New York Times*, Friday, May 31, 1985.

Guglielmi, O. Louis, "I Hope to Sing Again," *Magazine of Art*, v. 37, no. 5, May 1944, p. 175, illus.

"Guglielmi's First," *Art Digest*, v. 13, November 15, 1938, p. 20, illus.

Kramer, Hilton, "Brooklyn Bridge Celebrated," *New York Times*, Saturday, May 26, 1973.

McCullough, David, "The Great Bridge and the American Imagination," *New York Times Magazine*, March 27, 1983, illus. p. 38.

New York Post, November 19, 1938, illus.

"Rational Grotesqueries," *Time Magazine*, November 1938.

Sozanski, Edward, "Guglielmi's Eclectic Vision," *Providence Journal*, February 1, 1981.

Spiller, Mary Ellen, "Fifteen Paintings by Louis Guglielmi, Nationally Known Artist, Will Be Exhibited Tomorrow," *Louisiana State University Newspaper*, March 10, 1952.

Trachtenberg, Alan, *Brooklyn Bridge, Fact and Symbol*, New York, Oxford University Press, 1965, unnumbered plate between pp. 86 and 87.

Wechsler, Jeffrey, "Magic Realism: Defining the Indefinite," *Art Journal*, v. 45, no. 4 (Winter 1985), p. 297.

Hartley, Marsden
1877–1943

Painting No. 49, Berlin, 1914–1915 (*Portrait of a German Officer* or *Berlin Abstraction*)

Oil on canvas, 47 x 39¼ inches (119.3 x 99.7 cm)

Unsigned

Provenance

Estate of the artist

Hudson D. Walker, New York

Babcock Galleries, New York (as *Portrait of a German Officer*)

Zabriskie Gallery, New York

Felix Landau Gallery, Los Angeles

Arnold H. Maremont, Chicago

Sotheby Parke-Bernet, New York, Sale #3630, May 1, 1974, Lot 12 (as *Berlin Abstraction*)

Peter Davidson and Co., Inc., New York

Acquired 1977

Exhibitions

1950
Albion, Michigan. Albion College, *Marsden Hartley: A Retrospective Exhibition Lent by Hudson D. Walker of New York*, April 15–April 30, checklist no. 6.

1955
New York. Martha Jackson Gallery, *Marsden Hartley: The Berlin Period, 1913–1915, Abstract Oils and Drawings*, January 3–January 29, checklist no. 5.

1958
Ogunquit, Maine. Museum of Art of Ogunquit, *Sixth Annual Exhibition*, June 28–September 8, cat. no. 22.

1961
Chicago. Illinois Institute of Technology, *Maremont Collection at the Institute of Design*, April 5–April 30, cat. no. 38, illus.

1964
Washington, D. C. Washington Gallery of Modern Art, *Treasures of 20th Century Art from the Maremont Collection*, April 2–May 3, no. cat.

1977
Great Britain. The Arts Council of Great Britain, *The Modern Spirit/American Painting 1908–1935*, cat. no. 40, illus. color, p. 10.

Edinburgh. The Royal Scottish Academy, August 20–September 11.

London. Hayward Gallery, September 28–November 20.

1979
2 Jahrzehnte Amerikanische Malerei, 1920–1940, cat. no. 26, illus. p. 26.

Dusseldorf. Städtische Kunsthalle, June 8–August 5.

Zurich. Kunsthaus, August 23–October 21.

Brussels. Palais des Beaux-Arts, November 15–December 31.

1980
Marsden Hartley, cat. no. 30, plate 81.

New York. The Whitney Museum of American Art, March 4–May 25.

Chicago. The Art Institute of Chicago, June 10–August 3.

Fort Worth. Amon Carter Museum of American Art, September 5–October 26.

Berkeley. University Art Museum, November 12–January 4, 1981.

Bibliography

Barry, Roxana, "The Age of Blood and Iron: Marsden Hartley in Berlin," *Arts Magazine*, October 1980, pp. 166–171.

Geldzahler, Henry, *American Painting in the 20th Century*, exhibition cat., The Metropolitan Museum of Art, New York, 1965, p. 60.

Levin, Gail, "Hidden Symbolism in Marsden Hartley's Military Pictures," *Arts Magazine*, October, 1980, pp. 154–58.

Hirsch, Stefan
1889–1964

Excavation, 1926

Oil on canvas, 35 x 45 inches (88.9 x 114.3 cm)

Inscribed s h 1926 on license plate

Provenance

The Downtown Gallery, New York

Elsa Rogo, New York

Rosa Esman Gallery, New York

Acquired 1979

Exhibitions

1930
New York. The Museum of Modern Art, *An Exhibition of Work of 46 Painters and Sculptors Under 35 Years of Age*, April 12–April 26, cat. no. 86, p. 9.

1930
Cincinnati. Cincinnati Art Museum, *The Thirty-Seventh Annual Exhibition of American Art*, June 1–June 29, cat. no. 43, p. 10.

1971
Annandale-On-Hudson, New York. Bard College, *Stefan Hirsch, 1899–1964: Retrospective Exhibition*, September 9–September 27, listed in cat., unnumbered, dated 1931.

1977
Washington, D. C. The Phillips Collection, *Paintings by Stefan Hirsch*, November 5–December 4, cat. no. 13.

1979
Stefan Hirsch: Pioneer Precisionist, checklist no. 4, illus.

New York. Rosa Esman Gallery, November 6–December 8.

Grand Rapids. Grand Rapids Art Museum, December 18–January 6, 1980.

Bibliography

"Exhibitions in the New York Galleries," *Art News*, April 19, 1930, illus. p. 12.

Flint, Ralph, "Around the Galleries," *Creative Art*, 6, May 1930, supp. p. 114, illus.

Rubenfield, Richard, "Stefan Hirsch, Pioneer Precisionist," *Arts*, November 1979, pp. 96–97.

"Stefan Hirsch—Painter," *Index of Twentieth Century Artists*, vol. II, no. 7, April 1935, p. 105.

"Stefan Hirsch, Pioneer Precisionist," *Artnews*, February 1980, p. 206 illus. in color.

Hopper, Edward
1882–1967

Chop Suey, 1929

Oil on canvas, 32 x 38 inches (81.2 x 96.5 cm)

Signed lower right: EDWARD HOPPER

Provenance

Frank K. M. Rehn Gallery, New York

Mr. and Mrs. Mark Reed, Alexandria, Virginia

Mr. and Mrs. Louis Cohen, Great Neck, New York

William Zierler, Inc., New York

Acquired 1973

Exhibitions

1930
Cincinnati, Cincinnati Art Museum, *The Thirty-Seventh Annual Exhibition of American Art*, June 1–June 29, cat. no. 45, illus.

St. Louis. City Art Museum, *Twenty-fifth Annual Exhibition of Paintings by American Artists*, September 20–November 2, cat. no. 52, illus. p. 25.

1931
Philadelphia. Pennsylvania Academy of the Fine Arts, *126th Annual Exhibition*, January 25–March 15, cat. no. 229, p. 13, illus.

1932
Springfield. Museum of Fine Arts, *Opening Exhibition*, October 7–November 2, cat. no. 194.

1934
Ottawa. National Gallery of Canada, *Exhibition of Paintings by Artists of the United States*, circulating in Canada, cat. no. 46, p. 12, illus.

1937
Pittsburgh. Carnegie Institute Museum of Art, March 11–April 25, cat. no. 15.

1943
Chicago. The Art Institute of Chicago, *54th Annual Exhibition: American Paintings and Sculpture*, October 28–December 12, cat. no. 1.

1950
Edward Hopper, color illus. plate 9, cat. no. 32.

New York. The Whitney Museum of American Art, February 11–March 26.

Boston. Museum of Fine Arts, April 13–May 14.

Detroit. The Detroit Institute of Arts, June 4–July 2.

1964
Edward Hopper, cat. no. 18, illus. p. 20.

New York. The Whitney Museum of American Art, September 29–November 29.

Chicago. The Art Institute of Chicago, December 18–January 31, 1965.

Detroit. The Detroit Institute of Arts, February 18–March 21, 1965.

St. Louis. City Art Museum, April 7–May 9, 1965.

1971
Philadelphia. Pennsylvania Academy of the Fine Arts, *Edward Hopper Retrospective*, September 24–October 31, cat. no. 95.

1981
Edward Hopper: The Art and the Artist, cat. color plate 328, pp. 52, 235.

New York. The Whitney Museum of American Art, September 16, 1980–January 18, 1981.

London. The Hayward Gallery, February 11–March 29.

Amsterdam. Stedelijk Museum, April 22–June 17.

Dusseldorf. Städtische Kunsthalle, July 10–September 6.

Chicago. The Art Institute of Chicago, October 3–November 29.

San Francisco. San Francisco Museum of Modern Art, December 16–February 14, 1982.

Bibliography

Arts Council of Great Britain, *Edward Hopper, 1882–1967: A Selection from the 1981 Exhibition at The Whitney Museum, "Edward Hopper, The Art and the Artist,"* London, 1981, cat. no. 72, p. 42.

DuBois, Guy Pène, "Edward Hopper," *American Artists Series*, The Whitney Museum of American Art, 1931, illus. p. 27.

"Edward Hopper: Famous American Realist Has Retrospective Show," *Life*, April 17, 1950, pp. 100–104, illus. in color p. 101.

"Edward Hopper," *Magazine of Art*, v. 30 no. 5, May 1937, illus. p. 278.

"Edward Hopper—Painter and Graver," *Index of Twentieth Century Artists*, supp. to vol. 1, no. X, p. i.

"Edward Hopper—Painter and Graver," *Index of Twentieth Century Artists*, supp. to vol. 1, nos. 10, 12, p. iii.

Goodrich, Lloyd, *Edward Hopper*, New York, 1972, illus. in color, p. 208.

———. "Edward Hopper," *The Penguin Book of Modern Painters*, Penguin Books, New York and London, 1949, illus. in color, pl. 9.

———. *Edward Hopper*, New York, Abrams, 1976, p. 72, color plate p. 73.

Kazin, Alfred, "Hopper's Vision of New York," *New York Times Magazine*, September 7, 1980, illus. in color p. 48.

Mellow, James R., "Painter of the City," *Dialogue Magazine*, v. 4, 1971, illus. p. 76.

Hopper, Edward
1882–1967

Cottages at North Truro, Massachusetts, 1938

Watercolor with underdrawing of graphite on paper, 20⁹⁄₁₆ x 28⅛ inches (52.3 x 71.4 cm)

Signed lower right: EDWARD HOPPER

Provenance

Frank K. M. Rehn Gallery, New York

Mr. and Mrs. Harris B. Steinberg, New York

William Zierler, Inc., New York

Acquired 1973

Exhibitions

1961
Barnstable, Massachusetts, Cape Cod Conservatory of Music and Arts, *Second Annual Cape Cod Festival of the Arts*, June–July.

1962
Riverdale, New York. Horace Mann School, *Modern Art From the Collection of Mr. and Mrs. Harris B. Steinberg*, April 1–April 30, cat. no. 10.

1963
Tucson. University of Arizona, *A Retrospective Exhibition of Oils and Watercolors by Edward Hopper*, April 20–May 14, cat. no. 34.

1970
New York. William Zierler, Inc. *Fall 1970: New Acquisitions*, September 15–November, cat. no. 27, illus. in color, unpaged.

Bibliography

Archives of American Art, Harris B. Steinberg Papers, Roll 667, frames 1304–1315.

Kantor, Morris
1896–1974

Orchestra, 1923

Oil on canvas, 35 x 34 inches (88.9 x 86.4 cm)

Provenance

Mr. and Mrs. Edgar B. Miller, Chicago

Vanderwoude Tananbaum Gallery, New York

Acquired 1984

Exhibitions

1963
New York. The Whitney Museum of American Art, *Pioneers of Modern American Art in America: The Decade of the Armory Show 1910–1920*, cat. illus. p. 80.

1965
Davenport, Iowa. The Davenport Municipal Art Gallery, *Morris Kantor Retrospective*, June 3–June 27, cat. no. 1, illus.

Bibliography

Brown, Milton, *American Painting: From the Armory Show to the Depression*, Princeton, 1955, illus. p. 186.

Kelly, Leon

born 1901

The White Compotier, 1921

Pastel on board, 21⅝ x 13¹⁵⁄₁₆ inches (55.1 x 35.3 cm)

Signed and dated lower right: Leon Kelly/1921

Provenance

Barbara Kulicke, New York

Washburn Gallery, New York

Acquired 1983

Exhibitions

1981
New York. Washburn Gallery, *Leon Kelly, Paintings and Drawings 1920–1960*, February 4–February 28, checklist no. 4.

1982
Houston, Janie C. Lee Gallery, *Cubist Drawings, 1907–1929*, November 15, 1982–January 15, 1983, cat. no. 20, illus. p. 55.

1983
New York. Washburn Gallery, *Under Glass*, July–August.

Lachaise, Gaston

1882–1935

Back of a Walking Woman, c. 1922

Bronze, unique cast, 16½ x 7 x 3 inches (41.9 x 17.8 x 7.6 cm)

Unsigned

Provenance

The Downtown Gallery, New York

Dr. and Mrs. Michael Watter, Washington, D. C.

Robert Schoelkopf Gallery, New York

Washburn Gallery, New York

Acquired 1978

Exhibitions

1955
New York. The Downtown Gallery, *Contemporary Art, Gallery Purchases*, May 24–June 11, cat. no. 16.

1963
Gaston Lachaise 1882–1935, Sculpture and Drawings, cat. no. 33, illus.

Los Angeles. Los Angeles County Museum of Art, December 3, 1963–January 19, 1964.

New York. The Whitney Museum of American Art, February 18–April 5, 1964.

1975
New York. Robert Schoelkopf Gallery, *Gaston Lachaise, Drawings and Sculpture*.

1978
New York. The Intimate Gallery, *From the Intimate Gallery, Room 303*, October 4–October 28, 1978, checklist no. 9.

Lachaise, Gaston

1882–1935

Mask, 1924

Bronze washed with nickel and brass on black marble base, lifetime cast, 6 x 5 x 4 inches (15.2 x 12.7 x 10.2 cm)

Signed: G. Lachaise o 1924 in lighter metal, lower center

Provenance

Charles Henry Coster, New York

Sotheby Parke-Bernet, New York, Sale #5066, June 23, 1983, Lot 163.

Lachaise, Gaston

1882–1935

Mask, 1928

Bronze, lifetime cast, 8¼ x 5½ x 3½ inches (20.9 x 13.9 x 8.9 cm)

Unsigned

Provenance

Mrs. Fitch Ingersoll, Boston

Richard C. Bourne and Co., Hyannis Port, Massachusetts Sale, May 18, 1982, Lot 48.

Hirschl & Adler Galleries, New York

Zabriskie Gallery, New York

Acquired 1983

Exhibitions

1982
New York. Hirschl & Adler Galleries, *Lines of a Different Character: American Art from 1927–1947*, November 13, 1982–January 8, 1983, cat. no. 75, pp. 93, illus.

Lachaise, Gaston

1882–1935

Standing Nude, n.d.

Graphite on paper, 10⅞ x 8⁷⁄₁₆ inches (27.6 x 21.4 cm)

Signed lower left: G. Lachaise

Provenance

Robert H. Ginter, Beverly Hills, California

Christie's, New York Sale #5400, September 28, 1983, Lot 64.

Lucioni, Luigi
born 1900

Still Life with Peaches, 1927 (*Red Checkered Tablecloth*)

Oil on canvas, 24 x 30 inches (60.9 x 76.2 cm)

Signed and dated lower left: Lucioni 27

Provenance

Leo Bing, Los Angeles, California

The Frederick S. Wight Art Gallery of the University of California, Los Angeles

Sotheby Parke-Bernet, New York, Sale #320, v. II, October 6, 1981, Lot 415.

Joel Bogart, New York

D. Wigmore Fine Art, Inc., New York

Acquired 1983

Exhibitions
1982
New York. Hirschl & Adler Galleries, *Lines of a Different Character: American Art 1927–1947*, November 13, 1982–January 8, 1983, cat. no. 73.

Bibliography

Antiques, December 1983, illus. color, p. 1132.

Gallati, Barbara, "Lines of a Different Character: American Art 1927–1947," *Arts*, v. 57, April 1983, pp. 40–41.

———

Marin, John
1870–1953
From Deer Isle, Maine, 1922

Watercolor with black chalk underdrawing, 19⁹⁄₁₆ x 16³⁄₁₆ inches (49.7 x 41.1 cm)

Signed lower left: Marin 22

Provenance

Estate of the artist

Kennedy Galleries, Inc., New York

Acquired 1985

Bibliography

Reich, Sheldon, *John Marin: A Stylistic Analysis and Catalogue Raisonné*, University of Arizona Press, Tucson, 1970, Part II, no. 22.16, p. 497, illus.

———

Marin, John
1870–1953
My Hell Raising Sea, 1941

Oil on canvas, 25 x 30 inches (63.5 x 76.2 cm)

Signed and dated lower right: Marin 41

Provenance

The Downtown Gallery, New York

Mr. and Mrs. David Levy, New York

Mr. and Mrs. Phillip M. Stern, Washington, D. C.

Peter H. Davidson and Co., Inc., New York

Acquired 1982

Exhibitions

1941
New York. An American Place, *John Marin, Oils and Watercolors, 1941*, December 9, 1941–January 27, 1942 (listed in the cat. as either no. 3, *Sea Raising More Hell*, or no. 4, *Sea Raising Hell*).

1955
John Marin Memorial Exhibition, cat. no. 12, illus.

Boston. Museum of Fine Arts, March 1–April 16.

Washington, D. C. The Phillips Memorial Gallery, May 11–June 29.

San Francisco. San Francisco Museum of Modern Art, July 30–September 11.

Los Angeles. Art Galleries of the University of California, September 28–November 9.

Cleveland. Cleveland Museum of Art, December 1, 1955–January 15, 1956.

Minneapolis. Minneapolis Institute of Arts, February 3–March 20, 1956.

Athens, Georgia. University of Georgia Museum of Art, April 21–May 22, 1956.

New York. The Whitney Museum of American Art, June 13–July 29, 1956.

1961
New York. The Museum of Modern Art, *The Mrs. Adele R. Levy Collection/A Memorial Exhibition*. June 9–July 6, illus. p. 31 in cat.

1962
John Marin in Retrospect: An Exhibition of His Oils and Watercolors, cat. no. 15, illus. p. 23.

Washington, D. C. The Corcoran Gallery of Art, March 2–April 15.

Manchester, N. H. Currier Gallery of Art, May 9–June 24.

Bibliography

Archives of American Art, Downtown Gallery Papers, Roll ND 14, frame 617.

Reich, Sheldon, *John Marin: A Stylistic Analysis and Catalogue Raisonné*, University of Arizona Press, Tucson, 1970, Part II, no. 41.28, p. 717.

———

Mason, Alice Trumbull
1904–1971
Forms Evoked, 1940

Oil on panel, 17 x 22 inches (43.2 x 55.9 cm)

Signed lower right: Alice Mason

Provenance

Estate of the artist

Washburn Gallery, New York

Acquired 1977

Exhibitions

1973
New York. The Whitney Museum of American Art, *Alice Trumbull Mason Retrospective*, May 12–June 17, cat. no. 2.

1976
New York. Washburn Gallery, *American Abstract Painting from the 1930s and 1940s*, September 9–October 2.

1977
Albuquerque. University of New Mexico Art Museum, *American Abstract Artists*, February 27–April 3, listed in cat., unnumbered, illus. p. 29.

1977
Houston. Museum of Fine Arts, *Modern American Painting, 1910–1940: Towards a New Perspective*, June 30–September 25, cat. no. 54, illus. p. 20.

Matulka, Jan
1890–1972

At Sea, c. 1932

Oil on canvas, 36 x 30 inches (91.4 x 76.2 cm)

Unsigned

Provenance

Estate of the artist

Robert Schoelkopf, New York

Acquired 1979

Exhibitions

1979
Jan Matulka, 1890–1972, cat. no. 21, illus. p. 68, fig. 71.

New York. The Whitney Museum of American Art, December 18, 1979–February 24, 1980.

Houston. Museum of Fine Arts, April 3–June 1, 1980.

Birmingham, Alabama. Birmingham Museum of Art, June 15– October 1, 1980.

Washington D. C. National Collection of Fine Arts, November 21, 1980–February 9, 1981.

1982
Ferdinand Léger and the Modern Spirit, 1918–1931, An Avant Garde Alternative to Non Objective Art

Paris. Musée d'Art Moderne de la Ville de Paris, March–July 8.

Houston. Museum of Fine Arts, July 15–September 12.

Geneva. Musée Rath, November 4, 1982–January 16, 1983.

Matulka, Jan
1890–1972

Bohemian Village, c. 1920 (*Slovak Village Turi Pole*)

Watercolor on paper, 17¼ x 23⅝ inches (43.8 x 59.9 cm)

Signed lower right: J Matulka

Provenance

Robert Schoelkopf Gallery, New York

Acquired 1979

Exhibitions

1979
Jan Matulka, 1890–1972, cat. no. 29, illus. p. 44, fig. 33 as *Slovak Village*.

New York. The Whitney Museum of American Art, December 18, 1979–February 24, 1980.

Houston. The Museum of Fine Arts, April 3–June 1, 1980.

Birmingham, Alabama. Birmingham Museum of Art, June 15–October 1, 1980.

Washington, D. C. National Collection of Fine Arts, November 21–February 9, 1981.

Matulka, Jan
1890–1972

Cityscape, c. 1925

Gouache and graphite on paper, 21¹⁵⁄₁₆ x 14 inches (54.7 x 35.6 cm)

Signed lower left: Matulka

Provenance

Robert Schoelkopf Gallery, New York

Acquired 1979

Nadelman, Elie
1882–1946

Dancing Figure, c. 1916–1918

Bronze, 30 x 12 x 12 inches (76.2 x 30.5 x 30.5 cm)

Signed on back, under skirt: Elie Nadelman

Provenance

Mrs. John Alden Carpenter

Kraushaar Galleries, New York

Sotheby Parke-Bernet, New York, Sale #859, April 9, 10, 1947, Lot 129.

Mrs. Henry T. Curtiss

Robert Schoelkopf Gallery, New York

Acquired 1979

Exhibitions

1934
New York. Rockefeller Center

1936
Texas Centennial Exhibition

1937
New York. Milch Gallery

1937
Cleveland. Cleveland Museum of Art

1946
New York. Marie Steiner Gallery

Neel, Alice
1900–1984

Jose Asleep, 1938

Pastel on paper, 12 x 9 inches (30.5 x 22.9 cm)

Signed and dated lower left corner: Neel 38

Provenance

Robert Miller Gallery, New York

Acquired 1986

Exhibitions

1986
New York. Robert Miller Gallery, *Alice Neel: Drawings and Watercolors, 1928–1984*, December 2, 1986–January 3, 1987.

Bibliography

Hills, Patricia, *Alice Neel*, New York, Abrams, 1983, color illus. p. 67.

O'Keeffe, Georgia
1887–1986

Beauford Delaney, early 1940s

Charcoal on paper, 24½ x 18⅝ inches (62.2 x 43.2 cm)

Unsigned

Provenance

Doris Bry, New York

Acquired 1976

Exhibitions

1970
Georgia O'Keeffe Retrospective Exhibition, cat. no. 87.

New York. The Whitney Museum of American Art, October 8–November 29, 1970.

Chicago. The Art Institute of Chicago, January 6–February 7, 1971.

San Francisco. San Francisco Museum of Modern Art, March 15–April 30, 1971.

O'Keeffe, Georgia
1887–1986

Black, *White and Blue*, 1930

Oil on canvas, 48 x 30 inches (121.9 x 76.2 cm)

Signed with monogram and star on panel affixed to verso, also titled and dated in the artist's hand on a label affixed to verso.

Provenance

Edith Gregor Halpert, New York

Sotheby Parke-Bernet, New York, Sale #3484, March 14, 1973, Lot 46, illus in cat.

Exhibitions

1949
New York. The American Academy of Arts and Letters and the National Institute of Arts and Letters, *Work by Newly Elected Members and Recipients of Grants*, May 27–July 3, checklist no. 42, p. 4.

1960
The Precisionist View in America, listed in cat., unnumbered.

Minneapolis. Walker Art Center, November 12–December 25.

New York. The Whitney Museum of American Art, January 24–February 28, 1961.

Detroit. The Detroit Institute of Arts, March 24–April 23, 1961.

Los Angeles. Los Angeles County Museum of Art.

San Francisco. San Francisco Museum of Modern Art.

1962
Geometric Abstraction in America, cat. no. 68, p. 18.

New York. The Whitney Museum of American Art, March 20, 1962–May 13, 1962.

Boston. The Institute of Contemporary Art.

Utica, New York. Munson-Williams-Proctor Institute.

St. Louis. City Art Museum.

Columbus, Ohio. Columbus College of Art and Design.

1963
New York. The Downtown Gallery, *Summer 1963*, June 11–July 3, no cat.

1965
New York. The Downtown Gallery, *A Gallery Survey of American Art*, September 8–October 2, no cat.

1965
Washington, D. C. National Collection of Fine Arts, Smithsonian Institution, *Roots of Abstract Art in America*, December 2, 1965–January 9, 1966, cat. no. 139.

1967
New York. The Downtown Gallery, *42nd Annual Exhibition*, September.

1968
New York. The Downtown Gallery, February.

1968
New York. The Whitney Museum of American Art, *The 1930s: Painting and Sculpture in America*, cat. no. 79, illus., unpaged.

1969
New York. The Downtown Gallery, September.

1970
New York. The Downtown Gallery, November.

1973
Cambridge, Massachusetts. The Busch-Reisinger Museum, Harvard University, *Selections from the Edith Gregor Halpert Collection*, February 4–March 3.

1974
St. Louis. The Saint Louis Art Museum, *Paintings by Georgia O'Keeffe*, September 29–November 3, no cat.

1975
San Antonio. Marion Koogler McNay Art Institute, *Georgia O'Keeffe*, October 24–November 30, no cat.

1979
2 Jahrzehnte Amerikanische Malerei, 1920–1940, cat. no. 87.

Dusseldorf. Städtische Kunsthalle, June 8–August 5.

Zurich. Kunsthaus, August 23–October 21.

Brussels. Palais des Beaux-Arts, November 15–December 31.

Bibliography

Archives of American Art, Downtown Gallery Papers, Roll ND 60, frame 003.

Arnason, H. H. "The Precisionists: The New Geometry," *Art in America*, v. 48, no. 3, 1960, p. 55, illus.

"The Art Galleries," *The New Yorker*, April 14, 1962.

Castro, Jan Garden, *The Art & Life of Georgia O'Keeffe*, New York, Crown, 1985, pp. 98–100, 102.

Rice, Patricia, "Remembering Georgia O'Keeffe," *St. Louis Post-Dispatch*, Everyday, Thursday, March 20, 1986.

O'Keeffe, Georgia
1887–1986

Horn and Feather, 1937

Oil on canvas, 9 x 14 inches (22.8 x 35.5 cm)

Unsigned

Provenance

The Downtown Gallery, New York

Doris Bry, New York

Acquired 1978

Exhibitions

1937
New York. The Downtown Gallery, *The O'Keeffe Portfolio*, November 9–November 20, checklist no. 6.

1937
New York. An American Place, *14th Annual Exhibition of Paintings*, December 27, 1937–February 11, 1938, checklist no. 26.

Bibliography

The Work of Georgia O'Keeffe: A Portfolio of Twelve Paintings, New York, Knight Publishers, 1937, limited edition.

Jewell, Edward Alden, "Georgia O'Keeffe Exhibits Her Art," *New York Times*, December 28, 1937.

———————

O'Keeffe, Georgia
1887–1986

Music—Pink and Blue 1, 1919

Oil on canvas, 35 x 29 inches (88.9 x 73.6 cm)

Signed on verso in graphite with O'Keeffe's monogram and star

Provenance

Doris Bry, New York

Acquired 1974

Exhibitions

1923
New York. Anderson Gallery, *Alfred Steiglitz Presents One Hundred Pictures: Oils, Watercolors, Pastels, and Drawings by Georgia O'Keeffe, American*, January 29–February 10.

1970
Georgia O'Keeffe Retrospective Exhibition, cat. no. 24.

New York. The Whitney Museum of American Art, October 8–November 29.

Chicago. The Art Institute of Chicago, January 6–February 7, 1971.

San Francisco. San Francisco Museum of Modern Art, March 15–April 30, 1971.

1974
St. Louis. The Saint Louis Art Museum, *Paintings by Georgia O'Keeffe*, September 29–November 3, no cat.

1986
The Spiritual in Art, cat. no. 21, illus. p. 125.

Los Angeles. The Los Angeles County Museum of Art, November 26, 1986–March 8, 1987.

Bibliography

Archives of American Art, Whitney Museum Artists Files: Georgia O'Keeffe, Roll 59–15, frame 162.

Castro, Jan Garden, *The Art and Life of Georgia O'Keeffe*, New York, Crown, 1985, pp. 56, 107.

Georgia O'Keeffe, New York, Viking Press, 1976, no. 14, unpaged, illus. in color.

Rice, Patricia, "Remembering Georgia O'Keeffe," *St. Louis Post-Dispatch*, Everyday, Thursday, March 20, 1986.

Heller, Nancy, *Women Artists*, Abbeville Press and the Los Angeles County Museum of Art, Los Angeles, 1987, illus. in color.

———————

O'Keeffe, Georgia
1887–1986

Sunrise, 1917

Watercolor on paper, 8⅞ x 11⅞ inches (22.5 x 30.1 cm)

Unsigned

Provenance

Doris Bry, New York

William W. Collins, New York

Blum/Helman Gallery, Inc., New York

Zabriskie Gallery, New York

Acquired 1982

Exhibitions

1958
New York. The Downtown Gallery. *Georgia O'Keeffe Watercolors*, February 25–March 22, cat. no. 26.

Bibliography

Archives of American Art, Downtown Gallery Papers, Roll ND 34, frames 455, 486.

———————

Roszak, Theodore
1907–1981

Construction, 1937*

Painted wood, wire, glass, 12 x 17 inches (30.5 x 43.2 cm)

Signed on front of box: T. J. Roszak

Provenance

Washburn Gallery, New York

Acquired 1977

Exhibitions

1976
New York. Washburn Gallery, *American Abstract Paintings from the 1930s and 1940s*, September 9–October 2, checklist no. 7.

———————

Roszak, Theodore
1907–1981

Spatial Construction, c. 1942–1945*

Painted steel, wire, and wood, 23½ x 17 x 10 inches (59.7 x 43.2 x 25.4 cm)

Unsigned

Provenance

Pierre Matisse Gallery, New York

Zabriskie Gallery, New York

Acquired 1977

Exhibitions

1951
New York. The Museum of Modern Art, *Abstract Painting and Sculpture in America*, January 23–March 25, cat. no. 86, p. 154, illus., date listed as 1943.

1956
Theodore Roszak, cat. no. 38, color illus. p. 37, date listed as 1943.

New York. The Whitney Museum of American Art, September 18–November 11.

Minneapolis. Walker Art Center, December 16, 1956–January 20, 1957.

*shown only in St. Louis

Los Angeles. Los Angeles County Museum of Art, February 13–March 17, 1957.

San Francisco. San Francisco Museum of Modern Art, April 4–May 26, 1957.

Seattle. Seattle Art Museum, June 12–August 11, 1957.

Bibliography

Moholy-Nagy, *Vision in Motion*, publ. Paul Theobold, Chicago, 1947, fig. 319, pp. 234–35.

Theodore Roszak Constructions 1932–1945, exh. cat., Zabriskie Gallery, New York, October 31–December 2, 1978.

Scarlett, Rolph
1889–1984

Untitled, 1940–1945

Oil on canvas, 36¼ x 39¼ inches (92.1 x 99.7 cm)

Signed on verso: R. S.
Signed on stretcher bar: Rolph Scarlett

Provenance

Collection of the artist

Washburn Gallery, New York

Acquired 1983

Exhibitions

1983
New York. Washburn Gallery, *Rolph Scarlett: Drawings and Watercolors*, April 26–May 14, cat. no. 45.

Shaw, Charles
1892–1974

Untitled, 1940

Oil on composition board, 30 x 22 inches (76.2 x 55.9 cm)

Signed on verso: Charles G. Shaw, 1940

Provenance

Washburn Gallery, New York

Acquired 1976

Exhibitions
1940
New York. Gallerie St. Etienne, *American Abstract Art*, May 22–June 12, cat. no. 50.

1975
New York. The Century Club, *Charles Shaw Memorial Exhibition.*

1975
New York. Washburn Gallery, *Charles Shaw: Work from 1935–1942*, December 2, 1975–January 10, 1976.

Sheeler, Charles
1883–1965

Catwalk, 1947

Oil on canvas, 24 x 20 inches (60.9 x 50.9 cm)

Signed and dated lower right: Sheeler—1947
Signed on stretcher: Charles Sheeler 1947

Provenance

The Downtown Gallery, New York

Mr. and Mrs. Charles A. Bauer

James Maroney, Inc., New York

Acquired 1978

Exhibitions
1947
New York. The Downtown Gallery, *New Painting and Sculpture by Leading American Artists*, September 23–October 18, cat. no. 19.

1947
New York. The Whitney Museum of American Art, *1947 Annual Exhibition of Contemporary Painting*, cat. no. 138.

1949
New York. The Downtown Gallery, *Charles Sheeler*, January 25–February 12, cat. no. 4.

1951
Sao Paolo, Brazil. Sao Paolo Museum of Art, *First Biennial International Exhibition*, October , cat. no. 64, section *Estados Unidos.*

1955
Worcester, Massachusetts. Worcester Art Museum, *Five Painters of America: Louis Bouché, Edward Hopper, Ben Shahn, Charles Sheeler, Andrew Wyeth*, February 17–April 3, cat. unnumbered.

1963
Iowa City. University of Iowa, *The Quest of Charles Sheeler: 83 Works Honoring His 80th Year*, March 17–April 14, cat. no. 54, p. 50, illus. fig. 20, text p. 28.

1968
Charles Sheeler, cat. no. 112, p. 25.

Washington D. C. National Collection of Fine Arts.

Philadelphia. Philadelphia Museum of Art.

New York. The Whitney Museum of American Art.

Bibliography

Archives of American Art, Downtown Gallery Papers, Roll ND40, frames 240, 241.

Breuning, Margaret, "Americans Who Are Not Artistic Illiterates," *The Art Digest*, v. 22, no. 1, October 1, 1947.

Friedman, Martin, *Charles Sheeler: Paintings, Drawings and Photographs*, New York, Watson-Guptil, 1975, illus. color, p. 127.

———. "The Precisionist View," *Art in America*, v. 48, no. 3, Fall 1960, p. 31, illus.

Sheeler, Charles
1883–1965

Classic Landscape, 1928

Watercolor, gouache and graphite on paper, 8¹³⁄₁₆ x 11¹⁵⁄₁₆ inches (22.4 x 30.3 cm)

Signed lower right: Sheeler 1928

Provenance

Robert Tannahill, Detroit

Mr. and Mrs. Edsel Ford, Detroit

Mr. and Mrs. Lawrence A. Fleischman, Detroit

Dr. and Mrs. Irving F. Burton, Huntington Woods, Michigan

Sotheby Parke-Bernet, New York, Sale #3417, October 18, 1972, Lot 40, illus. in color.

Exhibitions

1935
Detroit. Society of Arts and Crafts, *An Exhibition of Paintings by Charles Burchfield and Charles Sheeler*, January 16–February 2, cat. no. 23.

1939
New York. The Museum of Modern Art, *Charles Sheeler, Paintings, Drawings, and Photographs*, October 4–November 1, cat. no. 76, p. 50.

1953
Ann Arbor. University of Michigan Museum of Art, *Mr. and Mrs. Lawrence A. Fleischman Collection of American Paintings*, November 15–December 16, cat. no. 32.

1954
Detroit. The Detroit Institute of Arts, *Ben Shahn, Charles Sheeler, Joe Jones*, March 9–April 11, cat. no. 7a, listed as *Classical Landscape*.

1955
Detroit. The Detroit Institute of Arts, *A Collection in Progress: Selections from the Lawrence and Barbara Fleischman Collection of American Art*, Summer, cat. no. 43, illus. p. 36.

1958
Mexico City (?). *Collecione Fleischman*, cat. no. 40, listed as *Paisaje clasico*, unpaged.

1960
Milwaukee. Milwaukee Art Center, *American Paintings 1760–1960 from the Collection of Mr. and Mrs. Lawrence A. Fleischman*, March, illus. p. 106 in cat.

1964
Tucson. University of Arizona Art Gallery, *Selections from the Lawrence and Barbara Fleischman Collection of American Art*, February 1–March 29, cat. no. 91, p. 115, illus.

1969
Detroit. The Detroit Institute of Arts, *Selections from the Friends of Modern Art*, May, cat. no. 167.

1978
Detroit. The Detroit Institute of Arts. *The Rouge: The Image of Industry in the Art of Charles Sheeler and Diego Rivera*, August 1–September 24, cat. no. 26, p. 34, 37.

Bibliography

Archives of American Art, Charles Sheeler, Roll D282, frame 804.

Art in America, v. 60, no. 5, 1972, p. 18.

Bennett, Ira, *A History of American Painting*, London, The Hamlyn Group, 1973, p. 185, illus., p. 186, fig. 187.

Dochterman, Lillian Natalie, "The Stylistic Development of the Work of Charles Sheeler," State University of Iowa, 1963, unpublished Ph.D. dissertation, p. 50, no. 28.143.

Goodrich, Lloyd, *Art of the U.S.A. 1670–1966*, New York, 1966, no. 255, p. 94, illus.

Stewart, Rick, "Charles Sheeler, William Carlos Williams and Precisionism: A Redefinition," *Arts*, November 1983, v. 58, no. 3, p. 108.

Sheeler, Charles
1883–1965

Classic Landscape, 1931

Oil on canvas, 25 x 32¼ inches (63.5 x 81.9 cm)

Signed and dated lower right: Sheeler–1931
Signed on canvas stretcher: Charles Sheeler

Provenance

The Downtown Gallery, New York

Edsel B. Ford, Dearborn, Michigan

Mrs. Edsel B. Ford, Grosse Point Shores, Michigan

Edsel and Eleanor Ford House, Detroit, by transfer, 1982–1983

Sotheby Parke-Bernet, New York, Sale #5055, June 2, 1983, Lot 210, illus. in color in cat. and on cover.

Hirschl & Adler Galleries, Inc., New York

Acquired 1984 by Mr. and Mrs. Barney A. Ebsworth Foundation

Exhibitions

1931
New York. The Downtown Gallery, *Charles Sheeler, Exhibition of Recent Works*, November 18–December 7, checklist no. 4.

1932
Chicago. The Arts Club of Chicago, *Paintings and Drawings by Charles Sheeler*, January 19–February 2, cat. no. 3.

1932
Detroit. The Society of Arts and Crafts, *American Contemporary Paintings and Sculpture*, January–February, cat. no. 26.

1932
New York. The Museum of Modern Art, *American Paintings and Sculpture, 1862–1932*, October 31 1932–January 31 1933, p. 38, no. 95, illus.

1933
Detroit. Society of Arts and Crafts, *A Loan Exhibition of Retrospective American Paintings*, April 18–May 6, cat. no. 13.

1934
Cambridge, Massachusetts. Fogg Art Museum, Harvard University, *Watercolours and Drawings by Sheeler, Hopper and Burchfield*, December 5–31, cat. unnumbered.

1935
Detroit. Society of Arts and Crafts, *An Exhibition of Paintings by Charles Burchfield and Charles Sheeler*, January 16–February 2, cat. no. 17.

1938
Paris. Musée du Jeu de Paume, *Trois Siècles d'Art aux Etats Unis*, May–July, cat. p. 45, no. 154, illus. no. 35, as *Paysage Classique*.

1938
New York. The Downtown Gallery, *Americans at Home*, October 4–October 22, cat. no. 25.

1939
New York. The Museum of Modern Art, *Art in Our Time: An Exhibition to Celebrate the Tenth Anniversary*, April, cat. no. 140 illus.

1939
New York. The Museum of
Modern Art, *Charles Sheeler,
Paintings, Drawings, and Photo-
graphs*, October 4–November 1,
cat. no. 22, p. 45, illus.

1946
London. The Tate Gallery,
*American Painting from the
Eighteenth Century to the
Present Day*, June–July, cat.
no. 192, p. 18.

1953
Cedarburg, Wisconsin. Meta
Mold Aluminum Company,
*Contemporary Art Collected by
American Business*, April, cat.
no. 40, illus. inside cover, inac-
curately listed as owned by
Mr. Henry Ford II, Ford Motor
Co.

1954
Detroit. The Detroit Institute
of Arts, *Ben Shahn, Charles
Sheeler, Joe Jones*, March 9–
April 11, cat. no. 7, as *Classical
Landscape*, 1932 (sic).

1954
*Charles Sheeler: A Retrospec-
tive Exhibition*, October, cat.
pp. 8, 9, 21 illus., p. 27, 45,
no. 15.

Los Angeles. University of
California Art Galleries.

San Francisco. M. H. DeYoung
Memorial Museum.

Fort Worth. Fort Worth Art
Center.

Utica, New York. Munson-
Williams-Proctor Institute.

Philadelphia. Pennsylvania
Academy of the Fine Arts.

San Diego. San Diego Fine
Arts Gallery.

1957
Detroit. The Detroit Institute
of Arts, *Painting in America:
The Story of 450 Years*,
April 23–June 9, cat. no. 164,
p. 14, illus. p. 31, listed as
Modern Classic.

1958
Fort Worth. The Fort Worth
Art Center, *The Iron Horse in
Art*, January 6–March 2, cat.
no. 96, fig. 24.

1960
*The Precisionist View in Amer-
ican Art*, pp. 36, 58, listed in
checklist, unnumbered.

Minneapolis. Walker Art Cen-
ter, November 13–December 25.

New York. The Whitney
Museum of American Art.

Detroit. The Detroit Institute
of Arts.

Los Angeles. Los Angeles
County Museum of Art.

San Francisco. San Francisco
Museum of Modern Art.

1963
Iowa City. The University of
Iowa, *The Quest of Charles
Sheeler, 83 Works Honoring
His 80th Year*, March 17–
April 14, cat. no. 36, pp. 19, 20,
fig. 10, 22.

1966
New York. The Whitney
Museum of American Art,
*Art of the United States: 1670–
1966*, pp. 94 illus., 154, no. 255.

1967
Cedar Rapids, Iowa. Cedar
Rapids Art Center, *Charles
Sheeler, A Retrospective Exhi-
bition*, October 25–Novem-
ber 26, pp. [8], [9], cat. no. 9,
illus.

1968
Charles Sheeler, pp. 21, no. 63,
40, 43, illus., 155, no. 63.

Washington, D. C. National
Collection of Fine Arts, Octo-
ber 10–November 24.

Philadelphia. Philadelphia
Museum of Art, January 10–
February 16, 1969.

New York. The Whitney
Museum of American Art,
March 11–April 27, 1969.

1969
Detroit. The Detroit Institute of
Arts, *Detroit Collects, Selections
from the Collections of the Friends
of Modern Art*, no. 168, as
Classic Landscape–River Rouge,
28⅞ x 36 inches (sic).

1976
Detroit. The Detroit Institute
of Arts, *Arts and Crafts in
Detroit, 1906–1976*, Novem-
ber 26, 1976–January 16, 1977,
p. 184, no. 239, illus., dated
1932 (sic).

1977
New York. Hirschl & Adler
Galleries, *Lines of Power*,
March 12—April 19, illus.,
p. [33], text p. [9].

1977
The Arts Council of Great
Britain. *The Modern Spirit:
American Painting 1908–1935*,
illus. in color, p. 13, cat. no. 101.

Edinburgh. The Royal Scottish
Academy, August 20–Septem-
ber 11.

London. Hayward Gallery,
September 28–November 20.

1978
Detroit. The Detroit
Institute of Arts, *The
Rouge: The Image of Indus-
try in the Art of Charles
Sheeler and Diego Rivera*,
August 1–September 24, pp. 7,
12, 15, 16, 33, 34, no. 27,
facing p. 35 illus., 38.

1978
New York. The Whitney
Museum of American Art,
*William Carlos Williams and
the American Scene, 1920–
1940*, pp. 81, fig. 47, 84–85,
165.

1979
*2 Jahrzehnte Amerikanische
Malerei, 1920–1940*, pp. 152,
cat. no. 78, illus. p. 93.

Dusseldorf. Städtische Kunst-
halle, June 8–August 5.

Zurich. Kunsthaus, August 23–
October 21.

Brussels. Palais des Beaux-Arts,
November 15–December 31.

1980
*Paris and the American Avant-
Garde, 1900–1925*, no. 30 illus.

Kalamazoo. Kalamazoo Institute
of Arts.

Alpena, Michigan. Jesse Besser
Museum.

Ann Arbor. University of
Michigan Museum of Art.

St. Joseph, Michigan. Krasl Art
Center.

East Lansing. Kresge Art Center
Gallery, Michigan State Uni-
versity.

Jackson, Michigan. Ella Sharp
Museum.

1984
New York. Hirschl & Adler
Galleries, *The Art of Collecting*,
pp. 58, illus., 58–60, no. 44.

1986
The Machine Age in America,
1918–1941.

Brooklyn. The Brooklyn
Museum, October 16, 1986–
February 15, 1987.

Pittsburgh. The Carnegie
Institute, April 4–June 28, 1987.

1987
Charles Sheeler
Boston. Museum of Fine Arts,
October 13–November 10.

Dallas. Museum of Fine Arts,
June 15, 1988–July 10, 1988.

Bibliography

Archives of American Art,
Downtown Gallery Papers,
Roll ND40, frames 312–313.

*Art at Auction: The Year at
Sotheby's, 1982–1983,* London,
1983, pp. 10, 134, illus. in color.

Art in America, *The Artist in
America,* New York, Norton,
1967, p. 169.

"Art of Charles Sheeler," *The
Christian Science Monitor,*
Boston, Saturday, October 14,
1939, p. 12, col. 3–7, XXXI,
no. 272.

Beam, Laura, "Development
of the Artist/ . . . /IV/Charles
Sheeler," ms., American Asso-
ciation of University Women,
1940, p. 23.

Born, Wolfgang, *American
Landscape Painting, An Inter-
pretation,* 1948, pp. xiii, 211,
213, fig. 142.

Brace, Ernest, "Charles Shee-
ler," *Creative Art,* XI, October
1932, pp. 98, illus., 104.

Brown, Milton, et al. *Amer-
ican Art: Painting, Sculpture,
Architecture, Decorative Arts,
and Photography,* New York,
Abrams, 1979, illus., color,
pl. 66, p. 427.

B. T., "The Home Forum,"
The Christian Science Monitor,
XXXI, June 28, 1939, p. 8,
col. 2–5, illus.

*Bulletin of the Museum of
Modern Art,* VI, May–June
1939, p. 13, illus.

C. B., "Art of Charles Sheeler,"
The Christian Science Monitor,
XXXI, October 14, 1939, p. 12,
col. 3.

"Cedarburg Shows Off Top
Art," *The Milwaukee Journal,
Picture Journal,* June 7, 1953,
p. 3, illus., incorrectly listed as
lent by Henry Ford II.

Chanin, A. L., "Charles Shee-
ler: Purist Brush and Camera
Eye," *Art News,* LIV, Summer
1955, p. 72.

"Charles Sheeler—Painter and
Photographer," *The Index of
Twentieth Century Artists,*
v. III, no. 4, January 1936,
p. 231.

Coates, Robert M. "The Art
Galleries/ A Sheeler Retro-
spective," *The New Yorker,*
XV, October 14, 1939, p. 55.

Cortissoz, Royal, "Types of
American, British, and French
Art," *New York Herald Tribune,*
October 8, 1939, XCIX, no. 33,
929, col. 1–5, p. 8, sec. VI.

Cravin, George M., "Sheeler at
Seventy-five," *College Art
Journal,* v. 18, no. 2, Winter
1959, p. 138.

Crowinshield, Frank, "Charles
Sheeler's 'Americana,'" *Vogue,*
XCIV, October 15, 1939, p. 106.

Davidson, Abraham A., *The
Story of American Painting,*
New York, Abrams, 1974,
pp. 131, no. 118, illus., 132,
133.

Devree, Howard V., "Art/
Charles Sheeler's Exhibition,"
New York Times, Nov. 19,
1931, p. 32, col. 6.

Dintenfass, Terry, *Charles
Sheeler (1883–1965), Classic
Themes: Paintings, Drawings,
and Photographs,* New York,
1980, p. 9.

Dochterman, Lillian N., "The
Stylistic Development of the
Work of Charles Sheeler,"
Ph.D. dissertation, State
University of Iowa, 1963,
pp. 49–50, 56, 58–60, 65, 320,
no. 31.153, illus.

Dozema, Marianne, *American
Realism in the Industrial Age,*
exh. cat. Cleveland Museum of
Art, 1980, illus. p. 86, fig. 16.

"Exhibits Work of Three Dec-
ades," *The Villager,* Greenwich
Village, New York, VII, no. 28,
October 12, 1939, p. 7, col. 3.

"Exhibition in New York:
Charles Sheeler, Downtown
Gallery," *Art News,* v. 30,
no. 8, 1931, p. 8.

Frankenstein, Alfred, "This
World/The Charles Sheeler
Exhibition," *San Francisco
Chronicle,* XVIII, November 28,
1954, p. 21, col. 1, mag. section.

Freedman, Leonard, ed., *Look-
ing at Modern Painting,* 1957,
p. 100, illus. p. 101.

Friedman, Martin, *Charles Shee-
ler: Paintings, Drawings, and
Photographs,* 1975, pp. 8, 95,
112–13, color pl. 17.

Genauer, Emily, "Charles
Sheeler in One-man Show,"
New York World Telegram,
LXXXII, October 7, 1939,
p. 34, col. 1.

Hunter, Sam, *American Art of
the 20th Century,* New York,
Abrams, 1972, p. 91, illus. in
color, enlarged ed., p. 111.

International Auction Records,
Editions Mayer, vol. XVII,
1984, p. 1271, illus.

Jewell, Edward Alden, "Sheeler
in Retrospect," *New York
Times,* LXXXIX, November,
p. 9, col. 3.

———. "Art of Americans Put
on Exhibition," *New York
Times,* October 5, 1938, col. 1,
"Art."

Kepes, Gyorgy, "The New
Landscape in Art and Science,"
Art in America, XLIII, Octo-
ber 1955, p. 35, illus.

Kootz, Samuel M., "Ford Plant
Photos of Charles Sheeler,"
Creative Art, v. 8, no. 4, 1931,
p. 99, illus.

"Les Etats Unis," *L'Amour
d'Art,* XV, Nov. 1934, p. 467,
fig. 606, as *Paysage Classique.*

Les Realismes, 1919–1939
exhibition cat. the Georges
Pompidou Centre, Paris, and
Staatliche Kunsthalle, Berlin,
1980, pp. 30, 36, illus. as
Paysage Classique.

"Loan Listings," *Fogg Art
Museum Annual Report, 1934–
1935.*

McCormick, W. B., "Machine
Age Debunked," *New York
American,* Nov. 26, 1931, p. 19,
col. 2. Also printed in *Los
Angeles Examiner,* Dec. 9,
1931.

McQuade, Donald, gen. ed., *The Harper American Literature*, New York, Harper and Row, 1987, vol. 2, color illus.

"Museum of Modern Art to Open Its Fifth Show of A Living Artist's Works," *New York Herald Tribune*, XCIX, October 4, 1939, p. 21, col. 2–3.

"New Exhibitions of the Week: Works that Were Shown Abroad," *Art News*, October 15, 1938, v. 37, no. 5, p. 13.

"New Phases of American Art," *London Studio*, V, February 1933, p. 90, illus.

New York Times Book Review, LXXXII, July 7, 1934, sec. 5, p. 4, illus.

New York Times Book Review, LXXXIX, September 15, 1940, p. 3, sec. 6, col. 3–5, illus.

Pemberton, Murdock, "The Art Galleries/The Strange Case of Charles Sheeler," *The New Yorker*, VII, Nov. 29, 1931, p. 48.

Richardson, Edgar P., *Painting in America from 1502 to the Present*, New York, 1965, p. 341, illus. p. 377.

———. "Three American Painters: Sheeler—Hopper—Burchfield," *Perspectives USA*, Summer 1956, following p. 112, illus.

Ringel, Fred J., ed., *America as Americans See It*, 1932, illus., facing p. 303.

Rourke, Constance, *Charles Sheeler, Artist in the American Tradition*, 1938, pp. 83, illus., 147–48, 153, 166, 194.

Silk, Gerald D. "The Image of the Automobile in Modern Art," Ph. D. dissertation, University of Virginia, 1976, pp. x, 114, 292, fig. 93.

Sims, Patterson, *Charles Sheeler, A Concentration of Works from the Permanent Collection of The Whitney Museum of American Art, a 50th Anniversary Exhibition*, 1980, pp. 24, 25, illus.

Sorenson, George N. "Portraits of Machine Age/Sheeler Exhibition Called Year's Most Important, *The San Diego Union*, Jan. 9, 1955, col. 5–8 illus., e–3 col. 8.

Stewart, Rick, "Charles Sheeler, William Carlos Williams, and Precisionism: A Redefinition," *Arts Magazine*, November 1983, v. 58, #3, pp. 100–114.

Sweeney, James J., "L'art contemporain aux Etats-Unis," *Cahiers d'art*, XIII, 1938, p. 61, illus.

Towle, Tony, "Art and Literature: William Carlos Williams and the American Scene," *Art in America*, LXVII, May–June 1979, p. 52, illus.

Whelan, Anne, "Barn Is Thing of Beauty to Charles Sheeler, Artist," *The Bridgeport Sunday Post*, August 21, 1938, p. B4.

Wight, Frederick S., "Charles Sheeler," *Art in America*, XLII, October 1954, pp. 192, illus., 197.

———. "Charles Sheeler," *New Art in America, Fifty Painters of the 20th Century*, 1957, pp. 97, 102, illus.

Williams, William Carlos, "Postscript by a Poet," *Art in America* XLII, October 1954, p. 215.

Wilmerding, John, "Cubism in America," *American Art*, 1976, p. 181.

Yeh, Susan Fillin, "Charles Sheeler and the Machine Age," unpublished Ph.D. dissertation, City University of New York, 1981, pp. 42, 64–65, notes 126–32, 72–73, 95, 113, 145, 150, note 31, 152, notes 57–58, 154, notes 84–85, 185–86, 189, 217, 222–24, 231, notes 39, 47, 296, p. 44.

———. "Charles Sheeler, Industry, Fashion, and the Vanguard," *Arts Magazine*, LIV, February 1980, p. 158.

———. "The Rouge," *Arts Magazine*, LIII, Nov. 1978, p. 8, illus.

Sheeler, Charles
1883–1965

Still Life, 1938

Oil on canvas, 8 x 9 inches (20.3 x 22.8 cm)

Signed and dated at bottom center: Sheeler—1938 Signed on back of original stretcher: Charles Sheeler, Still Life 1938, Charles Sheeler.

Provenance

The Downtown Gallery, New York

Nelson A. Rockefeller, New York

Hirschl & Adler Galleries, New York

Acquired 1979

Exhibitions

1939
New York. The Downtown Gallery

1939
New York. The Museum of Modern Art, *Charles Sheeler: Paintings, Drawings, and Photographs*, 1939, no. 42, illus.

1943
Boston. Institute of Modern Art, *Ten Americans*, October 20–November 21, cat. no. 24, illus.

1951
Houston. Contemporary Arts Museum, *Sheeler, Dove Exhibition*, January 7–January 23, cat. no. 25.

Bibliography

Archives of American Art, Downtown Gallery Papers, Roll ND 40, frames 282–283; Whitney Museum Artist Papers, Roll NY 59–5, frame 726.

Slobodkina, Esphyr
born 1908

Ancient Sea Song, 1943 (*Large Picture*, 1945)

Oil on board, 35¼ x 43½ inches (89.5 x 110.5 cm)

Unsigned

Provenance

Collection of the artist

The Owl Gallery, Woodmere, New York

Washburn Gallery, New York

Acquired 1978

Exhibitions

1945
Eight by Eight: American Abstract Painting Since 1940, cat. no. 63, illus. p. 2 as *Large Picture*.

Philadelphia. Philadelphia Museum of Art, March 7–April 1.

Boston. The Institute of Modern Art, April 11–April 28.

1975
New York. Washburn Gallery, *Eight by Eight: American Abstract Painting Since 1940*, October 1–October 25, cat. no. 18, illus. p. 5 as *Large Picture*.

1983/1984
Abstract Painting and Sculpture in America 1927–1944, cat. no. 131, illus. in color p. 137, text p. 221.

Pittsburgh. Museum of Art, Carnegie Institute, October 29–December 31, 1983.

San Francisco. San Francisco Museum of Modern Art, January 26–March 25, 1984.

Minneapolis. Minneapolis Institute of Arts, April 15–June 3, 1984.

New York. The Whitney Museum of American Art, June 28–September 2, 1984.

Bibliography

American Abstract Artists: Three Yearbooks (1938, 1939, 1946), Arno Press, New York, 1969, illus. p. 180.

Smith, David
1906–1965
Untitled, c. 1936
(*The Billiard Players*)

Oil on canvas, 47 x 52 inches (119.4 x 132 cm)

Unsigned

Provenance

Estate of the artist

Rebecca and Candida Smith, New York

Washburn Gallery, New York

Acquired 1983

Exhibitions

1983
David Smith: Painter, Sculptor, Draftsman, cat. no. 12, plate 28, illus. color, p. 65.

Washington, D. C. Hirshhorn Museum and Sculpture Garden, November 4, 1982–January 2, 1983.

San Antonio. San Antonio Museum of Art, March 27–June 4, 1983.

1983
New York. Washburn Gallery, *David Smith: Paintings From 1930–1947*, September 20–October 30, cat. no. 10, illus. in color on cover.

1986
David Smith Retrospective
Dusseldorf. Kunstsammlung Nordrhein-Westfalen, March 14–April 27.

Frankfurt. Städelsches Kunstinstitut, May 1–September 30.

London. Whitechapel Gallery, November 7–January 4, 1987.

Bibliography

Brenson, Michael, "Art/20 Years of David Smith Painting," *New York Times*, Friday, October 7, 1983.

Stella, Joseph
1877–1946
Gladiolus and Lilies, c. 1919

Crayon and silverpoint on prepared paper, sheet: 28½ x 22⅜ inches (72.4 x 56.8 cm)

Signed lower left: Joseph Stella

Provenance

Family of the artist

Hirschl & Adler Galleries, New York

Acquired 1985

Exhibitions

1920
New York. Bourgeois Galleries, *Retrospective Exhibition of Paintings, Pastels, Drawings, Silverpoints and Watercolors by Joseph Stella*, March 27–April 24.

1982
New York. Richard York Gallery, *The Natural Image: Plant Forms in American Modernism*, November 6–December 4, cat. no. 46, illus.

1983
New York. Hirschl & Adler Galleries, *Realism and Abstraction: Counterpoints in American Drawing*, November 12–December 10, p. 91, illus. cat. no. 106.

1985
New York. Hirschl & Adler Galleries, *American Still Lifes From the Hirschl & Adler Collections*, January 5–February 16, no. cat.

Stella, Joseph
1877–1946
Tree of My Life, 1919

Oil on canvas, 83½ x 75½ inches (212.1 x 191.8 cm)

Signed lower right: Joseph Stella

Provenance

Valentine Dudensing Gallery, New York

Carl Weeks, Des Moines, Iowa

The Iowa State Educational Association, Des Moines, Iowa

Christie's, New York, Sale #6288, December 5, 1986, Lot 288, illus.

Acquired 1986 by Mr. and Mrs. Barney A. Ebsworth Foundation and Windsor, Inc.

Exhibitions

1920
New York. Bourgeois Galleries, *Retrospective Exhibition of Paintings, Pastels, Drawings, Silverpoints and Watercolors by Joseph Stella*, March 27–April 24.

1963
New York. The Whitney Museum of American Art, *Joseph Stella*, October 2–November 4, cat. no. 14

1976
New York. The Museum of Modern Art, *The Natural Paradise: Painting in America 1800–1950*, December, illus. in color, p. 157, checklist unnumbered.

1984
New York. The Whitney Museum of American Art, *Reflections of Nature: Flowers in American Art*, pp. 83, 151, illus. in color p. 163, fig. 131.

1985
Des Moines. The Des Moines Art Center, *Iowa Collects*, May 12–July 28, p. 52, illus. p. 15, checklist unnumbered.

Bibliography

Baldwin, Nick, "Stella," *Des Moines Register*, April 18, 1970.

Baur, John, *Joseph Stella*, New York, 1971, pp. 20, 46–47, illus.

Glaubinger, Jane, "Two Drawings by Joseph Stella," *The Bulletin of the Cleveland Museum of Art*, December 1983, pp. 382–95, illus. p. 385, fig. 6.

Jaffe, Irma B., *Joseph Stella*, Irvington, 1970, plate 59 and frontispiece.

Storrs, John
1885–1956

Abstraction #2, 1931/1935 (*Industrial Forms*)

Polychromed plaster, 10 x 5 x 4 inches excl. base (25.4 x 12.7 x 10.7 cm)

Signed underneath on one foot in orange paint: John Storrs, 21/5/35. Signed on other foot without color: 11/12/31

Provenance

The Downtown Gallery, New York

Robert Schoelkopf Gallery, New York

Acquired 1983

Exhibitions

1965
New York. The Downtown Gallery, *John Storrs*, March 23–April 17, cat. no. 38.

1976
Chicago. Museum of Contemporary Art, *John Storrs 1885–1956: A Retrospective Exhibition of Sculpture*, November 13, 1976–January 2, 1977, cat. illus. p. 14, unnumbered.

1986
John Storrs. New York. The Whitney Museum of American Art, December 11, 1986–March 22, 1987.

Fort Worth. Amon Carter Museum, May 2–July 5, 1987.

Louisville. J.B. Speed Museum, August 28–November 1, 1987.

Bibliography

Bryant, Edward, "Rediscovery: John Storrs," *Art in America*, v. 57, May–June 1969, pp. 66–71, illus. p. 71.

Davidson, Abraham, "John Storrs, Early Sculptor of the Machine Age," *Artforum*, v. 13, November 1974, pp. 41–45, illus., p. 41.

Storrs, John
1885–1956

Double Entry, 1931

Oil on canvas, 43¼ x 30¼ inches (109.8 x 76.8 cm)

Signed lower left: STORRS 5–3–31

Provenance

Robert Schoelkopf Gallery, New York

Acquired 1979

Exhibitions

1969
New York. The Downtown Gallery.

1983
Abstract Painting and Sculpture in America, 1927–1944, cat. no. 136, illus. in color, p. 139, text p. 228.

Pittsburgh. Museum of Art, Carnegie Institute, October 29–December 31, 1983.

San Francisco. San Francisco Museum of Modern Art, January 26–March 25, 1984.

Minneapolis. Minneapolis Institute of Arts, April 15–June 2, 1984.

1986
John Storrs. New York. The Whitney Museum of American Art, December 11, 1986–March 22, 1987.

Fort Worth. Amon Carter Museum, May 2–July 5, 1987.

Louisville. J.B. Speed Museum, August 28–November 1, 1987.

Bibliography

Carrier, David, "American Apprentices: Thirties Abstraction," *Art in America*, February 1984, pp. 108–114, illus. in color, p. 108.

Storrs, John
1885–1956

Study in Architectural Forms, c. 1923

Marble, 66 x 10¾ x 3 inches (167.6 x 27.3 x 7.6 cm)

Unsigned

Provenance

Estate of the artist

Mrs. Monique Storrs Booz

Robert Schoelkopf Gallery, New York

Acquired 1984

Exhibitions

1976
Chicago. Museum of Contemporary Arts, *John Storrs: 1885–1956, A Retrospective Exhibition of Sculpture*, November 13, 1976–January 2, 1977, cat. p. 12, illus. Listed as being lent by Mr. and Mrs. George B. Young to whom it was being lent by the artist's daughter, Mrs. Monique Storrs Booz.

1986
John Storrs. New York. The Whitney Museum of American Art, December 11, 1986–March 22, 1987.

Fort Worth. Amon Carter Museum, May 2–July 5, 1987.

Louisville. J.B. Speed Museum, August 28–November 1, 1987.

Suba, Miklos
1880–1944

Storage, 1938

Oil on canvas, 19⅞ x 24 inches (50.5 x 60.9 cm)

Signed lower right: MIKLOS SUBA. Signed on verso: Brooklyn, N. Y.

Provenance

Robert Schoelkopf Gallery, New York

Acquired 1978

Exhibitions

1943
New York. The Museum of Modern Art, *American Realists and Magic Realists (Americans 1943)*, February 10–March 21, cat. no. 230, as *American Landscape*.

1945
New York. The Downtown Gallery, *Suba: First One Man Exhibition of Paintings*, January 3–January 20, cat. no. 17.

1947
Paintings by Suba, checklist no. 18.

San Francisco. DeYoung Museum, December 9, 1947–January 17, 1948.

Colorado Springs. Colorado Springs Fine Arts Center, February.

1964
Kalamazoo, Michigan. Kalamazoo Institute of Arts, *Miklos Suba*, March 7–March 29, cat. no. 67, detail reproduced in serigraphy as cover.

1967
New York. Robert Schoelkopf Gallery, *Miklos Suba*, January 10–February 4, cat. no. 24.

1974
Syracuse, New York. Everson Museum of Art, *Miklos Suba: One Man Show*, no cat.

Tooker, George
born 1920

The Chess Game, 1947 (*The Chessman*)

Egg tempera on masonite, 30 x 14½ inches (76.2 x 36.8 cm)

Signed lower left: Tooker

Provenance

Frank K. M. Rehn Gallery, New York

Edwin Hewitt Gallery, New York

Robert Isaacson Gallery, New York

Irma Rudin, New York

Marshall Henis, Steppingstone Gallery, Great Neck, New York

Sotheby Parke-Bernet, New York, Sale #4112, April 21, 1978, Lot 208, illus. in cat.

Exhibitions

1947
New York. The Whitney Museum of American Art, *1947 Annual Exhibition of Contemporary Paintings*, cat. no. 156, illus.

1951
New York. Edwin Hewitt Gallery, *Paintings by George Tooker*, February 20–March 10, cat. no. 5.

1955
The New Decade: 35 American Painters and Sculptors, cat. illus. p. 88, unnumbered.

New York. The Whitney Museum of American Art, May 11–August 7, 1955.

San Francisco. San Francisco Museum of Modern Art, October 6–November 6.

Los Angeles. University of California Art Galleries, November 2, 1955–January 7, 1956.

Colorado Springs. Colorado Springs Fine Arts Center, February 9–March 20, 1956.

St. Louis. City Art Museum, April 15–May 15, 1956.

Bibliography

Garver, Thomas, *George Tooker*, New York, Clarkson N. Potter, Inc., 1985, pp. 15, 18, 128, 132, illus.

The Saint of Bleeker Street, New York, Playbill Inc., December 27, 1954. (The style of the production was inspired by four paintings by George Tooker which included *Festa*, *The Subway*, *Jukebox*, and *The Chess Game*).

Walkowitz, Abraham
1878–1965

The City, 1911

Graphite and black crayon on paper, sheet: 13 1/16 x 8⅝ inches (33.2 x 21.9 cm)

Signed lower right in ink: A. Walkowitz/1911

Provenance

Reader's Digest Association, Pleasantville, New York

Hirschl & Adler Galleries, New York

Acquired 1985

Exhibitions

1980
New York. Hirschl & Adler Galleries, *Buildings: Architecture and American Modernism*, p. 88, no. 92, illus.

1985
New York. Hirschl & Adler Galleries, *Town and Country 1889–1949: An Exhibition from the Galleries' Collection*, February 23–March 30, no cat.

Bibliography

Archives of American Art, Whitney Museum Artist Files: Abraham Walkowitz, Roll MY 59–15, frame 265.

Walkowitz, Abraham, *Improvisations of New York: A Symphony in Lines*, Girard, Kansas, Haldeman and Julius, 1948, unpaged, illus.

Wiltz, Arnold
1889–1937

American Landscape #3, 1931

Oil on canvas, 16¼ x 20¼ inches (41.3 x 51.4 cm)

Signed and dated lower left: Arnold Wiltz Jan. 1931

Signed and titled on back with Bearsville crossed out and Woodstock, NY substituted

Provenance

Dudensing Gallery, New York

Robert Schoelkopf Gallery, New York

Acquired 1978

Exhibitions

1932
New York. Dudensing Gallery, *Recent Paintings by Arnold Wiltz*, April 19–May 9.

1937
New York. Karl Freund Arts, Inc., *The Art of the Late Arnold Wiltz*, November 1–November 20, cat. no. 12.

Bibliography

"Arnold Wiltz," *Index of Twentieth Century Artists*, v. 4, no. 4, January 1937, p. 384.

"Around the Galleries," *Creative Art*, v. 9, October 1931, p. 331, illus.

"Around the Galleries: Dudensing Galleries," *Creative Art*, v. 10, June 1932, p. 474.

Xceron, Jean
1890–1967

Composition 239A, 1937

Oil on canvas, 51 x 34¾ inches (129 x 88.3 cm)

Signed lower right: J. X.

Provenance

Estate of the artist

Washburn Gallery, New York

Acquired 1977

Exhibitions

1971
New York. Peridot-Washburn Gallery, *Jean Xceron*, September 14–October 2.

1973
Chicago. Museum of Contemporary Art, *Post Mondrian Abstraction in America*, March 31–May 13, illus. in cat., unpaged, unnumbered.

1976
New York. Washburn Gallery, *American Abstract Paintings from the 1930s and 1940s*, September 9, October 2, illus. on front of cat.

1983
Abstract Painting and Sculpture in America, 1927–1944, cat. no. 144, illus. in color, p. 142, text p. 236.

Pittsburgh. Museum of Art, Carnegie Institute, October 29–December 31.

San Francisco. San Francisco Museum of Modern Art, January 26–March 25, 1984.

Minneapolis. Minneapolis Institute of Arts, April 15–June 3, 1984.

New York. The Whitney Museum of American Art, June 28–September 2, 1984.

Bibliography
Burnham, Jack, "Mondrian's American Circle," *Arts*, v. 48, no. 1, September 1973, pp. 37, (illus. in photographs of installation of exhibition.)

Zorach, Marguerite Thompson
1887–1968

The Picnic, 1928

Oil on canvas, 34 x 44 inches (86.4 x 111.8 cm)

Unsigned

Provenance

Estate of the artist

Kraushaar Galleries, New York

Acquired 1984

Exhibitions

1974
New York. Kraushaar Galleries, *Marguerite Zorach*, March 11–April 6, illus. on cover, cat. no. 13.

1979
Greensboro. Weatherspoon Art Gallery, University of North Carolina at Greensboro, *Spring Loan Exhibition*, April 8–April 29, no cat.

1983
Wilkes-Barre, Pennsylvania. Sordoni Art Gallery, Wilkes College, *1933 Revisited: American Masters of the Early Thirties*, March 20–April 24, cat. no. 40, illus. p. 51.

Bibliography

"Marguerite Zorach," *Artnews*, April 1984, p. 175, illus.

"Marguerite Zorach," *Arts*, June 1974, v. 48, p. 60.